THE
ARTIST'S
GUIDE
TO HIS
MARKET

THE ARTIST'S GUIDE TO HIS MARKET

by Betty Chamberlain

WATSON-GUPTILL PUBLICATIONS/New York

Copyright © 1970, 1975, 1979 by Watson-Guptill Publications

Revised, enlarged edition first published 1979 in New York by
Watson-Guptill Publications,
a division of Billboard Publications, Inc.,
1515 Broadway, New York, N.Y. 10036

Library of Congress Cataloging in Publication Data
Chamberlain, Betty.
 The artist's guide to his market.

 Includes bibliographical references and index.
 1. Art—Marketing. I. Title.
N8600.C48 1979 658.8'09'7 79-15912
ISBN 0-8230-0327-2

Manufactured in U.S.A.

First printing, 1979

In memory of
Just Lunning and Ben Shahn

CONTENTS

THE ARTIST'S GUIDE TO HIS MARKET

INTRODUCTION

If you are a fine artist, how can you find a place to exhibit your work? This is a universal question. As one painter has summed it up: "The greatest problem which professional painters and sculptors have is that of finding exhibition space. Where to show his work? This is becoming increasingly difficult. The galleries have a full roster of artists; there are few co-operatives, juried shows, which are limited in size, too few art associations—in short, fine artists face the discouraging situation of being unable to find places to exhibit."

"Isn't it enough for a painter to produce good art without entering into all the problems and difficulties you write about?" another artist wrote. "No wonder good paintings are rare. A good painter should be quiet, calm, peaceful, and unworried. When he has his mind on all these marketing and legal problems and spends his energies on them, he will never produce great art."

These problems are certainly very real indeed. If only the creative could be subsidized, there would be no need to worry about menial practicalities. If only there were always a Maecenas around the corner for all who create, their work would be both recompensed and recognized. But from Horace and Vergil on down through the ages, we know that the creative person has had the demeaning chore of pleasing and buttering up; and because of application procedures with government and foundation grants, there have always been many who could never count on continued subsidy and public exposure.

Even back in 1550 Vasari wrote: "If the arts of our own time were justly rewarded, they would produce even greater works

of art than those of the ancient world. Instead, the artist struggles to ward off famine rather than to win fame, and this crushes and buries his talent and obscures his name. This is a shame and disgrace to those who could come to his help, but refuse to do so."

The great majority has to cope with everyday practicalities for years before any unworried, peaceful ivory tower becomes more than a mirage, if ever. This book aims to provide information of a practical nature to artists who are seeking to overcome these difficulties of exposure and sale of their work. It supplies information about dealers and their practices, derived from art galleries large and small, in New York and elsewhere, as background material to help guide the artist. The dealer in business, and those who plan to go into the business, may well find this information useful as a yardstick for accepted practices and procedures.

The Art Information Center, Inc.

Most of the information given here derives from years of experience with thousands of artists and hundreds of dealers. In 1959 the author established the Art Information Center, Inc., in New York City, a nonprofit, tax deductible organization (so far the only one of its kind in the United States that works with artists on an individual basis). The members of the Board of Directors are, in alphabetical order: Betty Chamberlain, Stanley William Hayter, Jacob Lawrence, and Mrs. Andrew Ritchie. Founding Board members include the now deceased Just Lunning, Joseph B. Martinson, Andrew Carnduff Ritchie, and Ben Shahn. The purpose of the Center is to give free assistance to artists who wish to find outlets for their work and to dealers who seek new talent. It also helps curators, collectors, the art press, and the general public to locate the work of any living artist.

The Center came into being as a result of my eighteen years of work experience in four major museums, during which it became apparent that museums were unable to supply much help in these directions, although there were ever-increasing needs. The number of both artists and galleries had mushroomed ever since World War II, to the point where neither artist nor dealer could keep up with the growth, nor could they have any overall perspective on the art scene. Thus the artist

was at a loss to know where to try to show his work, and the dealer did not know how to help him. Confusion, disappointment, and discouragement resulted. Moreover, no one knew how to find out where to see or buy work by the thousands of living artists who did have gallery affiliations, for there was no source of information on what gallery handled which artists.

Services to Artists

The Art Information Center, Inc., was therefore set up as a clearinghouse for information in these areas of contemporary fine arts. It asks no fee or commission of anyone at any time. It sees by appointment some 800 artists per year, and on the basis of slides or photographs of work brought by the artist, it suggests some New York galleries most likely to be interested in the particular kind of work. These recommendations are also made partly on the basis of knowledge of which galleries are more apt to be able to take new work, for many dealers have a full roster and see no point in wasting everyone's time by looking at any more work. Indeed, most New York galleries refer artists to the Center when the artists just walk in at random. The dealers are glad to be able to give the artists some directions; and many an artist has learned in this way about the Center's services.

Needless to say, in order to know what kind of work the galleries are handling and what their situation is, it is necessary for us to go to visit many every week. Verbal descriptions without the visual actuality tend to be meaningless—works of art are not easily categorized. Nor are "directions" of galleries. If they were, if the whole feeling of the contemporary art field could be computerized, then IBM could do the job. But I see too many hundreds of artists who have to gird their loins even to come to the Center and who dread facing a dealer. To subject them to computerizing, to hand them a "canned" list, would be a most discouraging brush-off just when they need that least.

All artists who come by appointment are invited to call the Center if, in going to galleries, any questions arise in their minds about terms proposed, or if there is anything else on which they would like to consult. The Center encourages artists to report any questionable procedures that they may encounter among galleries they approach, for in this way we are better able to help the next artists who come to the Center. It is impossible to

tell by the looks or the location of a gallery whether or not its operation is conducted on a professional basis. Sometimes artists deviate from the list given them and wander in to see a dealer who welcomes them warmly, enthuses over their impressive talents, and offers a one-man show. Usually these are nonprofessional galleries, and if the artists phone the Center, they are always so advised frankly. Affiliation with such galleries would not only cost the professional artist undue sums of money but could also hurt his professional reputation. There is nothing illegal about such galleries, and perhaps they serve a purpose for amateurs. But when the Center learns of instances of complete misrepresentation on the part of any gallery, they are reported to the Better Business Bureau, the Art Dealers' Association of America, and the State Attorney General's Office of New York.

The time it takes to see each artist, to study his slides concentratedly, to select about ten or twelve suitable galleries for him from a list of some 550 New York galleries—plus dealing with inevitable incoming phone interruptions—runs from about forty minutes to an hour. For artists seeking immediate appointments this is often hard to understand; they wonder why they can't just drop in for five minutes.

In addition to compiling a selective list of galleries for each artist, the Center gives each artist some information on practices and procedures, appropriate approaches to dealers, business terms to seek, and what to look for, and what to look out for, in outlets for display.

But obviously this personal service must be limited, since there are so many artists who live too far away to visit the Center. Moreover, the Center can only refer artists specifically to New York galleries; it does all it can do merely to keep up with the hundreds there, without also attempting to know individual galleries elsewhere. Yet, often it is far more advantageous for artists to show closer to home. With concepts of what are correct and useful procedures, artists wherever they are, can be better prepared to solve these problems.

The chapters that follow aim to disseminate such information not only much more widely but in more complete detail than is possible in appointment periods. Even if you can visit the Center for individual help, you should derive from these pages much information that is equally important. And if you

6

cannot make a personal appointment, there are many suggestions here on how to determine your own best procedures.

The Center recently added another free service for artists:

The Educational File. This is an up-to-date record of where special art or craft skills and disciplines may be developed in courses and workshops; winter and summer, daytime and evening; for children up to 16 and adults; on subjects ranging from Chinese brushwork to stained glass, tapestries, medical illustration, ceramics and pottery, jewelry, and art therapy, as well as painting, sculpture, and graphics. Information on this service is available by telephone or by mail; enclose return postage with your letter. The educational file was developed with the aid of a grant from the National Endowment for the Arts and matching funds from foundations and individual contributors. Additional information from all art organizations is always most welcome.

Services to Dealers

Each artist who communicates with the Center is invited to leave or send in duplicate slides or photographs so that dealers who come in, seeking new talent, may select from these reproductions any artist whose work is of interest to them.

All reproductions left at or sent to the Center should be labeled with the dimensions of the originals, the medium, and the artist's name. Size is often important to galleries, and it is impossible to determine it from a tiny reproduction; medium can also be confusing in reproduction; name is essential on each slide because dealers inevitably mix up the slides they have viewed, and then no one can know to whom they really belong.

An interested dealer then gets in touch directly with the artist, usually arranging to visit his studio to see originals. Occasionally, when geographical distance is a problem, the dealer may ask the artist to send a few works. There are usually some 700 to 800 unaffiliated artists represented in the record of reproductions at the Center—a file that, of course, changes constantly as some artists find gallery affiliations and are removed, and new artists are added.

Many dealers, both in and outside New York, have found their artists in this way when they were about to open galleries. Frequently, dealers come from far-flung areas, seeking to represent and show in their regions some interesting new artists

from "the effete East," or from "the art center of the world." Naturally, dealers prefer to select an artist who does not have a contract with another gallery, for they wish to avoid having to split commissions with another dealer. Hence our slide file is for artists who have no such contracts. In some cases the Center receives a written description of the kind of work desired by a dealer who is far from New York; the Center then selects some reproductions to send on a short loan.

Services to Museums, Collectors, Art Press, General Public

The Center keeps up-to-date records—not with slides—of living artists who have gallery affiliations, and anyone may call or write to locate their work, and where they are exhibiting and have exhibited since 1959. At last count more than 45,000 living artists are listed, with their gallery affiliations, since the Center was founded in 1959. To maintain the accuracy of its records each September the Center sends to all New York galleries, as well as a great many others in cities throughout the U.S. and abroad, a form on which the galleries are asked to list the artists they represent and handle. Because artists frequently change their gallery affiliations, and because there are so many changes from one seasonal contract year to the next, the records must be checked and changed at the beginning of each season (the art season in New York is roughly from late September to June 1). In addition, the Center is on a great many mailing lists and regularly records all information from the brochures and announcements received. All listings from major art publications, art columns, and advertisements are also checked regularly.

It should be stressed that this information applies only to the fine arts. The Center does not work in the field of illustration or commercial art. And naive purchasers who buy in some out-of-the way shop, after a sales talk about how "famous" the artist is, may be doomed to disappointment when they call the Center, only to find that the artist is not listed because he has never shown in any recognized gallery. Of course, no listing is complete. But if an artist is not listed in the files, always consult two other compilations: *Who's Who in American Art* and *International Directory of Arts,* published in Frankfurt—am—Main.

Hundreds of calls and letters from people seeking this service come into the Center; no record of how many is kept, for

the Center is too busy answering them. A museum is anxiously looking for a particular artist's work to fill out a planned show. The Internal Revenue Service wants to know all galleries who have ever represented certain artists in order to obtain three appraisals each on works of art to be given to public institutions as tax-deductible gifts (some donors try to get away with a tax deduction of several times the value of the donation). An art writer or reviewer needs to check on work by a particular artist. A businessman wants to buy paintings by certain artists for his offices. A housewife has seen a sculpture in a friend's garden and wants to buy a similar one by the same artist. A tourist is particularly anxious, while in New York, to see work by so-and-so. There are even, from time to time, inquiries for the purpose of settling a bet or solving a crossword puzzle.

Collectors sometimes call anxiously for an artist's home address, but this is never revealed by the Center unless the artist has no gallery affiliation. Too often these collectors are seeking to bypass the gallery commission and try to talk the artist into selling at lower prices.

Other Services

The Center never attempts to duplicate any information service that is available elsewhere. If people request artists' biographies, they are referred to their galleries. If they are looking for grants and fellowships, they are referred to the Foundation Center and some standard references (see Chapter 19). If they want to enter competitive shows, they are told which publications list them, such as the *American Art Directory* (at the back), *Fine Arts Market Place,* and the "Bulletin Board" published monthly in *American Artist.* If they need to consult critical reviews, they are referred to the *Art Index,* the standard guide to art periodicals, which can be found in the public library. If they want to know what museums and art schools exist in any part of the country, they are again referred to the *American Art Directory.* The Center tries only to fill gaps where the information does not exist anywhere else, and to direct and guide people to those other sources of information that do exist.

All inquiries requiring an answer should enclose return postage, in view of the fact that all services are free and funds are minimal. Conforming to the New York art season, the Center is open only from mid-September to mid-June.

ARE YOU READY TO
EXHIBIT?

Hesitation ow can you know whether you are professional in your work, still a student, or really an amateur? In extreme cases, doting mamas sometimes try to push their teenage darlings into gallery shows because their high school art teachers graded them well after their first year or two and mentioned the word "talent." Obviously, the serious-minded artist knows that the urge and the realization must come from within, not from goading or flattery by relatives and friends. It is an old dictum that no one should try to become a fine artist unless he has to, when the inner drive is too strong to overcome. For the pursuit of art as a career is generally not only unremunerative but costly; the competition is fierce; and recognition is achieved by only a small percentage.

"To be considered a professional rather than an amateur painter," an artist wrote, running the gamut from one extreme to another, "must one's entire income be derived from painting? Or does one sale constitute professionalism?"

Professional or Amateur?

"Professional" versus "amateur" is a chronic dilemma, a constant source of arguments and differing points of view, and a major concern to many artists.

"At what point and by what standards does an amateur artist become, or consider himself, a professional artist?" writes an artist from a small city. "Judging by many of the art shows around here, 'professional' is anyone who can produce and sell a painting."

There is no rule of thumb or set criterion for making such a determination, so far as I know. Webster, on "professional,"

says: "engaging for livelihood or gain in an activity pursued for noncommercial satisfactions by amateurs." But the examples given refer chiefly to sports, such as "a *professional* golf player." In the sports arena just the receipt of money or payment of some kind determines the category. In the art field, however, everyone knows about sales of very amateurish work and about nonsales of much more competent and original work.

Several years ago I was requested to select artists to be newly included in *Who's Who in American Art.* In trying to pick those to be considered "professional," I was influenced by inclusion of their work in recognized museums more than by inclusion in private collections. True, many museum-owned works were donated by the artists, whereas collectors generally paid. But it is usually harder to get a museum's acquisition board to accept a work free than to get a friend or relative to buy. One-man shows were a criterion only if held under good, professional auspices.

Artists frequently categorize themselves quite obviously on the basis of their degree of ego. Some who have shown once or twice proclaim themselves professionals; others with much broader experience are full of doubt about their status. One states that he has been "a professional fine artist for four years," having shown in two cities. How did he decide upon his sudden "graduation" into professionalism just four years ago? Another reports that he devotes all his spare time—that is time not spent making a living—on serious painting; that he exhibits three times each year with his county art association; that he has won several awards—but that he has yet to make his first sale. With considerably more art recognition than the "four-year professional," he is nevertheless very dubious about how and whether he can be considered a professional.

No wonder there is confusion about where and how to draw that fine, undefinable line. There is no final arbiter.

Plagiarism

"How do you judge between using another picture for reference, and plagiarism?" asks a North Dakota artist.

Using another picture for reference is, in itself, of no great import, for the source of a subject does not matter. It is the handling, the treatment, the originality of style injected, that stamps the work with the artist's personal expression. Copying

has been a common practice throughout the history of art; for years it was a requisite in every art student's curriculum.

Titian copied a Dürer landscape drawing and labeled it as such. It is a prized possession of the Albertiner Museum in Vienna. Van Gogh copied Millet; Picasso did his version of Manet's *Déjeuner sur l'herbe,* which in turn was derived from Giorgione's *Fête champêtre.* Each of these works is fully imbued with the copying artist's own unmistakable style; thus these masters were not plagiarists.

To plagiarize is "to steal and use as one's own," according to Webster. This is obviously misrepresentation and explains in part why copyrights exist. Imitation of another artist's style, while not illegal, is widely censured. As soon as Andrew Wyeth became one of the highest-priced living artists, there was a rash of imitation Wyeths by opportunists without originality. It is indeed doubtful that any of them will hold up either in time or the market.

Some Questions to Ask Yourself

There are other, perhaps more intrinsic, criteria to consider. It may help you to ask yourself some questions.

1. Do you work on a steady, regular basis, or is your output spotty and interrupted? Some artists work very slowly. Peter Blume, for example, may have spent twelve years on one painting and all its preliminary drawings and sketches. But such artists nevertheless work regularly and consistently, not on an I-must-wait-for-the-mood basis.

2. Do you differentiate between your better and your less successful work? Do you "sleep on it" to get perspective so you can judge what to keep and what to discard? This is important not only for future exhibition purposes but also for your own development and for decisions about where you place emphasis and direction. I was gratified indeed when I received an unusual note from a New York artist: "Kindly cancel my appointment; I will contact you later. I have come to the realization that the work I have been doing is not up to what I want to do." It is only this kind of self-realization that is of value; no one else can do that for you.

3. Is your style consistent? True, many artists work in more

than one style at the same time. But usually, in the case of an artist who has "jelled," there is a strong vein of similarity, unity, and consistency, even between two fairly different styles. Or the artist, on self-examination, realizes that he is really leaning more toward one of his directions, sometimes using others for experimentation, practice, breadth of development—as studies for an ultimate production. If you go in too many different directions at once, you may well spread too thin in all of them.

A Singaporean Chinese girl, wanting to come to the United States, wrote: "I am artistically inclined, but I feel frustrated here . . . my artistic talents are just not exploited. What I would like to do: architecture, pottery, ceramics, fashion designing, stage designing, sculpture, portrait and figure drawing in all media, and abstract art." You have to admire the ambition of such a project!

If you are still trying out numerous approaches and are not sure what really speaks for you, then perhaps you are not ready to show.

4. Do you have a sufficient body of consistent work to show? Dealers generally want to see some fifteen or twenty examples recently executed by the artist before deciding whether or not to show him. They are not interested in work done earlier in a different style until you become old and famous, like Picasso, who warranted retrospective exhibitions during his lifetime, showing development in various periods. They want work in your current style, which is likely to continue to come out of your studio for at least some months ahead. What to do with a body of work in a previous style? Forget it. Perhaps put away some of the best for your future perusal of your development; perhaps give some as a present to your mother-in-law.

5. Do you try to be in the swing of new movements? If you are concerned with bandwagons and bend your talents toward adjusting to the latest fashion, the chances are that your work will not hold up over any length of time. There is always room somewhere for truly creative, original, and talented work in any style, even if it may seem old fashioned. The faddist, on the other hand, though he may make a momentary coup, is all too likely to wind up as an opportunistic flash in the pan, usually smacking of obvious imitation and repetition.

An artist, faced with this problem of change in what is avant-garde in Europe, wrote from Munich: "Excuse me, that you receive herewith a letter from an unknown person. But I heard you can help painters to get an exhibition in N.Y. More I don't know. I made already exhibit in Paris, but in Paris it is very difficult since 2 years with the abstract paintings. I like to exhibit my abstract aquarelles next year. Should I show perhaps with figuratives and flowers?"

If the work is not really yours, emanating from your own basic need to express it your own way, better not do it. Or if you do it just to prove to yourself that you can, do not show it.

6. Do you expect to make a living from your art alone? Even those artists who do have reputable galleries representing them run into many difficulties.

John Canaday, formerly art editor of *The New York Times,* who wrote periodically on the plight and problems of the artist, described one, "typical of many, whose increasing reputation, after exhibitions of his work in a series of major shows, is nevertheless not reflected in increasing income."

He also reported on the experiences of another artist who, he says, faces "a problem faced by all artists, that of exhibition in a New York gallery." The artist, who had had eight New York shows in the previous sixteen years, "must seem to most artists to have achieved more than average success," said Mr. Canaday. "His gallery is old, well-established one, not particularly aggressive but much respected—dependable and financially stable." But "expense is certain and profit is at least uncertain from a gallery show," and Mr. Canaday went on to quote the experiences of this seemingly fortunate artist: after paying the required costs of framing and publicity for his latest one-man show, and selling ten paintings from the show, he cleared a total of $470 "to cover the cost of paints, canvas, and studio space for the two years' work represented by the exhibition. . . . The gallery's side of the story is that it took in about $325 a week to cover expenses during the three weeks of the show. This is obviously much less than it costs to run the place."

The artist told Mr. Canaday: "There is no asset for the average artist like the socially gifted wife. From all of this, it is pretty apparent that I have exactly three choices. I can find myself

such a wife, or I can kill myself, or I can continue to support myself by teaching, which I am quite happily committed to doing."*

Only a handful of top-name artists are able to live by their creations; indeed many who are well known still must do something else for their livelihood. There is an informative discussion of this problem—and of some of the other ways in which artists make a living—in the book *Art Career Guide* by Donald Holden (New York: Watson-Guptill Publications, 1973, pp. 66–86). It is unrealistic, wishful thinking on the part of any fine artist to believe that he is going to earn his living by his works of art. Should it happen in the course of time, it would be a great bonanza—but don't count on it.

Earning a Living

Better to try to figure out a job for yourself that permits you as much time as possible for your art. Some artists prefer to do related work, like teaching or commercial art; others prefer to divorce their money-making from their chosen profession completely. Some are able to work remuneratively at engineering drafting or an applied art, producing in only three to six months an income sufficient to leave them completely free for their own work the rest of the year. Many work full-time, regular job hours and still have the drive for a large art output in their spare time.

One of the most idyllic artist-jobs I have heard of was that of a Northwest artist who sat painting for many seasons in a forest fire tower north of Seattle, paid to keep an eye out for smoke at the same time. Another is that of an artist who takes off on trips to caves, from Lascaux to Mexico and the U.S. Southwest, makes accurate copies of prehistoric art, and reproduces and sells them widely; he then returns home to his own painting until more cave-art income is needed. Visual artists are not alone in these sideline requirements; many musicians who are basically serious composers supply background music for TV documentaries or movies, and some even put out such hack work as commercial jingles.

*Short quotes from John Canaday © 1968 by *The New York Times* Company. Reprinted by permission.

Museum Jobs

If you seek employment in a museum, there is usually not much value in going to an employment agency; go, rather, to the personnel departments of the museums themselves. Even dealer galleries very rarely turn to any employment agency when they need assistants; they are more apt to use the grapevine method. For professional jobs in museums, consult *Aviso,* the monthly newsletter of the American Association of Museums, which publishes openings throughout the U.S. You can get this publication by joining the association; membership is open to all.

Teaching Jobs

For teaching jobs, there are placement bureaus in various colleges and universities. The College Art Association of America maintains a placement bureau for its members (fees are scaled according to income; membership is open to all). It solicits information on job openings from more than 2,000 colleges, museums, art centers, and galleries; and mails *Position Listings* to its members five times a year. At its annual meeting institutions interview many member applicants. Teaching positions in colleges usually require a degree in education or some other graduate degree.

All major college or university art departments are listed by state and city in the second section of the *American Art Directory* along with courses taught, size of enrollment, and other pertinent information, should you wish to apply. There are increasing numbers of artists-in-residence in many of these institutions, as well as in schools below college level; these positions do not necessarily require that the artist have a degree, or that he be well known. Currently, increased attention is given by colleges and art schools to the practicalities of life after graduation. For example, the Union of Independent Colleges of Art, embracing 9 colleges around the U.S. has a Career Opportunities Service for placement of its alumni—not necessarily in teaching jobs only.

Those independent art schools that do not give degrees will much more readily employ artist-teachers who do not have degrees. Some of these schools will employ artists only on a part-time basis, for they feel that it is important to his effectiveness

as teacher for the artist to have sufficient time to continue his own work in his studio. Many have evening courses.

Some artists have found employment in various fields through the U.S. Employment Service or through state employment agencies.

GALLERIES
AND HOW
THEY FUNCTION

F ine arts galleries deal primarily in paintings, sculpture,. mixed mediums, graphics, and, in ever-increasing numbers, crafts and photography when these are considered to be artistic expressions.

"Art Dealers" versus "Picture Dealers"

The Art Dealers' Association of America, to which more than 100 older, established galleries belong, makes the distinction between a true "art dealer" and a dealer in "pictures." The dealer in pictures, says the Association, is engaged in "an entirely honorable 'business', but essentially different from the fine art business." Thus the artist who wrote me from Holland was, from his description, seeking a "picture" dealer: "I am a painter of old Dutch paintings, and should like to come in contact with a person who is buying art paintings, so my question is, if you can give me those addresses." The Art Information Center, however, functions primarily in the fine arts field of "art dealers."

The Art Dealers' Association defines the true "art dealer" as one who "is making a substantial contribution to the cultural life of his community by the nature of the works offered for sale, worthwhile exhibitions, and informative catalogs or other publications. Art dealers in the leading art centers—both members and nonmembers of the association—perform a most important function. It is the dealers rather than the museums which first discover and exhibit the works of new artists [Note: Exceptions to this statement surely should be made such as in the case of Alfred H. Barr, Jr., first Director of New York's Museum of Modern Art.] The dealers' exhibitions, which are

open to the public without charge, are among the most important 'free shows' of any kind thus available. They represent an outstanding benefit to artists, museums, collectors, and the public generally."

A legal case, based on this assumption of benefit, was won a number of years ago by the Leo Castelli Gallery in New York. Neighbors protested that his gallery violated a zoning law: it was a few feet beyond the prescribed commercial area. However, Castelli proved to the court that his gallery was acting much more as an educational center than as a commercial one: his door was always open, free to all; his carpets were worn out by students and scholars who never bought; his publications were sent free to libraries and universities. The final result was that the gallery was allowed to remain in the same location.

But, on the other hand, the association warns that "art dealers are engaged in business. They hope to operate at a profit. . . . Their galleries are not museums. Their owners and operators are primarily engaged in buying and selling works of art. Dealers' galleries are not public service stations and they do not offer to the public drinking water, telephones, or toilets."

Indeed it is well to keep this in mind. I went with a visiting out-of-town artist to a gallery preview, and as soon as she reached the crowded party, she made a beeline for the gallery's telephone. Fortunately, I was able to distract her and explain that this would not be appreciated. "But it's only a local call," she said, accustomed to unlimited calls in her hometown. But aside from the cost of every local call in New York—and why should a dealer pay for all visitors' calls?—the gallery does not want its line tied up by outsiders so no one can reach it.

The Art Dealers' Association of America is a nonprofit organization of dealers in New York and elsewhere in the United States. A dealer is elected to membership on the basis of his knowledge of his particular field and his complete integrity. The association is active in combating fraudulent practices. A prospective member must have been in business for at least five years, must have a good reputation for honesty in his dealings, and must be considered by the association a true "art dealer." The requirement for ethical standards applies to dealings with both the public and artists. Any dealer who is a member of the association will doubtless have its booklet describing its activities and listing all its members, who are generally considered the cream of the crop among art galleries. So unless you have al-

ready gained a considerable reputation, it is not very likely that you can start out in one of these galleries. But the standards they set are practiced by many galleries that are not members. These standards, which are described in greater detail below, are most helpful to the artist.

Some Standards to Look For

The professional gallery charges a commission on sales but does not require any fees from the artist. This kind of dealer makes his living from his sales commission, not from the artist's pocket. If he takes a couple of works on trial consignment, he expects the artist to be responsible for the costs of delivery and framing—and that is all! Any additional charges are nonprofessional.

If the dealer publicizes a group show, that is *his* financial responsibility. For a one-man show only, he has a right to charge to the artist the costs of publicity for which he must contract outside the gallery. If you want total coverage in insurance, you may have to supplement his insurance, for dealers do not carry insurance for 100% of value. These are the terms to look for, based on the concept that the dealer should be in business because he has judgment both for quality and for what will sell.

Occasionally, organized groups of artists want to show together in a gallery. A professional dealer is highly unlikely to consider displaying a whole group already constituted according to someone else's judgment. He must select individually and personally what he feels has merit, what relates to his specialization, and what would appeal to his particular clientele.

What to Look Out For

The nonprofessional dealer, of which there are many, including some self-styled "co-operatives," will often show almost any artist's work for money. The dealer may insist on a guarantee against commissions—which means that you assure him of anything from $200 to $5,000 in sales commissions, whether he sells that much or not! Naturally, this removes his incentive for making sales, for he knows you will have to pay him anyway. And remember that for every $1,000 guarantee you give him, he would have to sell $2,500 worth of your work for him to get a 40% commission and for you to get back your $1,000.

He may also charge hanging fees. He may charge costs of

publicity for a group exhibition split among the artists showing. His "costs" may include his rent, light, and heat. Thus, a dealer of this variety knows ahead of time that he has his income guaranteed by *you,* and he does not need to bother about even trying to be an active or effective dealer.

These are warnings for the professional artist, for there is indeed a reason for the existence of nonprofessional galleries. There are Sunday painters, amateurs, and retired businessmen who want very much to have a show, invite their friends, have a catalog to show the folks back home, and collect a few press comments from certain small publications that will write a "review" if the artist buys an advertisement. For these nonprofessional artists, probably the most direct and forthright dealers are the outright rental galleries who have a set fee for a certain amount of wall space.

In one exceptional situation an artist can achieve a measure of professionalism through a rented show: when his position or promotion depends on having a New York exhibition. There have been cases of artist-teachers in colleges remote from New York who were told that they could only be promoted, with salary increase, if they had a one-man show in New York—a type of "publish or perish" edict transferred into the art world.

The New York art season coincides with the academic year; hence a teacher is tied down by his work and has not the time to make the trip there to shop for a professional gallery. His recourse is to rent a show and thus obtain his promotion. It is foolish for the college officials to require him to do this; they doubtless do not realize that shows in pay galleries prove nothing about professionalism and that such shows may even make it difficult for a promising artist later to exhibit in a professional gallery. Their requirement thus indicates not only their ignorance of the field but also their lack of confidence in their own judgment and competence.

Some nonprofessional dealers charge fees that vary according to what they think the artist will put up with. Some of these go to many competitive shows, take notes on the artists who have no gallery affiliation, and write them offering shows and complimenting them on their great talent. (Warning! You can nearly always assume that any such approach comes from a gallery that exists on artist payments rather than on sales com-

missions, for it is not a practice of professional galleries.) Too often, professional artists are elated by this "recognition" and fall for the costly and nonprofessional show, which, in the long run, can be detrimental to the professional in terms of both his pocketbook and his reputation. Curators and press generally avoid these galleries, for their practices are known in the art field; and the professional gallery may be dubious about taking on an artist who has had his name affiliated with a nonprofessional dealer.

If you want to show in Europe, don't be surprised if you find a quite different situation, for charging various fees is a much more commonly accepted practice abroad.

It is pretty difficult to predict whether a dealer is going to be successful or go out of business or even go bankrupt. There have been cases in which artists were unable to retrieve their works from a bankrupt dealer because he placed everything from his gallery in a warehouse, where he already owed a large debt. Unless the artists paid the dealer's back bills, they could not obtain their works. In one recent case, a number of the artists kept an alert eye on their gallery's proceedings, realized the impending hazard of their dealer's situation, and took their works away in the nick of time.

Even outrageously obvious crooks have been able to pull the wool over the eyes of unsuspecting artists for several years, before enough artists became sufficiently aware to put them out of business by not falling for the act. There was a dealer— fortunately now gone—who told artists that the way to start showing was to do so in Europe; after this, they could walk into any gallery in New York and get a one-man show. How artists could have been so naive as to believe such a blatant misrepresentation is hard to understand, but quite a lot did. The dealer took three paintings from each artist, sent them abroad, arranged for some sort of minor press review (easily purchased abroad), and charged each artist $2,500. Many an artist borrowed widely from friends and relatives to pay this, believing that then he would be "made." The Art Information Center reported the dealer to the lawyers of The Art Dealers' Association and to the Better Business Bureau, but neither could do anything legally because, in each case, the artist had signed a statement that he agreed to precisely these terms. The Better

Business Bureau could only send the dealer a notice that he was misrepresenting his services, and, if asked, the Bureau would have to label him thus. But too many naive people do not think to check with the Art Information Center, nor with the Better Business Bureau, nor with The Art Dealers' Association.

Agents

Many an artist asks me to recommend a reliable agent who will take care of all exhibiting and marketing problems for a fee or commission. I have never seen an artist who did not resist having to shop for outlets. If only he could pass the buck onto an agent! Everyone hates to look for a job, for that is the worst job of all; but most people find it necessary. Frankly, I do not know of any agent to recommend in the fine arts field. Agents are often effective in other areas such as commercial art, the performing arts, and literature. But in fine arts, they are widely disapproved. The responsible gallery owner wants to be his artists' representative without working through a middleman; he wants to exercise his own professional judgment, often partly based on knowing the artists and discussing future plans and directions of their work; he seeks a personal rapport not possible when working through an agent—or through a friend or spouse.

Why the same direct relationship is not required in other creative fields, I do not know. But I would guess that it may be because the art gallery is most often a small operation, its owner making personal decisions about building and maintaining the gallery's image, rather than delegating such authority to subordinates as is common in the larger organizations of commercial art directors' staffs, concert management bureaus, and publishing houses.

Another hurdle is that there have been self-styled artists' agents who promised their clients publicity, prominent TV interviews, and fame virtually overnight, only to abscond with the artists' funds. Memory of such precedents lingers, even if these frauds are not legion.

For the vast majority of artists, the most reasonable and effective approach to finding outlets would seem to be the do-it-yourself personal method. There may even be numerous compensations in the contacts and comprehension that result.

The Art Gallery Work Force

The preponderance of dealers, even in the major art center of New York, started their galleries either alone or with only one part-time or full-time employee; and many still have the same limited staff even after five or more years. Although many others have increased their staff over the years, they have usually added only one or two employees. Thus, this occupation is still perhaps more individual—in the old-fashioned small-business sense—than most business operations today.

The question naturally arises: with so little assistance in the gallery, how much outside help must dealers employ? Actually, surprisingly little.

There are catalogs, brochures, announcements, and press releases to be written. Most dealers particularly enjoy doing this kind of work themselves, and so usually write their own literature.

There are shows to be installed and dismantled every three weeks during the art season and this they also do themselves, only occasionally hiring a carpenter for jobs involving unusually heavy material or special construction needs.

There is layout and typography to think about for all printed matter. A tiny percentage of dealers hire a graphic design specialist, but by far the largest number work this out for themselves along with their printers.

For traffic-transportation-shipping needs, they don't hire a traffic manager; they call up an art-trucking firm or, for imported art, a customs broker.

For advertisements, the dealers work with agents; but this costs the dealer nothing, for agents get their commissions from the publications in which they place ads.

For accounting, dealers hire someone to come in quarterly. Obviously, filling out government forms and checking the bookkeeping are aspects they do not relish, although they keep their own records in between the three-month visits.

Other outside help is likely to include a cleaning person; if the dealer is a woman, she is apt to prefer a cleaning man who can be pressed into service also for moving heavy objects, opening crates, and installing big paintings and sculptures.

It becomes quite understandable, then, that dealers do not welcome shipments of work on speculation, for their facilities

are too limited. Lack of space is one of the biggest problems, for suitable space is hard to find and very costly in every art district of every large urban area.

It is also natural that since dealers do so much of the gallery work themselves, they do not welcome a constant flow of time-taking artists who walk into every gallery to show work without first taking the trouble to observe whether or not their work is at all suitable to the particular gallery's direction or style.

SHOPPING FOR A GALLERY

A n artist is wise to take a little time away from his creative work to explore for himself what are his best initial potentials.

Decentralization

It has become less and less necessary to leave home and "migrate" to some big urban art center in order to obtain exposure, recognition, and sales. The widespread clamor throughout the country for decentralization has been getting results. More and more artists are making it in their own areas without ever going to New York, Los Angeles, or Chicago; more collectors are developing and buying locally; more museums and galleries are gearing shows to their own communities, their own artists.

The future of decentralization looks even rosier, according to scientist Isaac Asimov's predictions in *Modern maturity* magazine. He points out that the laser beam produces light in even wave lengths so that there is room for many millions of channels to convey pictures and words beamed from communication satellites. That by the end of the century every person on earth may be able to have his own, and to transmit both sight and sound, an aim not possible to achieve from television because of its limited and expensive channels.

For the artist, I doubt if this means that he would show and sell his works in the big cities via laser, but rather that visual information and education could reach everywhere, creating greater local acceptance, appreciation, and markets. Then there would be little need for the person or the image he creates to be transplanted elsewhere to achieve exposure and recognition . . . which would also be a helpful step toward relieving the energy shortage.

33

'But without having to wait for the year 2000, artists are in many cases finding outlets, purchasers, and commissions without ever going, or showing, outside their own regions. These developments are being fostered by National Endowment for the Arts (NEA) grants, by state councils on the arts in every state and territory; by institutions such as local museums, colleges, universities, and libraries; and by the artist's own ever-burgeoning organizations. Your state council's headquarters are easily located in the *American Art Directory*, which you will find at a local library or museum; your local council probably sends out a periodical bulletin on current opportunities for shows, grants, and competitions, so get on its free mailing list. Also, ask specifically about current potentials in your field or medium of interest. Check into any local and regional artist organizations (the state council should know about them), which may be set up to supply just such useful information. Encourage these groups to establish an art information center for the area (see Chapter 11). Look into the various potentials in your area instead of making that expensive trip to a big center.

To be informed about developments in your state and region, you need to read art columns and news in local newspapers, see shows, talk with other artists. As a taxpayer and constituent, express to your representatives and senators, both federal and state, your concern for sufficient allocation of funds to your state council on the arts for community arts services in all counties. They will listen; there is a widespread upsurge in interest in the arts, even among legislators.

College and University Collaboration
Check with nearby college and university art departments and professional art schools for what collaboration they can offer to local artists. They often have good facilities and resources they can share; they seek local interest and pride in their functions, which might well produce some needed local scholarship sponsors; their participation in community affairs is likely to entice better art faculty. Many are helping to form community galleries, as well as showing local work in their own exhibition areas. Many are supplying for artists the important forum needed for stimulation and fulfillment.

Artist Group Activities

What are your possibilities of organizing or joining the open-studio shows, by artist groups or individuals, that are attracting increasing attention and sales in many parts of the country? For these shows, you don't have to solicit grants or raise funds. To many, they have greater appeal than the gallery, for the purchaser is permitted to see behind the scenes of art, to meet the artist in his own surroundings and talk with him about art.

Other artist-inspired and -coordinated group activities, which are becoming more numerous, include open art shows and juried annuals for regional and sometimes nationwide artists, in both summer and winter. In some areas artists issue small, inexpensive publications that aim to interest the public in new work and to supply the artist with useful, practical information about upcoming exhibitions and opportunities for participation, problems of publicity, and other mundane considerations. There are also groups of artists who arrange traveling shows of their work to circulate in other communities in their region. You will find fuller details on artists' groups in Chapter 11.

Go to See Shows

In large cities, where many galleries are concentrated and where competition for clientele is sharpest, galleries are likely to specialize in some particular style or type of art expression. The best time to get an overall perspective of a gallery's direction is when it shows a few examples of work by each of its artists in a group show. Such shows are frequently held at the beginning and the end of the season, and prior to Christmas.

In smaller regions and suburbs, where there is less competition, galleries are more likely to show work in various styles in order to appeal to all tastes among potential buyers.

In either case, when you go to shows, make notes for yourself on what you saw where, including styles, mediums, sizes, prices. If you keep systematic records of this nature, you will be in a much better position to sort out—from among all the galleries, large and small—where you might best try your luck. Some galleries show no sculpture, but a few handle sculpture exclusively; some show only smaller work, often because of the size of the gallery; some handle prints and drawings as well as paint-

ing and sculpture, whereas a goodly number works only with graphics.

If you work primarily on paper—watercolors, drawings, prints—look for galleries that especially handle them and be prepared to realize that the more "expensive" galleries may feel they cannot afford to handle your output. For "papers," being less permanent, usually bring lower prices than canvases or sculptures and may take up just as much wall space. Dealers with high overhead costs need to hang higher-priced work. They relegate the papers of their artists—who also produce in more expensive mediums—to portfolios in the backroom for those customers who say, "I like this artist's work, but haven't you something less costly?"

This fact does not mean that your papers will not find a market; it means, rather, that you are more likely to find your market in galleries located either in urban areas where rents are lower than those in the major art section of a city, or else in the suburbs. Galleries usually charge a 50% commission on papers.

If you straddle the arts and crafts fields, you may have some difficulty in finding art gallery outlets, but this situation has improved enormously in recent years (see Chapter 16). If you are a creative photographer, again your display potentials are improving. There are not only more photography-as-art galleries, but—as is also true of crafts-as-art—there are more galleries and museums combining their interests in showing these forms of expression along with painting, sculpture, and graphic work.

The Museum of Modern Art in New York established a Department of Photography on the same footing as its Department of Painting and Sculpture as long ago as 1940—less than three years after the Museum's founding. In recent years New York has been able to boast a large International Center of Photography with virtual museum status; and there are many galleries around the country that specialize—as do painting and sculpture dealers—in certain directions of photography: experimental, abstract, superrealism, among others. Not only group but one-man shows are frequent. Many more photographs than ever before, both black-and-white and color, are being bought as works of art.

These things you need to know in order to approach potential outlets intelligently.

Gather Information and Background

If you know other artists, some of whom are perhaps more experienced, pick their brains. Not infrequently, an artist who has a gallery affiliation has taken a friend to his dealer when he knew that there was an opening in the roster, and has thus placed him. Dealers say, "If an artist whose work I respect recommends another artist, then I'll always go to the studio to see his work." But even if the result is not so direct, other artists may know more than you do about the reputations, practices, and availability of certain dealers. Add these impressions to your notes on galleries.

If you study and analyze various galleries in this way prior to asking them to look at your work, you will be in a much stronger position when you do select the galleries to try, for you will have a better awareness of where your work may find its proper surroundings and audience. One of the most discouraging aspects of a dealer's life is that so many artists just barge in, with no regard for, or knowledge of, the gallery's direction, mediums handled, price range. Indeed, some artists actually bring out slides of, say, landscapes to show a dealer when—if they would only look at the gallery display right around them—they could easily see the dealer specializes in abstract sculpture.

Even in the immediate environs of New York City, where it should not be too hard to learn about what is going on next door, an artist from a nearby suburb wrote to me complaining: "Most of the galleries seem to have turned to either Op, Hard-edge, or some other crazy 'way-out' stuff, or 'pornographica.' Is there really no hope for artists like me, whose work is figurative but contemporary, yet not 'far out' or conservative?" A plaintive plea, but it is obvious that this artist neither reads much about shows in New York nor goes to very many, despite his proximity.

A similar lack of effort to inform himself probably afflicted the artist who wrote from Massachusetts: "A few months ago I spent a couple of days in New York 'trying to sell some paintings; to galleries who didn't know me from Adam. Needless to say I wore out a good pair of shoes for nothing. Someone gave me your address just before leaving but somehow you were out. Believe it or not, I didn't have enough money to stay even one more day."

If your ultimate aim is the big, urban art market, then first

build up your reputation; keep records of sales you have made, collectors who have purchased your work, and jurors who have selected your work for competitive exhibitions or awards, as well as copies of press reviews you have received on local shows, brochures, and announcements. Some experience, no matter how modest it may seem to you, always looks better than none at all and can be useful to the dealer in his sales talks with potential customers.

In some ways the out-of-town artist has it easier, for exhibiting and receiving recognition is not as difficult outside the major art centers, as the following cases illustrate the extremes situation. A native New Yorker had just started painting but thought she had it made because she lived in the art center of the world. Having painted all of two pictures, she was already looking for a dealer! By way of contrast, an artist who came to New York from California had spent years showing wherever he could in the West, entering juried shows and winning awards. He had built up a very impressive list of some forty such recognitions before ever approaching the New York market. Needless to say, the Californian found gallery representation; the New Yorker did not.

Visual artists are not alone in the need to appreciate the basic advantage in attaining recognition elsewhere before trying for the top billings in the world's art center. In a recent radio interview, I heard a Canadian pianist, about to present his first New York recital after many years of performances and awards elsewhere, asked why he had not tried New York before. He replied, "I did not come here because I did not feel ready. I wanted to develop more maturity first." His interviewer was obviously impressed at such "unusual self-insight and self-restraint."

Artists in Foreign Countries

A great many artists in countries around the world write to me saying, "Please arrange a one-man show for me in one of the best galleries in New York." Some add a request for a series of shows throughout the United States. Frequently, they have obtained the name and address of the Art Information Center from the United States cultural attache or from a staff member at the American Library in their country—individuals who don't know how to satisfy such requests any better than I do.

The most difficult and poignantly naive inquiries arriving at the Center from artists seeking gallery outlets come from those who live in areas geographically so remote from any major art center that I am at a loss to know what to suggest.

This note came from Ghana: "Exhibition of Drawings and Paintings: I am a 33-year-old Ghanaian (African) lecturer in the Faculty of Art. I am also a practicing painter and have held exhibitions both in Ghana and in London. I paint mostly in oils and gouache—mostly in Ghanaian life—working, dancing, worshiping, marketing, etc. I have quite a number of my paintings on slides . . . Do please let me hear from you as soon as you can. Thanks."

What can I suggest to such a person other than that since he got once to London, maybe he can develop permanent representation in a gallery there and possibly be "found" by a scouting New York dealer—who is most unlikely to scout in Ghana (although this situation may soon change, now that Africa is the "in" place to travel).

An investment company in Australia wrote: "Our present concern is to explore the possibilities of introducing the work of Australian artists to collectors in New York as part of a scheme of exhibitions. The idea is to find a known, good gallery in each of a number of cities who would be prepared to show our Australian collection perhaps once a year and hold a modest stock for sale at other times, act as a centre for enquiries, etc."

It never even occurred to this firm that a "known, good gallery" would have its roster pretty full and would be able to find other worthy artists much closer by; nor had it considered all the freight and insurance costs or realized that a good dealer naturally wants to see originals before making decisions. And suppose he doesn't like them after they have come all that way? Geographic location, when it is remote, does indeed play a part. I hope you don't live *too* far away!

In many cases artists in other countries have never even tried to exhibit at home; they actually seem to expect to start at the top, sight unseen. An artist in France wrote: "I'm an American, but for the past several years have been living here in Provence. Although isolation is good for my work, it is bad in the sense that I have no outside contacts, therefore no way of selling my work, feeding my young family, and buying materials. How is an artist in my position without friends or contacts in New York

ever to find a gallery to represent him? It's a great enough strain just to produce one's work. . . ."

Well, why doesn't he go to Paris, become familiar with some of the hundreds of art galleries there, and then try to show in one? As for the "great enough strain just to produce," I have never seen an artist who does not much prefer to stay in his studio, who does not hate to have to shop for a chance to show. It is just like having to look for a job: an unpleasant task. But it has to be done. However reluctant he may be to accept this fact, if he wants to exhibit, an artist must expect to take some time away from his studio work. He cannot expect to achieve much by sitting home and writing a letter, or to break into the big time with no experience or prior acceptance.

Start Modestly

If you study and explore the gallery situation in the city where you would like to show, you will soon recognize the top galleries by their looks and size, by the kind of catalogs and announcements they issue, and by the size of the ads they take. If you have not yet attained a reputation, don't go to the top galleries and expect to make the grade—even if your work is in their direction. Being most in demand, such galleries are almost certain to have a full roster. When they do have an occasional opening, gallery directors are more likely to "steal" some artist from another, smaller gallery, where that artist has already made some reputation.

Explore the smaller galleries. There is nothing degrading about showing in a small gallery, or in a gallery that is offbeat and not in the geographical area of the top galleries, provided it operates within the accepted professional requirements.

Gallery-hopping is understandably a great outdoor sport for artists, for it is one way to get ahead and move from the lesser- to the better-known galleries. Exposure is important: it is much better to show in a modest gallery than not to show at all. If you are successful there, you may be invited to move up.

A gallery that is newly forming may be worth looking into, for the dealer almost certainly does not yet have a full roster. It is impossible to predict how well he is going to make out or how long he will stay in business. But if you have a chance to talk with him and to gain impressions about his judgment and his taste in selecting his artists, and if you feel that you could have a

good rapport with him, then you have little or nothing to lose by trying such a gallery. Many lasting relationships have developed between dealers and artists who started together on the ground floor. If the relationship doesn't work out and you must look elsewhere, at least you have built up some experience. Dealers, like artists, often start in a modest way. Then, if they are successful, they move into larger quarters in better art neighborhoods, taking their stable of artists with them.

Check the Reliability of New Dealers

Artists naturally like to check the reliability of new dealers, particularly when they are asked to send their work to a dealer who is about to open a gallery somewhere remote from an artist's residence. Many such dealers from various parts of the country come to the Art Information Center to search for new talent. On the basis of the slides they are shown, they go to artists' studios and select work to display. Artists so chosen often call or write the Center to try to learn something about the reliability of the dealer. This is a very difficult question to answer, for there is no Dun & Bradstreet's for art dealers-to-be. I have sometimes suggested that artists write to the curator of the museum in the dealer's city. The curator is likely to know something about the dealer if he has been active in the local art field. New dealers, in or outside New York, would be wise to provide themselves with credentials, including letters or statements that would convince the Center and the artists of their reliability. It is probably too much to hope that chambers of commerce might establish their own reliability checks in their localities.

SHOWING WORK TO DEALERS

I t scares dealers to see an artist entering the gallery with a big package or portfolio of original work. Dealers don't want you to set up work in front of the show they have on their walls, for then customers will not know which is for sale.

Take Slides

Dealers can look much more discreetly at slides or photographs than at originals, or projections. If they are interested, they will suggest a time either for you to bring in originals or for them to visit your studio. If you have an unusual technique or combination of mediums, which is only apparent in the original, then take along a relatively small original example, as well as slide or photographic reproductions. Approximately fifteen to twenty slides of your best recent work is a sufficient number to take. If you arrive with boxes and boxes of slides, the dealer will be alarmed at the thought of having to take the time to look at them all. But if you take only four or five slides, he will not get a sufficient feel of your style.

Although photographic reproductions in color or large transparencies are completely acceptable for this purpose, they are likely to be pretty costly. The 35-mm color slide is most commonly used. Artists who know little or nothing about photography nevertheless take their own, for it is very much less expensive than hiring a professional photographer—who often does not know much about photographing painting or sculpture. If, however, you know a photographer who understands art, and can make some sort of deal with him to shoot slides for you, there is no doubt that such professional work will

improve the look of your reproductions. Some artist organizations that have art-photographer members have successfully worked out this type of arrangement on an exchange or reduced-rate basis.

Artists who are strictly amateur photographers tell me that they get the best results by shooting their work outside, in daylight, when the sun is high. Apparently, the sun is the amateur photographer's best friend; artificial lighting is his Waterloo. I have seen many slides taken in the city that show a bit of roof or fire escape around the edges of the painting. It is a good idea to take three or four shots, with slightly different exposures, of the same work when you have it set up; then you can select the best of them for important use and still have duplicate sets on hand. Slides are pretty inexpensive; so it's wise to be profligate, for you often need more duplicates than you think.

You are apt to have various needs for slides: a dealer may wish to keep slides for a day or two for consideration or to show to a partner; you may wish to send some to the Art Information Center for dealers to see when they go there seeking new talent; you may want to submit work to competitive shows or to curators of museums who ask to see slides first; you may be interested in dealers who act as catalysts for sales to business offices and need a set of slides to show. You should keep a complete additional set for yourself, for you never know when you may need them or if those you have sent out will be returned. As long as you have a full set on hand, you can always have duplicates made at the photography shop. These duplicates will not be quite as accurate in color as original duplicates and will be more costly, but they will nevertheless serve your needs in a pinch.

Label Slides and Take a Viewer
All slides and photographs should always be labeled with the dimensions of the work, the medium (if it is not immediately obvious from the reproduction), the title (if you wish to use a title), and your name. These notations should be made on the frame or margin in the direction in which the slides or photographs are to be viewed; thus you indicate which way to put the slide in a viewer or which way to look at a photograph.

Though most galleries and museums have viewers for 35-mm slides, some don't. Therefore, it is wise to carry some

kind of simple hand viewer. A projector that throws the image up on a wall may scare dealers as much as a huge parcel of originals, for it is equally indiscreet. There are numerous small viewers on the market. I prefer to use the type without batteries which simply utilizes daylight, for the colors in paintings are more true in daylight, and batteries have a tendency to peter out and make the light flicker. The daylight viewer, the most inexpensive kind, is often hard to find, for photography supply stores prefer to sell the ones that cost several times as much. But I find that with persistence—by placing an order and then returning to remind the store about it—I can manage to get a daylight viewer.

If you carry a box of slides, then take a viewer for individual slides to slip in. Try it out before buying, for occasionally there is a distorting flaw in the lens. I have a good one with a Bausch & Lomb lens. For a plastic sheet of slides, the cylindrical type is more serviceable because with it one can view the slides right through the plastic; mine is an Agfa Lupe that magnifies eight times. The stereoscopic viewer—which *does* work by battery—is particularly good for sculpture because it best conveys the three-dimensional aspects.

Take Résumé

In most cases a dealer is more favorably inclined toward an artist if he knows that the artist has had some art experience and background: for the dealer understands that it will be easier to convince a vacillating, unsure purchaser if he can point out that the artist's work has been exhibited here and there, has perhaps been selected by some well-known juror or institution, has perhaps won a prize or two, has chalked up some sales.

For this reason, you should hand the dealer a résumé of your art background, along with the slides, so that he immediately knows that you have had some experience in the field.

Keep the résumé brief—a paragraph or a skeleton outline is enough. I have seen biographical material prepared by artists that went into long flowery discussions of philosophy and esthetics, making it difficult and time-consuming to dig out any actual facts from the dissertation. Dealers do not have time for all this, and they are not interested in your prose style; make it direct and easy for them.

Résumés are probably most effective when organized in outline form and in reverse chronology so that your more recent, more impressive achievements appear first (put your best foot forward) and can immediately catch the dealer's eye. Art education can be relegated to the end. List exhibitions, competitions, awards, and names of jurors who selected your work, for the juror is often more important than the location, providing the dealer with a sales talk. Name some collectors of your work, even those to whom you *gave*, say, a drawing; in this way you indicate you have some following, which could profitably be added to the dealer's mailing lists and potential customers.

Put yourself in the dealer's shoes and remember he cannot be an esthetic philanthropist: he has to be in business for business, for your best interests too. Instead of talking a lot, which only distracts from his concentration on your résumé and slides, let your work speak for you.

Approaching Gallery Directors

A great many dealers dislike making advance appointments by telephone with artists they do not know. An important patron-customer might walk in just at that time they have scheduled to meet with an artist, and then the dealer would be tied down by the appointment. To avoid this, dealers are apt to say, "We are booked up for the next two years," and that is the end of it; that door is closed to you. But if you just go—without an appointment—to a gallery you have selected as appropriate, you can observe whether the dealer is busy, either with a customer or with hanging a show, and, if he is not, approach him. Do show consideration and tact: if the dealer is busy, go away and return another time. I sent an artist to a gallery that might well have proved suitable for his work; and when he got there, the place was being redecorated and was in complete disorder. Nevertheless, this artist approached the dealer, who said, "But we are painting the gallery; you can see the drop cloths all over and the mess I'm in; come another time." In spite of this, the artist insisted, "I must see you now because I'm catching a train in forty-five minutes." The gallery director groaned and looked at slides, but it is unlikely that he would have taken on anyone at such a time. PS. the artist did not get the job.

A certain number of dealers do prefer to make appointments with artists; if you go to their galleries without advance notice,

they are more likely to look at their calendars and make a future appointment than if you use the impersonal telephone. If you have made a trip from some distance and can be in town only a few days, most dealers will considerately make the appointment within the limit of your time span.

Don't spurn a gallery assistant who may ask to see your slides before showing them to the director. A gallery assistant may be a gal Friday who pitches in on every aspect of the gallery's work; she is very seldom just a receptionist with no particular knowledge of the field. Assistants are by no means well paid; they work in galleries less for the money than because they have a vital interest in the field. Although they seldom have any final say, their interest and enthusiasm when they take your slides in to the boss could distinctly be to your advantage.

The best times to go to galleries are, naturally, when the directors are apt to be least busy. In many places Saturday is the big gallery-going day for the public and so is a bad day, at least in the afternoon. On Monday many galleries are closed. Tuesday through Friday is a better time, unless it is apparent that a gallery is hanging a show and preparing for an opening.

Scheduled openings can usually be ascertained ahead of time from the listings of forthcoming shows in the local press, *The Art Gallery's* "Exhibition Guide," or the New York *Art Now: Gallery Guide*. Before visiting a gallery consult one of the listings. Don't go when an opening is scheduled. Directors are not likely to be in their galleries before 10:30 or 11:00 A.M. and usually stay until 5:30 P.M.. Remember that a customer is most important in any dealer's life, so don't try to interrupt his conversations with a customer, even if you have an appointment.

Establish Rapport with Dealers

No two galleries are alike, and dealers cherish their individuality. So don't say to them, "I understand that all dealers" do this or that. Such generalizations will only get their backs up, and they will immediately point out how they differ and how they function on their own quite independent terms and ideas. Don't quote to them the generalizations made in this book.

Unless you are really incapacitated, go yourself to see dealers; don't send a middleman with your slides. All too often an artist is delighted to get out of the ordeal when a relative or friend offers to go for him. But "midwives" are not generally

welcomed; dealers want to know the artist directly, as well as his thoughts and plans. Rapport between artist and dealer can be very important, but it cannot be established by a third person. Wives frequently say to me, "But my husband must stay in his studio and work; if I can find a gallery that shows interest, then he will go to see them." The trouble with this approach is that any potential interest is nipped in the bud.

Just as in any other field of operation, a letter of introduction or a reference from a mutual friend is, of course, useful in seeing a dealer. But with a dealer who is wrong for your type of work, even a letter is not sufficient reason to show your work to that dealer; when both you and he know your work is not suitable for his gallery, the situation can only be embarrassing.

Some Dealers Are More Sympathetic than Others

Many gallery directors are genuinely concerned about artists, realizing how many more good artists there are than there is gallery space to exhibit them. "I have noticed," one dealer said, "how painful it is for an artist to have to go from one gallery to another. But we have virtually no space for a new artist unless one of ours leaves us or we decide we don't want to show him anymore. I think this tight gallery situation should be explained to artists so they won't be too disappointed." To allay the disappointment, dealers often suggest other galleries they think are more suitable for the particular artist's work. Actually, it is unreasonable for an artist to expect such referrals; the dealer, busy with his own gallery, has no reason to be informed about the directions of his competitors. Hence, with the best intentions in the world, he may give you bum steers.

I know one particularly sympathetic dealer who never refuses to look at artists' slides. In order to cope with this task, he asks artists to leave their slides overnight and then puts in many dedicated hours going over them after work. He estimates that about 600 artists come to him each season, many of whom are quite unsuited to his direction.

At the other end of the scale are some dealers who will not look at any artist's work. They have become too discouraged by the great waste of time involved. Most dealers fall between these two extremes and look at work some of the time—especially when there is a possibility that they might be able to exhibit a new artist.

If a dealer shows real interest in your work—and this is not hard to recognize—but regrets he has no room, then make a note to yourself to return to the gallery two or three months later, or, better yet, during the last half of May. Most contracts or agreements between dealers and their artists are for the season. If an artist is going to leave for another gallery the following fall, he must notify his dealer prior to summer vacation. Dealers usually make up the following season's schedule before they close for the summer. Even if an artist knows, say, in March that he is going to leave his gallery at the end of his contract, he is unlikely to create friction by saying so until near the close of the contract season. So a dealer is more likely to know about a gap toward the end of the art season than at any other time of the year. On your second visit you might take slides of some new work as an excuse to remind the dealer of your existence.

Temperament

Both artists and dealers are widely reputed to be temperamental. Sometimes dealers may seem more temperamental than artists; perhaps they are frustrated artists who do not have the outlet for self-expression that artists have. But a whimsical, impractical artist can be the bane of existence to a dealer who is efficient and businesslike. The following examples may seem extreme and exaggerated, but they are true.

A sculptor arranged with a dealer for a show of her work, and after it was installed, she told the dealer that she could not allow anything to be sold because the sculptures all fitted into her luxurious suburban home so well that she could not live without them. It had never occurred to this woman's dealer to require a written statement that he could sell the sculpture. Perhaps he should have, for I have heard a number of artists say, "I am not particularly interested in sales; I just want to have a one-man show and establish a professional reputation." It is a good idea to remember that galleries are "dealing"; they must make a living; they are not in business merely to promote the artist's own prestige.

A well-known, seasoned artist who had an exclusive contract with an established gallery was invited to join another, larger gallery in the middle of his contract year. Although he had been around long enough to know better, he blithely accepted

the new offer and was chagrined to find that he had to face a lawsuit, which he quite rightly lost.

Precision in Inquiries

If artists and dealers are considered vague, temperamental, and imprecise, certain would-be purchasers can top them any day. How would you answer a note like the one that arrived at the Art Information Center, sent from Connecticut: "My husband and I are interested in buying an oil painting. We would like something large, approximately 24" × 36", or 30" × 40", and hope to find one in a semi-abstract or impressionist style at a moderate cost"? Or this inquiry from an Arizona motel: "We would like very much to get information and brochures on large steel figures, true form rather than geometric. We have in mind objects that are over ten feet high"?

The inexplicit aspect becomes much more incredible when a professional in the field, the art director of a midwestern institution, can write with such imprecision: "We intend to present a major Art Gallery, in which we hope to display the finest art works available. I hope you will send me whatever information you can provide on the many aspects of Contemporary Art. Our gallery intends to exhibit the finest Art of a local, national, international nature and I eagerly await your reply." Even the Queens housewife contemplating her first art purchase was much more direct and to the point: should she buy "a beautiful hand-painted head of a gypsy, all framed, for $75? "I like it," she said, "but I want to know whether it will increase in value in a couple of years."

Nothing is more frustrating and annoying than such vague, general inquiries—"What do you do?" "What services do you offer?"—*You* need to explain what *you* do and what *your* interests are. Which can only be answered with an entire thesis.

Whether you request information from the Art Information Center, from a gallery or museum, from a foundation, or whatever, you can expect a sensible, informative reply only if you state your queries in a specific and sensible way. Know exactly what you want; ask for it simply and clearly. You'll be gratified by the response.

BUSINESS TERMS
AND AGREEMENTS

Always get a written receipt for any original work you leave with a dealer on consignment; it should specify each individual work. Asking for a receipt is not a reflection on his integrity, it is simply good business practice. This receipt is your *only* proof that the works are your property; otherwise it is your word against his. Anyone can go bankrupt, which means your works could be sold to pay the dealer's back rent.

Receipts and the Law

In New York State a law was passed in 1966 (amended in 1969) making it illegal to abscond with any work of art, or the proceeds of sale, for which the artist holds a receipt. Under this law the district attorney can prosecute a dealer for larceny if he wrongfully withholds an artist's work left on consignment, or the proceeds of sale. Even if the dealer has left the state, he can be extradited for prosecution. Of course the enforcement of the criminal aspects of the law depends upon the functioning of the district attorney, whose calendar is often loaded with cases he may consider more pressing than matters relating to art.

Nevertheless, this law takes a big step in the direction of protection for the artist. New York was the first state to pass such legislation, as well as a 1975 law exempting works consigned to a dealer (which is proved by your receipt) from seizure and sale by creditors if the dealer goes into bankruptcy. It is to be hoped that art organizations, artists, dealers, and museums will press for legislative action throughout the nation. Meanwhile, if you have trouble with a New York State dealer who has disappeared with your work, get in touch with your

local district attorney or with the Consumer Protection Division of the State Attorney General's Office. If you encounter difficulty with a dealer anywhere in the country who is a member of the Art Dealers' Association, its legal division will give prompt attention to your complaint, for the association is most anxious to maintain a good public image.

Insurance

When you consign work to a dealer, ask him what insurance value he can place on it. Some dealers carry no insurance on work while it remains in the gallery, leaving the artist entirely responsible for insuring his work. But many galleries insure for a percentage of value, covering only the time during which the work is on their premises. A great many artists carry Inland Marine policies on their work so that even though they are unlikely to have full-value coverage, they do have some additional protection on their own. The policy can insure wherever the work is—in studio, gallery, friend's house, or truck—and is often known as an "art floater" policy.

If you know for how much the dealer will insure your work while it is in the gallery (often he will write this down on your receipt), then you can decide whether you wish to carry more or less supplementary insurance yourself.

Art thievery has increased alarmingly in recent years, and insurance is proportionately harder to obtain. Reportedly there are international rings of organized bandits who know profitable outlets for stolen works of art, often in other countries. It has been said that they are even instructed by purchasers to steal particular works. There have been many news reports about cases involving the theft of famous art.

What is less recognized is that inexpensive works by relatively unknown artists may also be victims. Insurance companies generally will not cover any art shipped through Kennedy or O'Hare airports because of their high incidence of thefts. Even a work labeled "insured for $100" (packages are required to be labeled on the outside with value of contents) may be taken for the few dollars it could bring on the "hot" market.

It is still possible, however, to obtain art insurance in most areas outside major centers like New York and Chicago. Moreover, the entire theft situation may improve—and with it the insurance picture—if the International Art Registry, Ltd.,

succeeds in "fingerprinting" enough works of art, using the ingenious coding method described in Chapter 18.

Transportation

Shipping and cartage costs are almost always the artist's responsibility. Of course, in many cases the solution is simply a matter of borrowing a friend's station wagon. But when work must be sent to exhibitions and competitions, the shipper's costs, both ways, must usually be paid by the artist. In addition to regular air-freight lines, artists generally use the Postal Service, United Parcel Service, and the package express services of the Greyhound and Trailways bus companies. It is wise to do some comparative shopping among them all to discover which best serves your particular needs and the areas involved. On the other hand, when a dealer in Montreal, for example, wants to show work by an artist in New York, he may well offer to pay transportation either both ways or one way. How many concessions he is willing to make depends on how eager he is to show the work. If a dealer is anxious to import large or heavy material from abroad, he may have to split shipping costs, which might otherwise be prohibitive for the artist.

Sculpture Bases, Frames, Installation

Although many dealers supply all, or at least some, of the sculpture bases needed, virtually none supply or pay for frames. This practice is quite logical and understandable from a practical point of view, for a dealer who regularly shows sculpture will have bases on hand, whereas an artist who shows paintings has usually already framed them. If shipping with frames would be costly, the dealer will have the framing done on arrival but will send the bill to the artist. In general, frames need not be elaborate; many artists simply apply stripping themselves. Most installation costs are carried by the gallery. But if an artist's work requires unusual or special equipment, he may be expected to bring it from his studio or to pay at least part of the cost of having it constructed.

Commissions

There are still galleries around the United States whose regular sales commission rate is 33⅓%, but they are becoming fewer and fewer. Most galleries, especially those in New York, charge

at least 40% on paintings and sculpture, and 50% on graphics or other work executed on paper or any other fragile material. Fragile work has a shorter life expectancy, so must be sold at lower prices; but it takes up the same space as comparable works of greater durability, and the dealer must put in the same amount of work to exhibit it, so he may very well require a higher commission. With constant inflation, more and more galleries are pushing up to a 50% minimum commission on all sales, for, as with everything else that has increased in price, dealers' commissions have risen, along with their costs. When a modest-sized New York gallery rents for $90,000 per year (probably more by the time this is printed), one can well wonder how the dealer can sell enough to cover costs.

Be prepared, then, to pay these commissions to your dealer on sales. If you find a reliable dealer who charges less, you are just lucky. Some dealers, who assume part of the costs usually billed to the artist, take a still higher percentage. The few gallery directors who still charge a 33⅓% commission usually have to make up the difference in various additional costs to the artist. In most cases you can't win.

Work Left on Trial

Most dealers take work by living artists on consignment. This means that whether you are asked to leave work on a trial basis, for a group show or for a one-man show, the dealer pays you nothing until the work is sold.

Remember that most established galleries are booked quite far ahead with one-man shows of work by their roster of artists. Probably the best they can offer you at first is the opportunity to leave a few things on trial. A dealer can properly handle only about two dozen affiliated artists because he is expected to give each of them a one-man show every two or three years, as well as holding two or three group shows of their work each season. This obligation fills the art-season calendar, which runs roughly from late September to early June. If the dealer takes on too many artists, he cannot do right by them or their needs for proper exposure.

One long-established New York gallery found itself in a real predicament because its owner was too generous about taking on artists. When the owner died, his heirs found a roster of

forty artists—meaning that each one could have a show only about every four years, which is just not enough exposure for an artist who has "arrived." The new owners frankly explained their dilemma to the artists, urging them to try to find other galleries. They offered to help their artists in every way possible and to continue to represent and back them until they could find outlets able to give them more frequent attention.

Even if you have previously held exhibitions elsewhere, a dealer generally wants to see how his particular clientele reacts to your work. If the dealer takes work on trial and sells some in two or three months, he will doubtless ask for more; if not, he will probably suggest that you take it back. He many not even hang it or show it publicly; he may have in mind some particular customers whom he will invite to see the work in the gallery's backroom. This way of proceeding can be of distinct value to the artist, for many of the best sales are made in the backroom. Good customers can influence a dealer's decision about acceptance; sales often lead to a request from the dealer for more work to show out front.

Group Shows

In addition to the annual group shows of work by their regular artists, many dealers also hold group exhibitions of guest artists whose work interests them. These shows, frequently scheduled for off-peak seasons such as late May, June, or early September, are also a kind of trial run to see how the new work will be received.

In any group show the work is definitely shown out front in the gallery. Moreover, the show is often publicized by the dealer; occasionally there are some press notices about it. Success with such new work, in public and press response and in sales, can mean that you will be taken into the gallery's roster as soon as the next opening occurs. If you are asked to leave work either on trial or for a guest group show, do not stop there. It is a good idea to continue to see all the galleries that you have analyzed as suitable for your work. Dealers who have your work on trial do not expect exclusivity. You are completely at liberty to show elsewhere at the same time, without creating any prejudice by so doing. You may get additional similar opportunities, thus achieving more exposure, and quite possibly more

sales and recognition. Furthermore, you may thus have a chance to see which of several galleries works best with your particular art form, and which has the better clientele for it.

Dealers will object, however, if you permit price undercutting by another gallery, particularly in the same geographical area.

One-Man Shows

Once you are asked to have a one-man show, the dealer doubtless wishes to consider you a regular member of his gallery's stable. Occasionally, there are guest one-man shows; but these are rare events, for dealers are more apt to reserve this top recognition for artists who are definitely affiliated with them through some sort of contract or verbal agreement.

If you accept a dealer's offer of a one-man show, he will then almost certainly expect you to pull in your work from other galleries and enter into an exclusive agreement with him covering the year during which the one-man show is to take place.

Contracts

It doesn't matter whether a contract is printed in legal language, made through an exchange of letters, or verbally agreed on. In all cases the contract is considered binding. One highly reliable dealer in New York wrote to me: "I have found that it is best to deal with artists on the basis of mutual understanding and trust. I do not believe in 'contracts' because a contract is only as good as the two people signing it. Since I would never sue an artist in court, I would not find a contract meaningful. However, for the artist's protection of his work, I insist upon giving the following agreement to each artist when he first joins the gallery." And there followed a pretty comprehensive set of arrangements.

Particularly for a newcomer, it is more satisfactory and protective to have something in writing. If your dealer has no contract or agreement form, and you have merely discussed the terms of your agreement, go home and write a letter outlining what you feel to be your understanding of the agreement. Keep a carbon copy for yourself. If you have misunderstood or misrepresented any terms in the letter, the dealer will surely let you know the corrections. Keep these documents as your binding agreement.

Read every word of anything you sign. Some artists, elated at the thought of obtaining a one-man show or shy at the thought of seeming to doubt their "benefactor" dealer by scrutinizing the papers, have later found out some sorrowful factors to which they have bound themselves legally. Most good dealers will have more respect, not less, for the artist who takes time to go over a contract carefully, ask questions, and clarify points.

Artists' Equity Association, Inc., issues a form contract, a receipt form, and a bill of sale for the guidance of artists. You would do well to scrutinize these models which are available free to members from the Association's headquarters. Keep in mind, however, that these forms are drawn up primarily from the point of view of the artist. Certain of their terms—such as complete coverage by the dealer of all costs of a one-man show, and full value insurance by the dealer—are rather more idealistic than realistic, for they are rarely achieved. For a more typical contract form, see Chapter 20.

Terms of Contracts

Terms of contracts or agreements should cover the following:

Length of period during which the dealer is to act as your sales representative. Usually contracts are for one year. Some dealers, however, prefer two-year agreements when the artist is relatively unknown. They feel that investments in publicity, and groundwork laid, during the first year do not pay off until the following season.

Percentage of commission to gallery on sales. In the large art centers the sales commission is generally 40% to 50% on painting and sculpture and 50% on anything on paper, but there may be a few areas where the old 33⅓% commission is still retained. If the commission asked by a dealer is less than the normal going rate, scrutinize other terms and costs to make sure that you are not paying too much out of pocket to make up the differences in the commission. A gallery that asks only 25%, for example, may not base its business on making many sales, an arrangement that is not to your benefit. A gallery asking a low commission can be even more suspect than a gallery that charges more than the standard 40% to 50%. A few of the country's larger galleries, which handle high-priced, well-known artists, charge 55%. However, these galleries then take care of part of the

other costs usually charged to the artist, of widespread promotion, show distribution, and other activities for their artists.

Some contracts spell out the usually accepted agreement that the dealer receives no commissions on prizes or awards granted to the artist but does receive commission on a purchase prize. Charitable sales are generally exempt from commission unless the artist has received his full price. Full-price payment is unusual, for the soliciting charities may request that the artist split the sales price with them on a fifty-fifty basis, or perhaps with 75% going to the artist. With the increased cachet of contemporary art in the world of society, these requests from charities have become so numerous in recent years that many dealers have clamped down on granting any of them—not only because they receive no commission on such sales but also because they feel that their artists are being victimized. The charitable organization ladies have been all too prone to take the attitude, "We're not asking you for money, just for some of your work," with no apparent realization that an artist's work is his livelihood. Recently, however, this attitude has changed considerably, probably because artists and their organizations have gotten their backs up against such exploitation. More and more charity shows now suggest 75% to the artist, 25% to the charity. This arrangement can be beneficial to the artist, in both income and exposure to potential collectors.

Sometimes an artist is taken in unwittingly by an "invitation" to enter a show, inclusion in which is presented as an honor. An artist friend of mine answered such an invitation from a well-known print club that said it had obtained exhibition space in an established New York print gallery. The invitation did not mention commissions. He sent a large engraving, which he priced at $45. Soon he was notified that it had been sold. Later, he received a check for only $15, along with a statement that the gallery had taken one third and the print club had taken another third. He said he certainly would never have sent the print had he known he was inadvertently making a "charitable" contribution to the well-established print club.

The case of contributions of work to an art sale for a politician's campaign fund is entirely different. Dealers are not apt to intervene in an artist's political activities. There are no proceeds at all to artist or dealer if an artist donates work for this purpose. It is against federal law for anyone other than the cam-

paigner to receive payment from any political campaign activity. The donation must be complete and total.

Extent of exclusivity. By geography, exclusivity varies according to the gallery's outside contacts. Often the exclusivity required is just for the city and its environs; you are free to show and sell anywhere else without paying your dealer a commission. Often, however, exclusivity covers the whole of the United States. Sometimes it is worldwide—particularly if the gallery has branches abroad or exchange arrangements with foreign galleries. Geographical exclusivity does not mean that an artist cannot show elsewhere. Out-of-town shows are often arranged either by the dealer or the artist. In these cases, your dealer must agree to the exhibition, and the out-of-town dealer must agree to give credit in the catalog to your dealer and to split the sales commission with him, which means no extra charge to you. Your dealer invariably expects you to pay him his full regular commission on sales you make from your studio, or on any other sales made without the assistance of the gallery. You may give work to your friends, but you may not sell to them less the dealer's commission. Perhaps you wonder why. It is apparent that sales are definitely related to reputation, and your dealer, by showing your work and having your name promoted in connection with his gallery, has presumably enhanced your chances for sales. Moreover, many a dealer has found out by sad experience that both collectors buying and artists selling are all too prone to bypass the dealer's commission, no matter how much work and effort he has expended.

Exclusivity terms may also specify mediums. That is, many galleries make exceptions in their totality of representation for work such as prints or other multiple productions. If their own chief interest lies in your major work, they do not want to take up time and space with many less expensive items. In such cases, they are quite willing to state that you may also be represented by a print or multiples gallery. Occasionally, galleries also waive their rights to small works. For some years there was a gallery in New York for small paintings and sculptures only, every member of which had to have another, "regular," gallery in order to belong. This, of course, meant that the regular gallery had given its permission in each case.

Time of one-man show. The length of your show should be stipu-

lated in your contract or agreement. Normally, a one-man show should run for about three weeks. Dealers have learned by experience that it takes about this long for the show to pay off after it has caught on. Sometimes dealers suggest ten-day shows, usually because they want to make at least part of their income from a fast turnover of fees from artists, part of which may go into their pockets instead of into legitimate costs for the artist, a nonprofessional procedure.

Frequently the date, or at least the month, of the show is also stipulated. The usual times for scheduling one-man shows are October and November, and from January to mid-May. In December most dealers have group shows of work by their affiliated artists, exhibiting small pieces, watercolors, prints, drawings—items likely to appeal as Christmas gifts. Now and then some expensive artists have refused to have their shows in January or February on the theory that too many well-heeled collectors are off in Florida at that time. But very few people feel that this is a serious consideration, particularly in view of the fact that nowadays winter vacations are taken just about any time during the season.

Many agreements also mention that in addition to the one-man show, your work will always be represented in each gallery group show, and that a few works will be kept on hand at all times, in gallery bins, to be shown on request.

Prices and payments. Frequently contracts state that after sales prices have been mutually agreed upon nothing will be sold at a lower price without the artist's consent. Frequently, also, it is stipulated that the money the dealer receives from sales is held in trust, and that payment will be made in a reasonable time— perhaps fifteen days after final payment or perhaps regularly once a month.

Commercial use of art and reproduction rights. Commercial uses of works of fine art are becoming more and more frequent. Artists and dealers, therefore, are increasingly aware of the need for protection. If you registered your work with the Copyright Office after the revised law went into effect on January 1, 1978, you have automatic protection, for all reproduction rights remain with the creator/copyright holder even after the original has been sold. But for work not officially copyrighted (see Chapter 8), it is now quite common for dealers to stipulate in their agreements that they will at no time sell an artist's work

with reproduction rights for commercial use unless such rights are additionally purchased, and then only with the artist's permission. Thus, if an artist does not wish to see his noncopyrighted painting decorating an insurance company's promotion calendar, he can refuse to allow it to be reproduced, even though the insurance company purchased the painting. If he does not object to this arrangement, he will receive royalties or some other additional reimbursement. Most dealers now require a purchaser, commercial or otherwise, to sign an acknowledgment that the sale is made only on the understanding that all reproduction rights belong to the artist. If the dealer has arranged the sale, and if the artist gives his consent to reproduction, the dealer will expect 10% to 20% commission on any additional funds.

These understandings and agreements may well be spelled out in the contract. If the artist made contracts for reproduction payments prior to any gallery agreement, the dealer should not cash in on them; but in this case you had better see that the dealer contract states your rights to the full amount of these reproduction fees.

There are cases, such as for educational uses, when charges for reproduction rights are waived by the artist and his dealer, who are glad to help some professor illustrate his textbook. I see no reason why a modest charge should not be made even for educational books, for, though not on the best-seller lists, they often sell steadily for years. But this decision is entirely up to the artist under the usual contract clause covering this contingency.

Expenses. In addition to the costs of suitable framing, transportation, and insurance expected of all exhibiting artists, the contract usually states that the artist must pay all publicity expenses—but for a one-man show *only*. These expenses will probably be the largest of all (they are likely to come to a minimum of $1,000 in New York). But you are not apt to achieve a one-man show until you have already sold work left on trial or have exhibited in a group show (where you should not pay for publicity). Consequently, you will probably not have to face the publicity costs of the one-man show until after you have collected some funds to defray them.

Publicity costs usually include advertisements, a brochure with some reproductions, mailing, photographs for the press, and in some cases, an invitation and preview. Charges should

not include rent, light, heat, or a secretary's salary. You should be able to see the actual bills for these out-of-pocket expenditures, so that you will know just where your money went, and that it did not go into the dealer's pocket as a fee.

In many cases the dealer will consult the artist on publicity and will accordingly place larger or smaller ads, prepare an elegant or simple brochure, and cut down on or eliminate the preview to accommodate the artist's pocketbook and desires. But in many other instances dealers have contracts with publications for ads and these must be fulfilled; they have a regular size and format for brochures to be published in similar form as a kind of "signature" of the gallery; they have a standard type of preview. In such cases you are not in a position to dictate or argue; you have to take it or leave it, for the dealer is privileged to run his gallery as he sees fit. If you cannot afford the particular dealer's outlay on publicity, then you must try to get another dealer with a less "elegant" approach. The contract generally demands these payments in advance, so you cannot wait for sales from your one-man show to cover them.

There is a very wide range in outlay for publicity among galleries, depending on the individual dealer's practices and potentials. What the artist must pay for publicity also varies according to his reputation and his sales record. The better known and the more financially successful you become for yourself and your dealer, the more likely he will be to absorb at least some of the costs.

Contracts frequently state that the dealer agrees to pay for packing and shipping work to clients, and mention the percentage of total value he is willing to insure for, against loss or damage in the gallery only.

Cancellation of agreement. Most contracts are binding to the end of the stipulated period. At that time they may or may not be renewed by a further agreement. Some dealers, however, state that the contract may be cancelled by either party with a stipulated amount of notice, provided that printing for a show has not already been done and advertisements have not already been placed.

Preliminary Arrangements for a One-Man Show
Once the contract is signed, your dealer will probably come to your studio and select the work he wants to include in your

show. Usually, he will discuss the selection and be guided by your judgment, as well as his own. I have known of cases though, like that of an artist noted for his sculpture, who also wanted to exhibit his paintings. The dealer refused, feeling that the artist was inferior in his more recently developed medium and that showing this work would only be damaging to both their reputations. Some years later, in another gallery, the artist had his way; the general critical evaluation indicated that the first dealer had been acute in his prediction.

You may have to send most of your exhibition items to the gallery a month or six weeks before the opening so that critics of the art monthlies can preview them. Critics must see work this far in advance if their reviews are to appear at the time of your show. Most reviewers do not have time to go to studios. If the gallery is cramped for storage space, you may have to take the work back to your studio again until the time for its installation. Although your dealer will have a mailing list for both press and customers, he will undoubtedly request your own mailing list of friends and collectors or will ask you how many additional brochures you want printed to send to your mailing list. In many cases artists mail out their own lists, often adding notes of a personal nature to the brochure or announcement mailed.

Your dealer may wish to expand somewhat your brief résumé for biographical information to appear in the catalog and press release, and to use any good quotations available from your reviews. He will expect you to provide quality 8″ × 10″ glossy photographs of a half dozen of the works to be shown, perhaps with three or four copies of each. For this purpose it is probably advisable to use a professional photographer. The photographs will be mailed to a few selected publications in hopes that they will be reproduced; others will be kept at the gallery for critics who come to your show.

Critics and Reviews

Critics are people whom everyone shakes a fist at, except on the rare occasion of a good review. Not that critics always, or even most of the time, write bad reviews; it's just that they don't write any at all about so many shows. There are too many shows and too few critics.

How to get on their priority list is a chronic dilemma. Many different approaches are tried: irate letters to the editor; need-

ing telephone calls to the art department; a plethora of photographs and other material bombarding them in the mails; pleading and wheedling, excoriating and threatening. Critics nevertheless go their way, probably with no priority lists at all and with no regard for these numerous appeals. Often it is apparent that to some extent they go their way geographically, for reviews will appear on shows in galleries that are geographically close: one may assume that critics' feet get tired too. No matter how critics select what they cover, there are always many artists and dealers who are certain that their shows were far more worthwile and deserving than those reviewed. Old-timers consequently tend to relax, shrug their shoulders, and expect nothing. If a review does happen to appear, it is a great and unexpected event. Wherever you are, in large or small city, it's a good idea for you or your dealer—but not both, and preferably the dealer—to call members of the art press well ahead, to ask them when they would like to have an advance viewing, at the gallery or the studio.

Many publications carry listings of openings as an editorial service not paid for as an ad. Usually it is not hard to get a show listed if the information is sent before the deadline; and these listings, even if they make no critical comment, do help to guide people to your show. There are some little publications that will carry reviews if the shows are advertised in their papers.

You should put into a portfolio copies of whatever write-ups you get, along with other printed material such as brochures, announcements, and press releases about your work. You never know when you may want to approach another dealer; although some dealers want only to look at work, others do want to see such records when considering the possibility of handling your work. Some dealers like to keep portfolios of this nature in the gallery to show to prospective customers and to visiting press.

Installation and Preview
Dealers often welcome the assistance of the artist in installing a show. Time is very short: in a typical situation, the previous show closes on Saturday at 5:30 or 6:00 P.M.; your show opens on Tuesday afternoon. All dismantling and disposal of the previous show, refurbishing of gallery walls (nail-holes, paint scratches), as well as complete installation and labeling of your show, must be done on Sunday and Monday. Occasionally,

however, a dealer has his own special way of working or a special display technique, preferring to install the show by himself, with assistance from just his own staff.

For your preview there may be a party at which drinks are served, but just as often there is no party. Because Saturday is the biggest gallery-going day for the public, some dealers who do not wish to hold parties or stay open into the evening simply announce that each new show will have its opening on a Saturday, throughout the day, in which case they install on the preceding Thursday and Friday. In some cases geography plays a part in coincidental openings: galleries agree to coordinate them to make it easier and more appealing for gallery-goers, enabling them to see several shows in the same area.

When parties are held, the preview costs to be paid by the artist may include overtime for an elevator operator, and perhaps the hiring of a bartender—often a cheery college student who dons a white jacket, becomes proficient at the bar, and loves to be included in conversations of guests. Often a gallery assistant or a friend will take on these duties. Hard liquor and snacks are sometimes served; frequently it is simply white wine and cheese. The party has become something of a problem because of the "floater" and "hanger-on" element that drifts from one gallery party to another just for free drinks. There is actually a firm in New York that, for a "subscription" fee, will tell you by phone where free drinks are being served on any given night. Frequently, when leaving a gallery opening, you will hear someone announce, in an elevator full of gallery-goers, "They are serving hard liquor at such-and-such gallery." Naturally, both dealer and artist would prefer to be delivered from these elements and the costs incurred by them, as well as the atmosphere often imported by them. Some galleries issue invitations that must be shown at the door; others avoid the problem by serving nothing. In the latter case, it is not uncommon for the dealer or the artist to invite friends to cocktails or a buffet supper, at home or in a restaurant, thus entertaining only those to whom they wish to give official recognition or special consideration.

Commissions for Murals, Portraits, Architectural Sculpture, Monuments

Alert dealers always keep an ear to the ground for possible commissions for their artists, and many have mailing and tele-

phone lists of architects and interior designers to use when appropriate. But don't count on it. If you know any architects likely to commission sculpture, murals, or monuments in a vein that harmonizes with your work, check with your dealer to be sure his lists of contacts include those you know.

Look in the library at recent copies of the architectural magazines to see which architects have used in their constructions the kind of art you might supply; consult the *Dodge Reports* and the city building commissioners for new plans in your area and which architects are participating in them. Don't go to them directly unless you first arrange to do so with your dealer, for you then might duplicate and interfere with his efforts, and he would be justifiably angry. Once you have a dealer representing you, it is always you who must check with him before making any move aimed at contacts for sales: for this is his province, so he is expected to go about his business without checking with you.

Periodically two or three architects from an important firm "go shopping" in galleries for art to enhance a new building project. Such a visit usually puts the dealers into a tizzy of delight, with great hopes for "something big" to result. It is amazing how small the big art world can be. Word of these visits usually spreads like wildfire, and the architects are bombarded with calls from dealers not visited: "Please come to see my artists, too."

A number of galleries have developed in the cities especially to serve the interior design and decorator field. Some of those dealers have their own rosters of artists, give one-man shows, and operate as regular galleries. Others show work by artists with different gallery affiliations, split commissions on sales, never give one-man shows, and concentrate on placing work in "the trade." Many also show unaffiliated artists, but these galleries ask no exclusivity. There are private dealers who have no galleries but act as clearinghouses and catalysts in selling art to business firms and corporations. They hold no shows but work with sets of slides; they charge no fees other than the normal commission on actual sales. Frequently, these specialty dealers sell in quantity—for example, to a firm buying a painting for each office on three entire floors of a new, large office building. They also obtain mural commissions for new hospital wings and new apartment buildings through working with the interior design consultants for the buildings.

Apparently, not all such consultants always consult. In one instance, a large abstract mural was commissioned for the entire length of the lobby in a new apartment building. Two weeks after installation, the landlord appeared for the first time, gave forth the edict that it was horrible, and ordered it completely covered with canvas. The tenants then complained bitterly: they did not like canvas, they did like the colorful abstract mural. The tenants won. The canvas cover came down. The artist had already been paid; even so, he naturally was much happier to have his work seen and to receive popular backing for it.

Many of the firms selling furniture and interior accessories also welcome the opportunity to display some paintings and sculpture suitable to their line. They may borrow from art galleries and refer purchasers to them, asking no commission. They may show and sell work by unaffiliated artists if the work seem to have a rapport with their display rooms. Price labels are attached so their customers know the art is for sale; and when they sell, they take only a small commission, perhaps 10%, for handling costs. If these displays lead to commissions, the artist usually takes over on his own, with a nice thank-you to the furnishings firm. Sometimes interior decorators make purchases for their clients directly from an artist who has no gallery agreement; payment in some instances may be very good.

Although it is often the architects themselves who commission architectural sculpture and murals, some years ago they aparently were at a loss to know how to go about this. One well-known head of a large architectural firm called me about a huge sculpture he wanted to place outside a high-rise office building; it had to be big enough not to look dwarfed by the building. Where could he go to see work from which to select? Since this obviously called for a sculpture several stories high, I pointed out to him that he could scarcely expect to find already completed work in sculptors' studios, that he would have to commission such a piece. He could start with several sculptors whose work seemed suitable and ask for a maquette from each. Of course, he must pay for all the maquettes; but then he could choose the one that looked best beside the scale model of the building, and commission that one for execution, with no further obligation to the other artists who submitted maquettes.

Today architects are much more aware of these procedures, for it has become *de rigueur* for buildings of any importance to

contain works of fine art. Moreover, museum curators in recent years have often aided architects in these matters, in exchange for a tax-deductible contribution to the museum. The American Federation of Arts offers a regular consultant service of this nature to architects and business firms of all kinds.

These practices have been questioned, particularly by Artists' Equity Association and other artist organizations, which prefer selections to be made by competition or by specially selected art committees: for in assuming the position of "tastemaker" a museum or other organization opens up possibilities of a "favorite" list of artists to be recommended, of conflicts of interest in personnel, or of art collections of trustees and curators that would increase in value were the same artists to receive important commissions. Yet—in the past at least—these activities have helped to spread commissions among many artists; formerly there was a great tendency to employ the same ones over and over. A firm desiring a sculpture on its building was loath to stick its corporate neck out in a field unknown to it, and hence would hire the same sculptor already used by other firms because he seemed "safe."

The Business Committee for the Arts, with former Secretary of the United States Treasury C. Douglas Dillon as its first chairman, was established in 1967 to act as a catalyst between business firms and the arts. A good deal of its attention focuses on the performing arts. However, the committee manifests considerable interest in corporate collections and art commissions.

Further developments relating business and the arts are sure to be an important part of the future. If these potential opportunities interest you, follow the local press to learn what is happening in your geographic area. These developments will undoubtedly be publicized and reported. The firms involved will see to that: they have energetic publicity offices, and they are good advertisers (see Chapter 9).

There are various organizations that help artists to obtain commissions. The National Sculpture Society holds competitions and exhibitions (especially of architectural sculpture), accepting work by nonmembers for some of its shows. It gives prizes, including youth awards for sculpture by artists under forty-five, and three honor medals—to owner, architect, and sculptor—for the year's best architectural sculpture. It offers a consultant service for monuments. The National Society of

Mural Painters organizes traveling shows of "work sheets," and photographs of murals in situ.

Portraits, Inc., is a gallery with a roster of artists specializing in portrait painting; in addition, the gallery also acts as agent for mural commissions.

In spite of the enormous invasion of photography into the field, portraits in the various mediums are still commissioned quite frequently. Although many galleries show occasional portraits along with other kinds of work by their artists, and Portraits, Inc., specializes in this field in New York, it is probably a safe guess that portrait painters and sculptors obtain more commissions on their own than through dealers. Portraiture is a field that is perhaps more self-generating than any other; because of the personal nature of the portrait, the satisfied subject is apt to become your best salesman, and one commission tends to lead to another.

The Dealer's Percentage

The percentage charged by dealers on outside commissions varies considerably, usually in proportion to how much the dealer contributes to obtaining the commission for the artist. If he is entirely responsible for it, he will probably expect the same 40% to 50% as on other sales. If he advances cash to the artist to enable him to work on the commission, he may expect more, as in other situations where the artist receives an advance. If the artist obtains the commission entirely on his own, his dealer may expect only 10% or 15%, though some galleries require a minimum of 33⅓% on all commissions, regardless of their role.

In some cases where there are exceptional costs to the artist for materials or assistants, the dealer may take less, or he may base his percentage on the net amount of the commission after expenses. The Boston Visual Artists' Union has worked out what it calls the Boston Method, whereby steep production costs for large sculptures, murals, or tapestries are subtracted *before* the dealer figures his commission. Why, the union argues, should the dealer get a commission on a bronze-casting bill, thus forcing up prices and discouraging commissions—a situation not good for either artist or dealer.

Special Portfolio

If you want to work on commissioned projects, you will be wise to prepare, and keep up to date, a special portfolio. This

portfolio should contain reproductions of commissioned works already executed (if any), as well as proposals, sketches, maquettes, and other pertinent material, including portraits if you are a portrait painter. If you cull this specialized work from your total output, you or your dealer can use the portfolio as an effective presentation.

Reproductions

When commercial firms purchase works of art along with reproduction rights (providing the artist consents), they often do so for product advertising or for use on prestige promotion pieces to be given away. In either case, they are more likely to buy these rights from the artist on the basis of an outright sum rather than royalty, a sum that is perhaps double or triple the price of the original work.

If a firm is buying reproduction rights for a work belonging to a museum whose name will appear on the reproduction, the museum's permission, as well as the artist's, must be obtained. Both the museum and the artist should have the right to see its preliminary layout and copy to determine whether the presentation will be sufficiently dignified before agreeing to its use. Many artists and museums object to the imprinting of any copy over, or intruding into, the reproduction of the work of art. Many insist on at least a thin strip of "frame" around a reproduction of a painting, unless it is a detail where there is more of the painting beyond the "bleed" edge. Paintings are in general conceived to be within frames, so your composition will be destroyed if a reproduction of it does not enclose it properly. For reproductions of sculpture, this does not apply, and they are sometimes best shown in silhouette.

Both the artist's and the museum's names should appear in conjunction with the reproduction, and on the same page, not in a credit box somewhere else in the publication. Because such uses are usually predicated on the prestige value of the museum's name, and because museums are proverbially in need of funds, the museum frequently requires the firm to pay it a sum equal to that paid to the artist for these rights.

On the other hand, payment to a dealer who makes such an arrangement for an artist would perhaps be only 15% to 20%, for a business firm is not interested in buying the use of another business name. When reproduction is for strictly commercial

purposes, the fee can go much higher than it does for illustration: use on a fuel company's calendar should normally cost more than use in a newspaper's book review section.

Reproductions in Periodicals

Of course, no charge is made for reproductions used in conjunction with a critical review, or for other publicity purposes that are eminently to the advantage of the artist. Indeed, your dealer should make every effort to have your work reproduced free of charge and as often as possible in art columns, catalogs, journals, and books. Without question, such reproduction actually raises the value of the work of art and your status as an artist.

However, some periodicals tend to exploit the concept of "publicity" for the artist, when actually they wish to use reproductions of works of art primarily as free illustrations for texts not related to the artist. They don't want to pay or commission an illustrator for the job; in order to avoid paying an artist for reproducing his work, they will argue that the name credit they give him is sufficient reward because of its publicity value—a very dubious premise. The more reliable periodicals, however—such as *The New York Times* Sunday edition of the Book Review section—have long since established the precedent of paying an artist at least a small fee for using his work to illustrate their articles. Here again, it should be ascertained that the reproduction will be used in a dignified context and that credit to the artist will appear on the same page as the reproduction. Surely if more artists and their dealers, as well as more museums owning work by living artists, continue to demand fair payment and credit, the reproduction field will cease to be the racket it used to be, and will supplement the incomes of some artists.

Getting Published

Many artists are interested in getting their work published by reproduction houses, which then market them. Some hope for publicity and income from this source; some seek to fulfill numerous demands for the same picture.

Framable-size reproductions are a big-time operation, ranging from famous old masters to virtually unknown contemporaries. Large supply printers take works of art for publication on the basis of their own judgment about what will sell.

Commitments are made at their own risk as far as costs are concerned. They are in business; they aim to satisfy all public tastes; and their boards of selection choose on the basis of appeal rather than the artist's established reputation, whether they are dealing with the old masters or living artists.

Reproduction fees paid to artists vary considerably, depending on size and price of reproduction, distribution and promotion potentials, and the publisher's guess as to salability. An unknown artist may well get as much as one with a reputation. Large publishers seldom pay royalties because the bookkeeping would be too complicated; instead they pay a flat fee for rights to a limited edition. This assures the artist of immediate payment of a specific sum and removes his need to check any sales figures. The edition may be agreed upon as, say, 1,500 or 3,000; should it sell out, and the publisher want to reissue, he agrees to obtain further permission from the artist and to pay an additional fee, usually the same as the first payment.

Reputable firms offer you the right at any time to inspect their books as they relate to your account, in much the same way that the Internal Revenue Service is able to view books at will without notice. Thus you run no risk that the firm might overrun the edition or misconstrue total sales. All reproductions should be copyrighted. You must have all these arrangements in writing.

One of the largest art reproduction publishers in the U.S. of framable-size works of art is New York Graphic Society, Ltd. This firm was founded in 1925 and became a subsidiary of Time, Inc. in 1966. It publishes editions both of original prints and of color reproductions, plus a small number of black-and-white reproductions of works such as drawings.

Another large art reproduction publisher is Donald Art Company, Inc. This firm issues reproductions on paper, canvas, hard board, plaques, and table mats.

Both firms maintain showrooms in New York City; both are well geared to publicize, advertise, and distribute on a nationwide basis.

There are, of course, many other firms around the country that you could locate through the yellow pages or your local art reproduction store. Before you make a deal with them, try to learn something about their reliability from other artists who have had experience with them, from the Better Business

Bureau, and from the chamber of commerce. Be sure their contractual terms (in writing) conform to those outlined here.

When seeking consideration by a reproduction house, send color slides or other good reproductions. Don't expect an immediate decision, for often the jury or selection staff meets only once a month to make these decisions. Usually, they do not purchase any originals; rather they buy the reproduction rights only. Each fee arrangement for an edition of reproductions is an individual matter.

PRICING AND
SELLING

Dealers will often ask you what price you want to place on your works. If you have sold only from your studio or in smaller metropolises, you may not know just how to do this. Obviously, the dealer is interested in asking as high a price as possible, for then his commission will bring him more revenue. It is also apparent that a dealer knows his own customers' pocketbooks better than anyone else. Since the interests of the dealer are the same as yours—to get as good a price as possible—your best bet may be to ask, and take, his advice on the matter. The dealer knows that he cannot over-price work by unknown artists; he realizes he can push up prices after successes; and he understands the range of his customers' buying habits. Some dealers have more wealthy clients than others; if pricing seems too low to you, it would be better to go to other dealers than to argue.

Pricing

Most of the artists I see are fairly modest, when they start out, about what they think their work is worth on the market. One elderly painter wrote to me from Detroit: "What the artist should charge for his works is a hard question; well, I solved mine 40 years ago when my teacher and I set prices on worthwhile paintings at $15 for an 8″ × 10″ and a little more for the larger ones. Today my prices are $60 for an 8″ × 10″ to $250 for 16″ × 20″, and this price range has brought me a very satisfactory sales record, flowers accounting for most sales. Great wealth I did not amass, but it has been a very interesting and rewarding experience, expanding around the U.S. and eventually many other places around the world."

This letter came from a *male* artist, a fact worth mentioning, for some men believe that only *females* who are otherwise supported can be modest in their demands.

A watercolorist whose work sells very well, but at low prices, wondered if her prices should be raised: "Isn't it better to charge less and try to get your work known first? Or am I placing too little value on my time, when a purchaser pays $60 to frame one of my watercolors? Now that bothers me completely!" she exclaimed.

When work has a good market and is in increasing demand may be a good time to raise prices—but not too much all at once. It is perhaps advisable to keep in mind that if the increases put a stop to the sales, it could be demeaning to have to lower them again to recapture the market. One approach might be to step up prices gradually to test the absorption potential; another is for dealer and artist to set a price range within which the dealer can haggle, and thus see what the market will bear while not losing sales.

If you can be objective about your work, try some comparative shopping, observing the price tags on somewhat similar works, particularly on those that are wearing red stars. Sometimes a sympathetic dealer or a knowledgeable collector might be helpful in your evaluations, which are easier to make from the outside.

Occasionally, I run into someone who has grandiose ideas. One man told me that he had never exhibited and never sold but would take nothing less than $3,000 for one of his paintings. Would I please find him a gallery? My reaction was that he would do better to hang his paintings on his own walls instead and to enjoy his expensive collection. Another artist, an unknown Florida painter, wrote: "I have about 200 primitive oil paintings, some in hand-made frames. Could you please give me the address of a gallery that might be interested in buying them? Have sold some of my paintings [for] $8500. . . ." One could only wonder, if true, why he would bother to try for a New York gallery.

There are indeed artists who feel that they are superior to all others and that they should be in a top price bracket even if still unknown. Perhaps their attitudes are purely egotistical or paranoid. But it is also possible that they are exacerbated by the unreasonable demands of some purchasers who, even at low prices, want totally unreasonable assurances.

A purchaser of watercolors wrote, "I don't understand what basis is used for pricing." He went on to argue that an artist who produces a watercolor a day, five days a week for 11 months—a one-month vacation allowed—would have 240 paintings and, at $100 each, an income of $24,000 a year. (I wonder if he is a cost-accountant for mass-produced conveyor-belt items.) "Yet few can make their living at fine art; most are pricing at more than $200, *not* selling, pricing people like me out of the market. The whole business appears crazy to me!"

The watercolor aficionado continued: he wanted "a masterpiece of its type, a work that can be lived with for years with a continuing realization of its excellence," plus a work "that would sell well at auction if I didn't like it after a time." There is no intimation of his own potential inadequacies or limitations; the assumption is that the buyer must be supremely godlike. As if anyone could offer such guarantees on matters for which the responsibility rests in the collector's head! Such a purchaser would be the first to object if an artist or dealer tried to dictate what to buy; yet he obviously does not trust his own judgment and wants it to be covered by impossible promises.

Another inquiry from some graduating students at a Massachusetts college is also instructive: "We are considering a class gift for the school and would like any available information on statues. We would like something that could be placed as a centerpiece on the main quadrangle as a possible portrayal of the contemporary period. Our funds are limited to a $200 to $400 price range." One hopes that after their commencement, they commenced to learn a few practical facts—even if only about costs of materials, not to mention the livelihood of artists.

Art as Investment

Novices in art buying are all too readily taken in by the get-rich-quick and you-can't-lose ballyhoo about art as an investment that has plagued the market for some years. The housewife from Queens who contemplated buying a painting of a gypsy's head had been reading about top auction prices for big-name art and jumped to the conclusion that fabulous increases in value applied to all painting. Nor is this too surprising in view of the fact that much commercial promotion of art in recent years has used just such rare examples of increases "far greater than any stock or bond on Wall Street" as a hard-sell approach, suggesting, "You, too, may make a killing!"

"I'm mainly interested in buying art for profit and I'll spend quite a lot—what should I get?" another asked.

There are books on art as investment, as well as a biweekly eight-page mimeographed "hot-tip" bulletin published out of Wall Street at an annual subscription of $125; the "tip sheets" are written by Dr. Richard Rush (doctorate in business administration). Some books urge caution in speculative art buying and point out hazards, adding that in most cases where the artist is living, he is left out in the cold in such wheeling and dealing. Dr. Rush, however, talks mostly about purchases of works by artists who are no longer living; he specializes in international auctions, presupposes a background of connoisseurship regarding state, quality, authenticity, and previous sales prices of any potential purchase, and generally recommends buying top-quality, attractive works in prime condition, for best *resale* value—which has little to do with the pleasure of living with art.

No one seems to mention the prime collector's hazards. It is true that to lend a work to a museum, or to have it reproduced in the museum's catalog or an art magazine, adds value to the work. But once the name of the collector appears on a museum label or in a caption, he may become of great interest to a ring of art thieves. So successful are these thieves—reputedly selling many stolen works in South America—that many stolen works are never recovered. This is one reason why museums find it more and more difficult to borrow from noted collectors, and why when collectors do lend they often do so anonymously. Insurance is hard to get because of the thievery, and an underinsured stolen collection is no investment. If you don't want thugs to break in, you can put your art in a safe vault, thus sacrificing all visual delight and violating the whole purpose of art (see Chapter 18).

One result of the art-investment boom is that a lot of eager buyers are getting stuck with phonies, so avid are they to purchase "names." An appraiser I know, who has built up a computer bank on literally millions of works of art, related the distressing fact that one out of every ten appraisals requested proves to be a forgery or fake. "Why don't [collectors] buy new and relatively unknown work instead?" he asks. "They'd do much better."

When I am queried about art as investment, I usually try to convey the unglamorous and homely idea of buying art for

pleasure; if it's worth X dollars to you to have on your wall, then buy it; if you start by buying something, anything you like, it may well open up a whole new, developing world for you—one of pleasure. After a couple of years looking at and shopping for art, your taste may change radically and you may then spurn your early purchases—but they will have served you well as introductions to a rich field.

Discounts

Museums and collectors: Artists and dealers alike must anticipate demands from certain quarters for discounts. All museums expect to buy at a discount, not only because they are nonprofit educational institutions but also because they know a museum acquisition enhances both the reputation and the market of an artist. In the past couple of decades the generally accepted museum discount in New York has been reduced from 15% to 10%. Occasionally, however, galleries will give a little more when trying to put a new artist "on the map."

Another category of discount buyer is the large collector who frequently buys in quantity. Just about every artist and dealer wants to be represented in certain well-known collections. A noted example is that of Joseph Hirshhorn, who for many years has extensively bought works by relatively unknown contemporary artists, often purchasing a score or more by the same artist. Many artists have been launched by his purchases and many have subsequently become well known. The collection—and a museum to house it in Washington, D.C.—has now been given to the nation. For an artist's work to be part of the Hirshhorn collection was for many years, even prior to establishment of the museum, as advantageous to his sales as representation in a museum collection. Consequently, the same 10% discount was customarily applied.

Over the past years many big collectors have agreed to bequeath their art to a particular museum. Even if these works were kept at home most of the time prior to death, IRS gave tax allowances that could be spread over a number of years, thus encouraging much privately owned art to wind up in public institutions for the benefit of all. In this practice the U.S. compared favorably with many other countries where, even when an art treasure is willed to a museum, the heirs must still pay

inheritance tax on it. Thus, in many cases here, dealers have habitually allowed such collectors discounts, deeming them tantamount to a museum discount, since the works were to wind up in museums.

Unfortunate for the general public and the entry of private collections into the public domain is the fact that too many collectors have taken undue advantage of these tax allowances; have even conned tax-supported museums into storing their collections free of charge, and retaining their sons, or other relatives, in positions of administrative power on their boards. Understandably, therefore, the IRS is cracking down on these tax shelters; accordingly, galleries may perhaps no longer allocate discounts on sales to collectors, all because of those few greedy and unscrupulous collectors and museums alike who killed the goose that laid the golden egg.

Other discounts: Most dealers also give a 10% discount to educational institutions other than museums, such as universities, colleges, libraries. Many give preferential prices on purchases by other galleries, and as a commission to architects and decorators buying for their clients. Not infrequently, an artist or student purchaser is allowed a discount: I know one dealer who will take off 10% for an eager purchaser if he is poor. Though I am puzzled about how the "means test" (or gauge of pocketbook) is applied, I do know that I have benefited by this kindly attitude. Discounts may also be offered by a dealer when he is selling off inventory.

Sales from the Studio

Lots of people prefer to purchase directly from an artist's studio, rather than from his gallery. Often this preference simply stems from a desire to see and talk with a real live artist and to get in behind the scenes; it makes prestigious cocktail conversation about their purchase. Creative artists often fill many people with awe. Artists respond to this adulation with reactions that range from total rejection of such invasions and interruptions, to long-suffering toleration, to a friendly welcome.

Another big reason why purchasers prefer to visit an artist's studio rather than go to his gallery is to try to persuade the artist to sell without the dealer's commission, promising that they won't tell. This tactic, of course, violates all artist-dealer commitments. Nevertheless, a cagey buyer figures it will be

easier to twist the arm of an unbusinesslike artist than to bicker with his professional dealer.

At the Art Information Center, I often receive requests for an artist's address. Unless the artist has no gallery affiliation, I give out only the name and address of his dealer. Compilations such as *Who's Who in American Art* and *International Directory of Arts* do publish artists' addresses, but many purchasers either don't seem to know these sources or don't want to go to look them up in the library. And I never suggest these reference works. To mention the fact here is, I hope, "safe" because this book, directed to artists and dealers, is not likely to be read by collectors. The bypassing procedure by a collector is not only unfair to the dealer but is also a burden, an embarrassment, and a nuisance to the artist.

Dealers themselves frequently make appointments with their artists for purchasers to visit studios, with the understanding, of course, that no price dickering will ensue. For practical reasons of space, the dealer may have only a few of the artist's works on hand; the purchaser may wish to see more before making a selection. If the artist is affiliated with a gallery, this is the acceptable way in which sales are made from his studio with integrity and good faith.

Outright Purchases

Very few "art dealers" buy work outright from living artists. Some occasionally buy work by artists in their own roster for their personal collections. A few make purchases from their artists in cases of need. A few buy on a monthly payment basis as a kind of advance to an artist.

A number of the dealers who work with the interior design and decorator trade do often buy outright. They are usually located near the centers of such trade; they are catering to decorators, who in turn are catering to their clients. The decorators must get their commission if they produce clients; the dealer must get his commission if he sells your work. With an extra middleman, it becomes more difficult for the dealer to work with the artist on the usual commission basis; he will try to buy outright for as little as possible, sell for as much as possible, and hope his judgment and sales pitch are good enough to assure his profits.

In the low-priced market there are "picture" dealers who buy

outright for quick, inexpensive turnover. Numerous frame shops also buy paintings, drawings, and prints to display and sell with their frames; often with a sign: "This picture with any frame in the window—$125." Naturally, such purchasers will try to bargain with the artist. They are probably much more shrewd as businessmen than most artists, who verily are not precisely noted for astuteness in transactions involving their work even when being sold down the river. But you must realize these dealers are running some risk when they put cash in your jeans before they know whether or not they have sales.

Installment Buying

For many years galleries have sold on the installment plan, and virtually all galleries continue to do so. Losses from this arrangement have proved to be virtually nil.

I remember making a fairly comprehensive telephone check among New York dealers on this subject when I was Publicity Director of the Museum of Modern Art in New York. The Museum was then thinking of establishing its art lending library—a potential form of installment purchase, for the borrower can subtract rental fees from purchase price if he later decides to buy. Not one of the dealers I called was unwilling to sell "on time"; and not one had ever lost on such sales, although they sometimes had to wait as long as two years for final payment—even, occasionally, when the total sum was owed only $600 to $800.

Apparently, people who want to buy contemporary art are not swindlers. Possibly the individual and personal experience of buying work by a living artist is more exacting than dealing with a big impersonal corporation. Six psychologists would probably come up with six other theories. Whatever the reason, it is to be hoped that nothing—especially this report—will encourage swindlers to move in and change this happy situation.

Many dealers stipulate a time limit on long-term purchases, from six months to two years; but some simply state "open" or "extended." I once arranged to buy a $125 lithograph from a gallery that required no down payment whatsoever. But I did pay a first installment of $50 and asked the dealer to hold the print until I could accumulate the rest of the funds. He was actually angry. "I don't care if you don't pay anything now," he

said, "but please, you must take it home because I might forget and sell it again. And anyway I don't want it cluttering up my limited storage space."

Before making the arrangement, dealers selling on time are apt to consult with the artist to ascertain whether he will accept delayed payments; most artists do. In some cases the dealer agrees to pay the artist in full at the time of the first installment, and he himself waits to be reimbursed from subsequent sums.

Unfortunately, I must record one exception to this rosy report; it is one that brings up a curious and rather surprising legal aspect. A dealer sold an artist's painting on credit but was unable to collect either payment or the painting from the purchaser. Artists' Equity took the painter's case to the Attorney General's Office, only to find that it was the artist who had to sustain the loss if the dealer could get neither the money nor the painting. Legally, the dealer, who did not get his commission, had already sustained his share of the loss. The artist could sue the dealer for negligence in checking his client's credit; but if he did, he would probably spend a lot more for legal costs than he originally lost in the price of his painting. One can only hope that this case is the exception that proves the rule.

Returns

Purchasers who want to return works of art for cash may not be successful in their efforts, for once the dealer has paid the artist, bookkeeping becomes complicated, and more likely than not, the money has been spent. But dealers do make allowances for purchasers who go home with a painting or sculpture and immediately discover that it doesn't "live with" according to their expectations: art can look very different in different surroundings. Some dealers will return cash if the work is brought back within a month. More often, credit is extended or an exchange is arranged.

A purchaser will probably encounter no difficulty if he wants to exchange the unwanted piece for another, more expensive work by the same artist, and if he is willing to pay the difference. This practice is not infrequent, both for private collectors and for museums. The New York Museum of Modern Art, for example, buys many works by living artists on the un-

derstanding that they may later be exchanged for more recent works, often at additional cost; thus it can attempt to remain a museum of "modern" art. But never does the Museum turn in works by living artists if this means that these artists will no longer be represented in the Museum collection. Once an artist has achieved the right to say that his work is owned by the Museum, it would be manifestly unfair and harmful to his professional standing to deprive him later of that right.

PUBLICITY

In the United States there are some 600 newspapers and eighty art magazines that cover art events. A list of these publications, with the names of their art critics, can be found in the appendix to the *American Art Directory*, a reference book that is revised and reissued every two years; this directory is easy to find in libraries and museums. Newspapers that have no art critics often cover art events and shows as features, perhaps on the women's pages or in amusement and leisure sections.

Press: Advertisements and Listings

In New York it is widely agreed that the most valuable advertising medium is the Sunday *New York Times,* which has much broader distribution in the nation than does the daily. Dealers, even in other parts of the country, have found that its ads may well draw more attention and results than those in other publications. The *Times* also has a Friday page of art reviews, the local art scene, and Saturday being the biggest gallery-going day, New Yorkers frequently use this page as a guide for their visits. Hence, for local purposes, many dealers also advertise on Friday. To encourage this practice, the *Times* offers a tie-in discount price if the same advertisement is published both Friday and Sunday.

The major monthly art magazines, *The Art Gallery* with its insert, "Exhibition Guide," *Art News,* and *Arts,* have national distribution and publish national listings and reviews, although their sales are heaviest in the New York area. For New York City gallery listings and maps, the small monthly pamphlet *Art Now: Gallery Guide* is widely used. Shows and the publicity for

them must be planned well in advance, for ads must be sent to these monthly publications at least four weeks before their publication dates.

The opinions of dealers vary considerably regarding the value of advertising in art magazines. Many galleries have annual contracts to advertise in every issue at a discount rate; some don't use the monthlies at all. One well-known dealer places small ads regularly—not, he says, because he thinks they bring him any results, but because we have so few art publications in this country that he thinks they should be supported.

American Artist has the largest circulation in the United States among monthly art magazines, but this publication is designed to be technically and factually informative to artists. It does not review gallery shows; therefore ads for exhibitions would not reach the right audience.

The big weeklies like *Time, Newsweek, Cue, New York,* and *The New Yorker* are not frequently used for gallery ads because they are just too expensive and because their readership is not primarily interested in contemporary fine arts. Moreover, there is no assurance that an art ad will appear on the art page; it may just get lost somewhere in an irrelevant section.

Many publications list current exhibitions and announce shows about to open. The information is considered editorial copy and therefore costs nothing. This useful form of publicity is used as a guide by many readers. Naturally, editors select what they will list, so there is no assurance of complete listing of all galleries.

But in all too many instances a gallery listing is omitted only because the dealer did not get his information to the publication before the deadline. In general, listing information must reach the publication earlier than advertising copy.

In addition to the art magazines, listings appear in such widely circulated publications as *Cue, The New Yorker,* and the "Arts and Leisure Guide" of the Sunday *Times.* The latter is probably just about complete for New York City and also lists interesting shows, particularly in summer, from Maine to Washington, D.C. Many newspapers across the country, especially those with art critics, list local and regional exhibitions.

Gallery Guides

In a number of other cities besides New York, such as Los Angeles, San Francisco, Chicago, and Louisville, where there

are numerous galleries, a monthly booklet is published, listing galleries, their addresses and phone numbers, and announcing the shows they will have during the month ahead, specifying the days and hours of visiting. Usually the galleries must pay for these listings. In return, they receive a number of free copies to hand out, or sell, to their visitors. But the listings are never complete because some galleries do not choose to pay the charges. There is no complete nationwide listing.

These pocket-sized booklets also carry advertisements, as well as reproductions and some editorial copy. A gallery that pays for a listing should send along with its information copy a couple of photographs of work by its exhibiting artists. A reproduction may well be used editorially if it is on hand when layouts are being made. If the gallery also decides to take an advertisement, the publishers are practically certain to use a reproduction in the editorial part of the magazine.

Press Releases

A simple, factual, directly written press release can often be helpful to art reviewers and reporters—and hence helpful to the artist in gaining their attention. The kinds to avoid are the flowery, emotional, exaggerated, or introspectively philosophical verbosities that too often emanate from the inexperienced or the egotistical. Press people who have neither the time nor the patience for such flights of fancy, tend to file them in the wastebasket.

The old newsman's 4-W rule—that who, what, where, and when must appear in the first sentence—is a good one. With all the releases that cross my desk, I become irritated when I have to search through numerous paragraphs to discover the opening date of a show, or to find what, in essence, is to be exhibited. Although it should be succinct, it does no harm in the first paragraph to repeat the name and address of the exhibiting gallery, even though these probably also appear in the letterhead. The reader's eye often goes directly to the body of the text, failing to encompass the larger type at the top. This observation reminds me of the well-known map publishing firm that issued a huge map of the United States, for which dozens of researchers checked the spelling of every little village. When the map came from the press, UNTIED STATES was printed in huge letters across the whole thing: the type was so large that no one saw it.

Using the straight facts, try to write a paragraph or two that describe the art to be shown in a manner that will help a reader to visualize it. I have heard an art magazine editor wisely explain to a new reviewer the following approach: think and write as if the reader would never actually see the works of art, so that the words convey the image. Some artists are themselves the ones best able to describe their work; quotations from their statements may well be pertinent. The press likes to use direct quotations because quotes give the impression of having come from the "horse's mouth" (and they fill space without effort or thought on their part).

In a press release you are addressing people who presumably have some knowledge of the field and who can thus comprehend art references. Don't hesitate to make comparisons with other artists and their work if these references will help in visualization. There is nothing pejorative about implying that work stems from, say Matisse or Shahn or Pollock. All serious artists have derived to some extent from their predecessors.

If the exhibiting artist has already been discussed in press notices and reviews, include some quotations from these clippings, selecting the best, most favorable comments on his work.

The last paragraph of a press release is a good place to give a brief sketch of the artist's professional background: where and with whom he studied; where and when he has exhibited; what jurors selected his work for competitive shows or awards; what collections own examples of his work—especially public collections, but also private ones if they are of importance. Biographical details other than those relating to art background are usually superfluous, unless they relate in some way to the artist's point of view as expressed in his work, or are needed to explain a gap in the continuity of his art production. The biography is sometimes set up in single-spaced copy, while the rest of the release is double spaced, which tends to set it apart visually, an aid to the reader pressed for time. This device also on occasion saves expenditure, for the single spacing may eliminate the need to run onto an additional page at added cost in mimeographing or offsetting.

If there really is a lot to say and it is expressed in an attention-holding way, there is no harm in a release that is three or four pages long. But if the material can be stated adequately and interestingly in one page, don't drag it out with padding.

Since reproductions are often important to the press, it is advisable to state at the end of the release: PHOTOGRAPHS AVAILABLE, with the telephone number of the gallery where they may be obtained.

It pays to proofread stencils or copy prepared by a printer for mimeographing or offset before it is printed. Typographical errors are generally all too common; when a typist is confronted with technical terms or words totally new and unfamiliar to him, there is no telling how he will mutilate them. *Collage* is almost certain to come out as *college,* and it would seem that most typists are congenitally unable to spell words like *acrylic* and *asymmetric,* even when they are reading accurate copy. Errors of this sort give a sloppy, nonprofessional mien to your show and may influence the reader to think that the whole affair is pretty amateurish.

It is occasionally possible to find a publicity agent specializing in the field of art who knows how to write a good press release and who also maintains an up-to-date press mailing list. But this is rare—and it means an additional cost. Most releases are written by the dealer, though sometimes by the artist if he has a flair for writing. Results are apt to be more sincere, more accurate, and more effective than those achieved by a hired PR hack who knows little or nothing of art and who uses the same sensational approach for everything, whether the subject is art, soap, or racing cars. Most dealers maintain their own mailing lists of press, museum personnel, and customers.

How to Use a Press Release

Editors of the art monthlies, art reviewers for weeklies, and art critics of local daily papers should receive copies of the press release. It is also advantageous to reach editors and writers who work for general periodicals that only occasionally include features on art subjects. You never know when the material you send them may fit in with the theme of some special article they are contemplating. Once you have already ordered the stencils or plates for printing the release, it costs only the small amount needed for the additional paper to have more copies run off to mail to such feature writers and editors.

If you can write covering letters pointing out the particular feature possibilities of your show, so much the better. Many women artists have thus received coverage on women's pages

and in women's magazines. Works of art with a particular slant or theme—whether political, ethnic, technological, or musical—have stimulated interest among writers on related subjects.

Curators and directors of local museums that show contemporary art should also be on the mailing list. Some dealers like to mail the release to their customers. Artists often send copies to previous purchasers, perhaps along with an invitation to the preview on which is written some banal but personal message like "Hope you can come." Architects, decorators, and designers may be in a position to influence their clients toward purchasing and commissioning contemporary art. As this trend has grown, more and more dealers and artists have built up their mailing lists to include such professionals, who have become important intermediaries. Indeed, in many areas certain dealers cater especially to this trade, which by itself can supply them with good business.

Many dealers order fifty to a hundred extra copies of the press release to hand out in the gallery, not only to visiting press but to anyone who shows an interest in the artist's work and wishes information about him. Moreover, they need a few copies to file for future reference.

Mailing houses—often combined with mimeograph and offset operations—are widely used as expeditors for releases, invitations, brochures, and catalogs (though a good many small galleries address their own mailings by hand). The mailing houses generally operate by machine, putting the list on addressograph plates that are run off automatically onto the envelopes. They can easily separate the lists under different headings, such as press, museums, architects, customers, in case the dealer wishes to use different sections of his list for different shows. It is important to notify the mailers of any changes in names and addresses and to keep the list up-to-date. Mailing houses will also address by hand from a special list used so seldom that it is not worth putting onto plates.

Along with the release, it is helpful to send a couple of photographs of the artist's work to a few hand-picked publications, such as the art monthlies and the dailies, which use art reproductions. Such photographs should have a glossy finish so they can be reproduced; standard sizes are usually 5″ × 7″ or 8″ × 10″. If feasible, send one horizontal picture and one vertical, for the

publication then has a better chance to fit one or the other into the layout (the space may permit either a one-column or a two-column cut).

Give the critics as much convincing material as possible, but don't badger them with visits and phone calls. Some artists and dealers have made themselves the *bêtes-noires* of local critics by constantly pestering them, with the inevitable result that the critics want to stay as far away as possible.

Personal Publicity

Sometimes artists who are looking for gallery representation ask me how they can get personal publicity; if they could obtain press coverage, they reason, they would then find a gallery. Actually, this is a cart-before-horse approach. To send out a release or other promotion piece without any newspeg, such as a forthcoming exhibition, is apt to be a complete waste of time and money. Once in a great while an artist can attract press notice by falling through a window or by painting while standing on his head. But most of the time the press is too busy to notice; moreover, such feats are unlikely to induce purchases by museums or serious collectors or, in the long run, to build up a professional reputation for the artist.

If, however, there is legitimate, bona fide press material regarding an artist, by all means use it. A prize, fellowship, or grant won, a sale to a locally important collector, a donation or sale to a museum or other institution, can make genuine news. Some artists can also make good copy for personality profiles. This kind of publicity can help to promote acceptance, to obtain new customers, to increase prices. Send copies of any such news piece to other media, to your collectors and prospective buyers, in order to engender greater interest in your current output.

One useful way to build up your art background and potential publicity is to offer gifts of drawings and prints to local museums. Naturally, the curators will not accept them, even as gifts, unless they find them art worthy, but they are more apt to acquiesce if they do not have to strain their limited budgets. If the donations are accepted, you can then legitimately state that your work is "in the collection" of this or that museum. No need to mention that the works are graphics, which are easier to give away and less depleting of your major works, which, of course, you would prefer to retain for selling.

If you can get listed in *Who's Who in American Art* and/or any of the Marquis Who's Who publications, this can indeed be helpful personal publicity. The inclusions in these volumes are screened on the basis of merit; as most people know, the listings cannot be bought, and there is no requirement that an artist purchase the book in order to be included. What artists often do not realize is that it means nothing to be listed in any of the numerous other imitative compilations that do require a fee or a purchase. These listings are simply a way to take your hard-earned cash.

Some publications in this latter category state that they screen résumés, but anyone who sends along the check gets in. Some try to sound prestigious by saying that they are members of the American Federation of Arts or the American Association of Museums: anyone can be a member of these organizations by simply paying the dues. Some tell you the Library of Congress Catalog Card number of their publication: virtually any book published in the United States is assigned a card number on deposit of two copies with the Library of Congress. Not all such operations are American; some of the solicitation comes from abroad in an endeavor to glean American money.

A related maneuver is the proposal from some self-styled college, which no one ever heard of, to give you an honorary doctorate. Buried deep in the descriptive literature is a statement regarding the minimum "contribution" required, which through some sort of tax loophole may even be tax deductible.

In sum, the simple rule of thumb is, Don't pay for "honors." This, of course, does not apply to membership in professional organizations.

If you feel that you have amassed enough background in art to warrant inclusion in *Who's Who in American Art,* request an application form from Jaques Cattell Press, an affiliate of the New York publisher R. R. Bowker. Decision will be made on the basis of the information you supply on the form. If you do not make it the first time, keep building up your record and apply again later. The publication is issued every two years.

Brochures, Catalogs, Invitations

Announcements of exhibitions range all the way from a simple postcard to a book full of color reproductions, with many imaginative variations and eye-catchers among them. A good deal

of ingenuity and inventiveness go into some announcements, frequently designed by the artists in keeping with their work. New materials, new printing techniques, and new formats are constantly popping up among these mailing pieces, which, when they are truly imaginative, achieve the aim of being noticed and posted—sometimes even becoming collectors' items. The most expensive product is by no means necessarily the most appealing, effective, or attention-getting.

Brochures usually include the artist's art background in outline form, often digested from the press release; a checklist of works to be exhibited, with title or number, medium, and size of each (height should precede width, according to standard museum practice); and perhaps a favorable quotation or two from an art writer or a previous press notice. However, if the mailing piece is a poster or similar format that limits the space for text, a mimeographed checklist and biography may be folded in with it or handed out at the show.

Galleries that publish catalogs with color reproductions may subsequently be able to use them for additional publicity by offering them, or electros made from them, to art publications. Such an arrangement is sometimes worked out in advance between a dealer and an editor so that size of color reproduction and time of delivery of plates will suit the needs of both. Obviously, this kind of publicity takes careful advance planning and is not achieved by the last-minute rush into print that is all too typical of many publicity efforts.

Some dealers with a long-range view put out periodic bulletins about their artists: where they have exhibited, sold, or been commissioned, and other facts relevant to their recent biographies. These bulletins are not primarily produced to obtain immediate press notice, but the information they contain is likely to go into the morgues of various publications, to be drawn upon at a later, more appropriate time. Bulletins are sent not only to the press but also to collectors of the artists' works, to keep them and their interest in the artists informed and ever alert.

Numerous galleries that plan ahead send to the press advance lists with brief descriptions of shows scheduled for several ensuing months. This enables the reviewer to put forthcoming events on his calendar so that he too can plan ahead.

There are various theories about when to mail announce-

ments and brochures. One of the most common is that they should be posted about ten or twelve days before the opening: the recipient should then have sufficient notice to attend but not enough time to forget about it; and the frequent Post Office delays would still not make delivery too late. Another practice is to send notices only one or two days ahead, which I suspect is more a practice than a policy, based on insufficient advance planning rather than on any tenable theory; many of these notices arrive after the opening they announce.

An out-of-town artist wrote to me asking for a list of all New York galleries to which to send a publicity circular about his forthcoming show in a city church. I could only reply that, with 550 galleries, he might better save his postage and paper unless he knew some specific galleries that exhibited work in his direction and medium, for this kind of broadside mailing usually winds up in the wastebasket. Publicity mailings need to be planned intelligently, not just scattered.

Radio and Television

It is pretty difficult to arouse interest in gallery showings among the big commercial radio and television stations. Although they must carry some cultural-educational material, they are more inclined to cover big museum shows to fulfill this requirement. Many stations do, however, announce forthcoming events in the arts; and it is indeed worthwhile to see that these programmers receive notices of gallery exhibitions.

Educational television, now so much on the rise, does offer good potentialities. These channels should certainly be on regular mailing lists; they should also receive color reproductions, if available, or photographs, preferably 8″ × 10″ and dull finished (not glossy) so they do not reflect the high-powered lights. Because of the usual shape of the television screen, horizontal pictures come over better and larger than vertical. These stations are much more likely to give illustrated spot announcements of forthcoming shows than are the commercial channels.

The educational channels, like the commercial ones, are more inclined to emphasize in feature coverage the activities of museums. However, the museums themselves are always looking for interesting material to supply. A good artist who is also an able speaker in interviews and discussions, or who is adept at demonstrations, is a boon to this kind of program and should

be brought to the attention not only of the local educational channel but also of the museum's publicity department. Also in constant demand are good ideas for television shows that have action, dialogue, and controversy, accompanied by telegenic original material. If the station does not have the funds to send out cameras and crews for shooting on location, then it becomes important to select material that can be transported safely to the studio.

An artist's chances of obtaining television time are greater if his work can be tied in with a public institution. The channel likes this stamp of authority, which removes from its personnel the onus of making selections in a field they may not know well and of seeming to play favorites among artists and their galleries. Of course, the museum is concerned about its own reputation for good judgment; it is not likely, then, to sponsor the television appearance of artists whose work it deems unworthy of hanging on its walls. In addition, you should consider—before proposing shows to museum publicity directors—that it takes a surprisingly large amount of material to make a decent television presentation. One good idea can sometimes be completely exhausted in fifty seconds. A lot of visual and verbal material, and a great deal of thought, must be stacked into even a ten-minute program.

Speeches, Demonstrations, Happenings

Publicity buildup for an artist is often achieved not only by radio and television appearances but also through lectures and demonstrations at art schools, clubs, and other organizations. The artist who proves himself able and interesting in making public appearances of this kind is likely to be offered opportunities to become better known. Museums that operate art schools are frequently happy to schedule such events for utilizing the talents of local artists for the benefit of their students, adult or juvenile. Programs of this nature are also organized for museum members. State and regional art associations (listed with the names of their officers in the *American Art Directory*), and the many art-literary-culture clubs which have latched onto modern art as "in," are also susceptible. Most of these organizations pay artists at least a small honorarium for such educational services.

An old technique used for attracting notice is the stunt that

shocks—a tactic probably stemming from the Dadaists of the 1917–1920 period. The "events" and "happenings" of the 1960s quite frankly were called "neo-Dada," and in some instances they achieved as much attention as did the toilet seat the Dadaists once hung as a work of art.

Many of the stunts have come and gone so fast, only fleetingly making their impact, that it is unlikely they achieved any real place in history: whether they involved defecating in the gallery of New York's Judson Church, nudist activities in the East Village, wrapping up entire buildings in various parts of the United States, or stretching a curtain across a Colorado canyon. As with "streaking", the mere mention of these a activities usually just produces a quirky smile and the yes-I-remember-that, wasn't-it-amusing? response indicating the impermanent. Some stunts are based on genuine reform motives—as was the Dada movement in the opinion of many art historians. More often they are devised purely as quick attention-getters, resulting in an amused raised eyebrow in response to their purposeless sensationalism—which may downgrade the reputations of the participating artists.

COPYRIGHT,
REGISTRY,
ROYALTIES

T

he scandalous loss of copyright protection for works of art has long been a worry to lawyers specializing in the art field and a puzzling mystery to artists in this country.

Copyright Laws

The first U.S. Copyright Law was enacted in 1790 to protect books, maps, and charts. Gradually, more kinds of creative expression became protected: music in 1831; drama in 1856; photography in 1865, thereby gaining recognition well ahead of works of art, which were included in 1870, although this served little or no purpose for artists. The big revision, which went into effect in 1909, then remained in an antiquated status quo for six decades before it began to be questioned and its inadequacies recognized. Finally, a revised law took effect on January 1, 1978. But for many years the applications of copyright to works of art have been virtually unknown and not understood by artists, despite the fact that such laws actually go back to 1735 in England.

The late Carl Zigrosser, eminent curator, writer, and general authority on graphic work, wrote some fascinating historical material for the Print Council of America on art plagiarism, forgery, and fraudulent practices. It seems that it was only very gradually, during the Renaissance, that any protection for artists on these scores became an issue worthy even of consideration of any kind. Poor Dürer did not get very far in his efforts. In 1505 he traveled all the way from Germany to Venice (though perhaps this was not too formidable a trek, considering that Columbus had sailed the ocean blue thirteen years earlier),

where he vehemently protested the flagrant plagiarism of his prints. Raimondi, the guilty villain of the piece, was only ordered by the Venetian authorities not to use thereafter the master's monogram on his spurious works.

In the next century Rubens was able to obtain only occasional special protection from the king for certain individual works. But by the eighteenth century numerous British artists— including, particularly, Hogarth—were seriously suffering from piracy and were petitioning for protection. Parliament finally listened, passed the first general copyright law affecting artists in 1735, and *The Rake's Progress* series was published under the protection of this new act of Parliament. Thus was established the basic principle of the artist's right in his own design, which spread to most countries. But all too often it exists more in theory than in practice.

As in the original copyright law, artists are still warned to cover themselves—*before* exhibiting—by affixing indelibly on each work of art: (1) signature, (2) year of execution of work, and (3) the symbol © (meaning copyright), thus establishing legally their protection against pirated reproductions. Such notice can be on the back of the work if it is visible—not covered by matting or a frame—so that it gives "reasonable notice of the copyright claim" (but does not destroy your composition). All publicly distributed copies or reproductions should carry the copyright notice. In the case of greeting cards, jewelry, or useful articles, you can omit the date of the work (which could make it look out of date and less salable), but not your name and the copyright symbol, ©.

Registry
Registering a work for copyright protection normally requires deposit of "two complete copies of the best edition." The primary purpose of this rule is to enlarge the holdings of the Library of Congress; but obviously the law still chiefly emphasizes multiples like books, films, recordings, and is still vague about unique works like paintings. The loophole is: "For particular classes, the regulations may permit the deposit of identifying material instead of copies (photographs or drawings in a specified form) . . . or of identifying reproductions." Thus photographs can be used to register paintings and even prints, if the edition is not larger than 300.

Although the law tells you that such registration is not a condition of copyright, it is a prerequisite for any infringement suit. So it is hard to see just what use your copyright is if you cannot act against violators. In order to be able to sue, you must register within three months after your work is "published." Publication is defined as "the distribution of copies of a work to the public." Although the law says "public display of a work does not of itself constitute publication," it is pretty clear that you had better show only to relatives and acquaintances, not in a gallery, art fair, or benefit show.

A registered copyright, now good for your lifetime and fifty years after, means that you retain all reproduction rights after the sale of the original. This is automatic; there is no longer any need to make a separate agreement. It also gives you the exclusive right to the reproduction of your work on any kind of article, whether useful or otherwise. The article cannot be copyrighted, only the use of fine or applied art on it. The law does not, however, forbid use of art on public television; but such stations must now pay for this use for the first time according to a rate schedule issued by the Copyright Royalty Tribunal.

Commissioned work may come under the law's category of "works made for hire." This particularly applies to work done normally as part of a regular employment requirement. But it can also relate to a collective work to which several artists contribute. However, all participants must expressly agree in writing that this "shall be considered a work made for hire." (The employer can't put it over on you.) If so agreed, then the employer can obtain protection for one hundred years from the creation of the composite work.

You cannot copyright ideas, methods, systems, or principles—only the particular manner in which they are expressed or executed.

Copyright "recordation" costs $10 per work. This can be pretty expensive if you have a lot of work in your studio and must, in addition, pay for good photographs of each one to supply for the records. But there are provisions for registering a whole group of works—perhaps up to twenty—at one time for one $10 fee. Write to the Register of Copyrights, Library of Congress, for Form VA (for works of visual arts, pictorial, graphic, or sculptural; published or unpublished) and for specific requirements for group recordation.

Royalties

The Visual Artists' and Galleries' Association (VAGA) was set up in New York in 1978 to police reproduction violations. As a licensing center for art reproduction rights, whether in periodical, book, poster, fabric, or television display, VAGA will negotiate and collect fees to be paid to artist and/or gallery members, will act as sleuths for unauthorized uses, and will commence litigation against violators where called for.

Membership for an artist is $10 a year and for a gallery or an artist organization $100 a year. The commission collected for reproduction-rights payments or damages awarded seems high, however: 30% in the U.S. and Canada; 50% elsewhere.

A good clearinghouse of source material for those who use reproductions is highly desirable. But most users are honestly seeking and paying for material they need. For routine negotiations of permissions, 30% or 50% is a lot out of the artist's pocket just for collection and distribution of the agreed-upon fees. This normal procedure must inevitably be the preponderance of the services rendered by the organization, for the crooks are only a small percentage of those in the market for art reproductions. It may be hoped that this or a similar clearinghouse will develop at perhaps a 15% commission, which would seem a more reasonable rate.

It is an old and oft-deplored story that all too frequently it is only the purchasers who receive the major benefits from their acquisitions of works by living artists.

In a number of European countries artists now receive a percentage of any increased price in the sale of a work subsequent to its first sale. Thus the visual artist there has the same kind of royalty rights as composers and writers. In France the droit de suite, in existence for many years, requires 3% royalty to the artist on any resale increase. In 1972 West Germany revised its copyright law to require dealers and auctioneers—over their strenuous objections—to pay to the living artist 5% of increases in resale prices. To prevent any arm-twisting pressure by an art dealer, German law does not permit the artist to waive this right. The law gives the artist the right to inspect a dealer's books.

In this country a proposal was drawn up in 1971 by a volunteer lawyer, Robert Projansky of New York. (Artists: please note how many dedicated souls you inspire to get out on the

ramparts to fight for you!) His proposal provides that the artist must receive 15% of any price increase in transfers of his work, unless he himself wishes to waive his rights, as for a friend. It also requires that the artist must receive a record of who owns each of his works at any given time, and gives him the right to have the work remain unaltered by the owner, the right during his lifetime to be notified if the work is to be exhibited, and to be consulted if restoration becomes necessary.

The Projansky Agreement is not just a one-way street for benefits to the artist alone—which would be too idealistic and therefore impractical; it requires the artist to provide the purchaser with a certified history and provenance of each work, thus guaranteeing its authenticity and accurate documentation, and thwarting fakes and frauds. The artist would also give advice on any needed repairs, and on appraisals of the work.

A copy of the Agreement would go with each work to each new owner; and another copy to the artist at the time of each transfer. The collector would pay only if he sold the work at an increased price, when he would have received profitable income. The Projansky Contract is available on request from Artists' Rights Association.

Some sales are being conducted on this basis, but so far they are too few and far between. There are those who think the 15% requirement too high. California passed a law requiring 5% royalty on resales; it was challenged in court and upheld, but in any case it can only apply within the borders of the state. It is too easy for those who want to evade the law to cross the state line to make a sale or a purchase. Unless we can get some such measures written into our federal copyright law, which apply nationwide—as in Europe—they are unlikely to become widespread or truly effective.

Even a national law is not the complete protection it should be, as the French have learned, for there are always those who will make sales secretly to try to get away with it. An artist is certainly unable to be a sleuth in such circumstances. Therefore, many belong to one of two French professional artists' organizations which follow all sales and intercede on the artist's behalf to obtain the 3% due him. Annual dues are very low; but the organizations retain 15% of all monies they collect for the artist—an incentive to be good sleuths.

Compared with composers and writers, the visual artist in the

United States is the "red-headed stepchild" of the arts. The writer, for example, receives income from up-marked resales and royalties for movie and TV rights, for paperback publication, for serialization; and a playwright receives income for a play for as long and as often as it may run. Why not the artist?

Moral Rights

The right to have your work remain unaltered by the owner or anyone else is another basic premise of European law—but not in the United States. Generally known as *droit moral*—in perpetuity, in France—this aspect is included in the Projansky Contract but not in any law. Proposed amendments to the copyright law include not only protection for the artist against any "distortion, mutilation, or other alteration" of his work, even in the way it is displayed—the so-called "right of integrity"—but also his right to claim recognition of his authorship, known as the "right of paternity"; in other words, not anonymous, or without signature or credit, or under a pseudonym. Whether such signature or credit, or under a pseudonym. Whether such amendments may include any clause to prohibit the destruction of a work at its owner's whim is problematical. In the 1930s when the Diego Rivera mural in Rockefeller Center was destroyed by its sponsors because it portrayed Lenin among numerous other figures of the day, there were many outcries claiming that a work of art had a right to its own life. But there is no clear law to this effect, even in Europe.

GOVERNMENT AND
CORPORATE AIDS
TO ART

I t has become more and
more important for artists to be aware of various government
arts organizations—federal, state, and local—and the potentials
they offer. More and more tax funds have been going into the
encouragement and assistance of the "cultural resources of the
nation," the term so frequently intoned like a religious
chant—but if so acceptable, why not use it? The U.S. is still
considerably behind most industrialized countries in the
amounts per capita spent on the arts. Improvement is too
gradual and slow, and with each insistence on biting the bullet,
art funds are all too apt to be the first to suffer.

Need for Government Support
Our national resources include artists and art institutions just as
vital to the U.S. as are natural resources, in their need to be
developed for the benefit of all. This was the firm belief of
Representative Julia Butler Hansen from Washington State,
who in 1967 became the first woman ever to chair any House or
Senate subcommittee: with her selection to head the Subcom-
mittee on Appropriations on the Interior, which is charged
with budgets of 28 agencies—for federal roads, park lands, oil
and pollution research, American Indians—and of the National
Endowment for the Arts (NEA). Support for the NEA in its
early days and constant increases in its government appro-
priations were due in large part to the efforts of Representative
Hansen up to the time of her retirement in 1974.

Others have taken up the banner. Eric Larrabee, former
director of the New York State Council on the Arts, invoked
Rachel Carson's warning in *Silent Spring* against "our headlong

rush into environmental self-destruction." Larrabee observed: "We are exhausting the cultural soil, starving our artists, bankrupting our museums. We want a world in which artists are not second-class citizens. In an economy of constant inflation, the artist deals in stable currency." The fossil-fuel supply is finite, but artistic expression is unlimited if cultivated and nurtured; it cannot flourish in a vacuum of poverty.

The major press—not just art publications—has made cogent appeals for government support of today's artists. Editor Noel Epstein of *The Washington Post* wrote: "It is chiefly by the creations of *living* artists and not by the number of museum-goers or symphony-attenders that we measure a culture, whether it is Pericles' Greece or today's America." The Golden Age of Pericles glittered with the achievements and creativity of its own time and people, not with any reflected glory of the past.

The noted drama-dance critic Clive Barnes issued a radio appeal: "I believe most passionately that the arts must be supported not by the rich but by the poor, which means by the people, which means by the government. ... We have been slow starters in the field and still have a long way to go to catch up—among virtually all civilized nations we have been the most backward in the support of the arts."

Even from the purely economic aspect, it has been shown with facts and figures, over and over again, that the arts are big business, a greater tourist attraction than all sports. This is why more and more states levy an arts tax on hotels, for example, for the benefits they receive in patronage. But, even as Pericles knew when he turned over all war revenues to the arts, art cannot flourish without outside support.

National Endowment for the Arts

What we do have, at the top of the ladder, is the NEA, an "independent" agency of the federal government created in 1965, following backing first by President Kennedy, then by President Johnson. It is advised by the 26 members of the National Council on the Arts, who are appointed by the President, as is the chairman of the NEA.

The act that established this operation specifically prohibits any interference in the administration of policies or the determination of programs of any organizations or agencies involved in the arts. Thus the freedom and independence of artist

groups were guaranteed from the start against federal dictates. But in some peculiar oversight the same freedom was not guaranteed to individual artists.

We all hope that this will be rectified, for artists fear and resist censorship. So far there has been little indication of dictatorship or censorship from government agencies on the erstwhile bases of political-social or sex or nonfigurative content. Here and there ominous threats pop up, as when a New York State assemblyman angrily demanded drastic cuts in state allocation of funds to its council on the arts because he found one sponsored work to be prurient in his view. He did not prevail, but such an outburst is a warning signal.

Government controls have become more subtle and harder to spot, control being exercised via fiscal restrictions on the artist, such as disallowing IRS deduction for any studio expenses unless the space is entirely separate from the "dwelling unit"; and requiring that the artist show a profit above costs in at least two out of five years or else lose eligibility for any deductions for business expenses. Thus the lawmakers manifest their insensitivity to the artist who cannot afford two rents and to the artist's need for time to achieve financial success, either of which can be debilitating.

As Noel Epstein has also pointed out: "It is the living artists who often resist mass tastes and create the most headaches for politicians. . . . The peril of government interference with works that provoke or puzzle the voters and the politicians has long troubled both supporters and opponents of direct federal patronage." If the climate of current thought opposes censorship on the basis of subject matter or style, then there are dangerous ways to subdue through the pocket.

The NEA is now the major patron of the arts, far surpassing the sums contributed by any of the philanthropic foundations, which have been decreasing their aid to art. Whether the NEA support for art will continue to increase depends to some extent on vigilance and awareness on the part of artists and their organizations. Whenever there are cuts in budget, art is first to go by the boards, even when art and education are not the targets of taxpayers' revolts, as in the case of California's Proposition 13 in 1978, which clearly spelled out that the revolt was against bureaucratic waste, duplication, inefficiency, and outright fraud and collusion.

For the visual artist, the loner, the difficulties are far greater than for the much better organized performing artists who always get the lion's share of any government allocations of funds. It is always the visual artists who are drastically underrepresented in appointments to the National Council on the Arts, resulting in a form of discrimination, if not subtle censorship. It is worth noting that in France the government board to determine allocations to professional fine artists has equal representation of artists and government art officials. Our top advisory board, selected by the NEA and then appointed by the President, tends to include one visual artist among its 26 members. Thus, when applying for grants, visual artists and their organizations have no chance to be judged by their peers. Even a congressman particularly noted for his efforts on behalf of cultural and educational legislation neglected to call visual artists as witnesses in a hearing aimed at furthering government recognition of the arts; instead his entire emphasis was on the museums and the performing arts.

State Councils on the Arts

The councils of many states have been equally remiss in appointing artists to their membership. However, in California a lot of artist-organized pressure succeeded in getting artists in as half of their council's membership. Artist organizations in numerous states have been able to increase greatly the benefits to the arts in their counties and communities by conducting letter and telephone campaigns to lobby their state legislators. In some states councils are required to plan for decentralization of decision making regarding smaller grants for community arts services, such determinations being assigned to local bodies.

Every state and territory now has its legislatively created arts council, for the expressed purpose of stimulating the creative and interpretive arts and outlets for them. Their support comes from the NEA, allocations from individual state legislatures, and matching grant funds from private sources.

In addition to dispensing certain grants, state councils on the arts should be good sources of information about local art activities and competitions. Often they have workshops, sometimes internship programs, occasionally free legal services; many publish calendars of art events and newsletters distrib-

uted free to those who ask for them. The *American Art Directory* lists each state's council headquarters, its top officers, and their addresses.

Art in Public Buildings

For years a program has been on the books for art in public buildings that receive any federal funds for their construction. Provisions allocate one half of 1%, up to a full 1%, of total construction costs to fine arts: murals, sculptures, stained glass, or other suitable forms of architectural art. Despite this long-time allocation, city, state, and federal buildings have been constructed with no art because the ruling does not *require* such art expenditure. Government-appointed architects determined whether or not they wanted art in their buildings. This left a big loophole; moreover, the architect has had a great deal of influence in picking the artists, if he did include art, and they were usually his friends. But if construction costs mount, as they so often do, art funds were generally the first to be purloined.

Recently, however, a number of states and cities have committed themselves to the 1% allocation to art, and active artist organizations like Artists' Equity have conducted intensive campaigns to make the 1% ruling mandatory nationwide. Where these laws do exist—in Seattle, Philadelphia, California, and Florida, among others—artists and their organizations are able to put them to good use, as they are in a position to say, "You have the need for art; we have the art." Philadelphia has had such a ruling since 1952, and the great quantity of public art to be seen there testifies to its efficacy. Illinois passed its law only in 1978, and Chicago has a mere handful of public art, for the most part privately funded.

The method of selecting artists for public commission is often a hotly debated issue; however, the art world does tend to agree that the building or city architect should not be the sole and final arbiter (and those architects doubtless disagree). There is widespread controversy over the invitational versus the juried competition methods, and whether to use local or "famous"—including foreign—artists for greater tourist revenues. Some argue for a blend, utilizing all possible advantages: the invitational appeals more to artists of high repute who tend to avoid competitions; the juried competition reveals talent that might otherwise remain unknown. These academic discussions

may go on ad infinitum. The major objective is to get work by living artists commissioned for public places.

Nationally, it is the General Services Administration's Office of Fine Arts that administers fine arts allotments in federal buildings. For the practical purpose of learning about potential local commissions, you would probably do better to go to your nearest department of public works and its art or design division, which should supply the necessary procedural information.

Museum Financing

Gradually government grants are reaching museums across the country, for staff, exhibitions, catalogs, and programs to extend to other community and regional institutions.

One recent boon for museums wishing to organize, import, and circulate exquisite shows in the U.S. is the fact that the government now underwrites the necessary insurance, which would be prohibitive for any museum, or group of museums, to cope with at current rates. Although these "top shows" may not prove much for exposure of today's art, they get more people into the habit of visiting museums generally; and the exhibitions are frequently very fine and even inspirational to today's artist.

In recent years corporations have been highly instrumental in helping to finance not only these special shows but also other museum endeavors.

One of the most common complaints from artists is summed up in a letter I received: "Our local museum pays little or no attention to work by local artists. How can we hope to get recognition when our own institution consistently turns its back on artists in its own region?"

Part of the problem is lack of funds; and with more and more museums having to charge admission, the desire is to have a good "gate" in order to bring in money. Part is lack of interest or judgment-development in any new art field on the part of museum officials, who, even with specialized training, have often not been taught how to develop and utilize individual judgment. And finally, there is a need for more creative, innovative programs. To ameliorate this situation, there have been proposals and actions (notably by Artists' Equity) to re-

quire better representation of artists on museum boards, more say in policy making. However it may be achieved, probably no one questions that the museums should be genuine nationwide aids to living artists.

There is a striking contrast here with our neighbors, the Canadian museums, and their situation vis-à-vis government support. Canadian museums not only exhibit their artists, but they pay them rental fees for showing in any publicly funded institution. Moreover, Canada was first to establish an Art Bank, with millions of dollars to purchase native contemporary art and circulate it throughout the country. Similar legislative measures have been afoot in the U.S. for some time.

I have heard Canadian artists complain that too many government purchases are from the same "artist-favorites." Perhaps so, for I am not close enough to know. But in the first five years of the Art Bank more than 7,000 works by some 900 artists were acquired, which does at least seem worthy of emulation here in the U.S.

Postage Stamps and Art

Another type of government art commission is for the design of postage stamps. The decisions for acceptance are made by the Citizens' Stamp Advisory Committee, which currently pays $1,500 per commission, perhaps more as the cost of living increases. The committee keeps a talent-bank file of brief résumés and a few reproductions. It does not seek design suggestions, for it usually has at least 4,000 subjects as backlog received from all kinds of worthy organizations. It chooses subjects and then selects artists whose talent-file records indicate suitability.

To put your résumé and slides on file for potential commission, write to the chairman of this committee.

The committee is selected by the postmaster general, who also has final authority over all decisions. Some years ago Robert Indiana's painting *LOVE* was accepted for a stamp, although the committee of eleven then included only one visual fine artist. A large percentage of philatelists voted on this and other decisions, doubtless because the Post Office is more interested in the sums such collectors pour into its coffers than in artistic merit. One member of the committee at that time, how-

ever, was the director of the National Gallery, J. Carter Brown, whose view on governance was: "Of course the ideal is if it is being run by its own kind."

Corporations and Art

"Support of the arts is the fastest growing area of corporate philanthropy," says the Business Committee for the Arts (BCA). "Business is rapidly becoming a major and reliable source of support."

Corporations are allowed 5% deductibility for charitable-philanthropic contributions, but the majority for years allocated far less than 5% to any charity and only 4% of that to all of the arts. But the tide has begun to turn. In 1967 business supported the arts with $22 million, whereas by 1977 the amount had risen to $250 million and the percentage of contributions rose to about 12%.

Museums across the country have been the largest beneficiaries of corporation support of the arts. Corporate funds frequently go to special exhibitions, for which the corporation prominently receives both credit and prestige publicity; but also some few actually go into general support just to keep a good thing going. Too often the grants from government sources are earmarked for new projects or programs only. They make a better showing before Congress or a state legislature. "Operating expenses" sounds too dull to inspire even museum trustees to lend their support, for there are no kudos, no thanks on thousands of catalogs, no bronze wall plaques for eternity. There is little recognition of the fact that support for continuation is the lifeblood of cultural endeavor.

Corporate giving to individual artists and for art purchases is still minuscule, though rather more substantial in the case of cultural art centers—for the obvious reason of reluctance to stick their necks out on the basis of their own judgment, while accepting as "safe" the already recognized. In addition to outright contributions, numerous corporations will supply a range of services and facilities: advertising space, travel expenses for special arts groups, and gifts of products. Many artist organizations have been able to furnish their offices for virtually nothing through corporate donations of desks, typewriters, and chairs in exchange for notes of gratitude in their newsletters. Of course, the firms can deduct the value of their donations

from their taxes. In some cases they provide printing and computer time, or expertise regarding tax credits for the art investor, as well as plaza and interior space for art events and exhibitions, especially if the municipality lends help in obtaining the necessary permits.

So far the largest companies, those with sales of more than $500 million, have contributed half of the total business support of the arts, even though they represent only 1% of all U.S. corporations. Much more effort should go to cultivating support among smaller corporations outside the big urban areas.

Artist organizations can themselves engender interest from local companies, for many prefer to assist art in their own communities for local prestige and promotion, especially if they are shown some precedents and a well-conceived project proposal. Occasionally, a corporation purchases works by regional artists for display in employee offices, or underwrites local shows with cash prizes, or matches employee gifts to art organizations.

Prospects may be more promising if your project relates to the firm's business: a department store to sponsor an art benefit cum fashion show; a glass company to underwrite an arts and crafts show. The Business Committee for the Arts can help with information on backgrounds, precedents, and approaches; at the same time you may give them an assist in their valiant efforts to involve new and smaller recruits among corporations. A highly useful tool is the *National Directory of Arts Support by Business Corporations*. It's expensive—$65 for the first edition—but, for an art group, may well be worth it, for it lists the specific arts interests of corporations, officers involved, local divisions, subsidiaries, and affiliates. You may alternatively consult the directory in a public library.

United Arts Funds

Another approach for funds that has particularly appealed to corporations is the United Arts Funds organizations of the American Council for the Arts, operating in 44 U.S. communities in 23 states during 1978 and constantly expanding. These organizations are the equivalent of the United Way in the field of health and welfare. They raise money through a combined appeal, annually, to benefit at least three different arts organizations. Approximately half the funds so raised have

come from corporations; other support, though smaller, has come from foundations and other forms of private giving, and results of employee campaigns in places of employment have been gratifying. The 22 museums on their benefit roster have averaged donations of 22% of those museums' operating budgets.

ART
ORGANIZATIONS

T here are hundreds of art organizations that aim to foster art; most are listed in the *American Art Directory* and the *Fine Arts Market Place*. Their basic aim is usually to engender greater interest in, and appreciation of, the arts of all periods; they are usually financed by the government, foundations, and individual patrons. These organizations are distinct from the thousands of organizations run and financed by artists themselves to improve their lot, and generally not listed in reference compilations. Government organizations for the arts, including the NEA and the state councils on the arts, can supply useful information to artists, as already described. The American Federation of Arts emphasizes its organization and circulation of many art exhibitions throughout the country. It has widespread representation listed in the *American Art Directory* along with directors and addresses.

The American Council for the Arts

The American Council for the Arts (ACA), which acts as a catalyst, adviser, and watchdog, is a national (not governmental), nonprofit service organization. Although it receives some funds from the NEA, it is backed by many private organizations and corporations and the U.S. public at large as "Advocate" members.

The ACA distributes no funds. It does supply information on how best to obtain them; gives art advice to states, regions, and communities; lobbies in Washington on matters affecting creative artists, such as censorship, individual rights, inequitable taxes, copyrights; aids in establishing community programs; gives professional information on art-related state legislation; and publishes numerous special studies on these subjects.

Business Committee for the Arts, Inc.

The Business Committee for the Arts was established in 1967 under the aegis of David Rockefeller. Its expressed purpose is "to stimulate, encourage, and advise" in the fields of both the visual and the performing arts. The Committee raised $825,000 from the 90 corporate leaders comprising its charter membership. The Committee does not itself administer funds. Rather it acts as broker between corporations and various arts groups, for purchases and commissions.

Under joint sponsorship with *Forbes* magazine, it gives annual awards in recognition of corporations that have innovative or outstanding programs in support of the arts. It has encouraged and stimulated the formation of corporation collections: as in the cases of AT&T, which purchased about 500 works of art by young, little-known artists, selected by employees for their offices; and that of Sears, Roebuck, which purchased 2,000 works by regional artists for its "tallest building in the world." BCA has engendered numerous corporation grants to commission artists for work in public places and has persuaded a lot of banks to offer their walls to regional artists. It sees and communicates with many artists and art organizations in a counseling capacity, giving advice about approaches to implement art projects and proposals that might derive aid from the business community.

The committee, which operates across the country, welcomes pertinent inquiries.

Volunteer Lawyers for the Arts

Individual artists and art groups who need legal advice they cannot afford can apply to a tax-exempt organization founded in 1969—Volunteer Lawyers for the Arts. These lawyers handle hundreds of art-related problems each year, from copyright to tax-deduction potentials to incorporation of non-profit groups.

To apply for such assistance, write to their headquarters stating your income and giving a brief history and outline of your problem. If you are eligible, headquarters will refer you to an interested lawyer with whom you can then work; the lawyer charges no fee for his services. If you are not eligible for free services, you can nevertheless learn which lawyer is well informed about your problem and hire him if you wish.

Ethnic and National Group Organizations

Certain organizations are established for particular ethnic or national groups. For example, Indian arts and crafts are periodically shown in various museums in collaboration with the Bureau of Indian Affairs, and in some specialized dealer-galleries, often along with Eskimo art.

Black artists exhibit at the Studio Museum in Harlem, as well as many other places in New York and other parts of the country. In California statewide conferences of black artists are held in Los Angeles and San Francisco. Probably the largest representations of black art have been assembled by the North Carolina College Museum in Durham and Atlanta University's Community Museum. The Rainbow Art Foundation in New York City offers printmaking opportunities to young nonwhite graphic artists, specifically American Indians, Eskimos, Asians, Hispanics, and blacks; the Foundation awards scholarships for study and circulates exhibitions internationally.

Work by artists and craftsmen from remote countries of the world can be seen at the Carnegie Endowment International Center Building and at the Institute of International Education, both located at United Nations Plaza in New York City. Jewish artists show at the House of Living Judaism, the Gallery of Israeli Art, and the Theodor Herzl Foundation, all in Manhattan. The work of Latin American and Canadian artists is the specialty of the Center for Inter-American Relations in New York City. Canadian contemporaries, including Eskimos, are given displays in the spacious gallery of the Canadian Consulate General in New York. Other sponsored centers include the Goethe House for German art, the Austrian Institute, the Japan Society, the Armenian General Benevolent Union (AGBU), the Kosciuszko Foundation for Polish art, and El Museo del Barrio for the work of Puerto Rican and other Latin-American artists.

Artists from Foreign Countries

Artists from foreign countries should visit their consulate in New York or their embassy in Washington, where an attaché concerned with cultural affairs should be able to direct them to special outlets. (I say "should be able" advisedly, for not infrequently attachés refer artists to the Art Information Center, which is all right, too.)

In addition to centers sponsored by foreign governments, there are certain dealer-galleries that specialize in showing contemporary work from particular countries: in New York exhibitions can be seen of work by artists from Haiti, China, Japan, Africa, Armenia, Germany, France, Israel, India, and the Caribbean. There is even a gallery that shows contemporary Persian miniatures!

Handicapped and Prison Artists

The NEA began in 1974 to formulate plans to lead "in advocating special provisions for the handicapped in cultural facilities and programs." Artists and art groups are, of course, most effective in implementing these aims on the local level. The more active they are, the more likely is their area or project to receive government support for these purposes.

The California Arts Council's division for Artists in Institutions has awarded grants to encourage, promote, and exhibit the work of the handicapped, and to commission works by the blind.

The Industrial Home for the Blind and its day centers in New York State have instituted courses in sculpture and other arts and take groups of children and adults to sculpture exhibitions for "touch tours." Genesis Galleries, in New York City, has fostered such tours under the guidance of the exhibiting artist and has contributed part of its sales commissions to the Home.

Government requirements for all public display buildings receiving federal funds now include ramps and other such aids to make the viewing of the arts accessible to all handicapped people.

There is increasing interest in stimulating art in prisons, not just as a harmless, time-passing device but as a valuable individual expression that develops personal dignity. Some worthwhile products are emerging and being exhibited in museums and galleries. Most needed for wider development are artist-volunteers to aid the prison artists—and to persuade wardens to permit instruction and critiques.

After the 1971 Attica prison riots, the noted black artist Benny Andrews, as a volunteer, started once-a-week classes at New York City's "Tombs" (now House of Detention) in an effort to divert destructive energy into constructive cultural channels. There are now programs all over the U.S., in houses

of detention, juvenile detention centers, and prison hospitals; some are financed in part by the NEA.

Under the aegis of Benny Andrews, a Black Emergency Cultural Coalition has been established to reach black prisoners. Although organizations like the Ethical Culture Society and some museums—occasionally with grants for the purpose—do exhibit prison work, Mr. Andrews feels it is more important to stimulate art activity and experience than to try to develop truly professional artists. Other fields of prison study include creative writing, especially poetry, that also offer important exposure to culture.

The problem in obtaining needed participation from artists and other teachers is largely geographic: prisons are isolated, and it is difficult to travel to them on a regular basis. In some cases the most dedicated teachers are ex-convicts. One, from Auburn, a maximum-security prison in upper New York State, graduated cum laude from Syracuse University and has worked especially with juvenile delinquents.

Specialized Groups

There are organizations specializing in just about everything: for watercolors, the American Watercolor Society; for work by women, the National Association of Women Artists; for sculpture, the National Sculpture Society and the Sculptors' Guild; for crafts, the American Crafts Council; for photography, the International Center of Photography; for murals, the National Society of Mural Painters; for casein painting, the National Society of Painters in Casein and Acrylic; for work related to the performing arts, the Library and Museum of the Performing Arts, of the New York Public Library; and for health aspects, the Center for Occupational Hazards.

These organizations, plus many others, can be found in the *American Art Directory* and the *Fine Arts Market Place.* Because new editions of these directories appear only once every two years, the current directories, perforce, cannot include new organizations, which are constantly developing. Moreover, the officer listings for art organizations, museums, and art schools lag far behind personnel changes. It is a pity that supplements are not published at least annually to list additions and changes, as is the practice of the *Art Index.* This valuable reference issues paperback supplements every few months.

Many art organizations listed in the directories have no particular specialization: Allied Artists of America; American Society of Contemporary Artists; Audubon Artists (which has nothing to do with pictures of birds, as some artists have believed, therefore mistakenly avoiding the various activities of the group); Knickerbocker Artists; National Arts Club; and Kappa Pi, the international honorary art fraternity with chapters in colleges, universities, and art schools throughout the United States. Most of these organizations periodically exhibit their members' work and also select for showing, either by jury or membership vote, work submitted by nonmembers. Many organizations that do not have adequate exhibition space of their own arrange to use existing galleries, such as museum community galleries, display spaces of regional art associations, college or art school galleries, public or commercial buildings with suitable exhibition potentials. The owners or operators of some of these facilities, especially those commercially financed, usually make them available only to acceptable groups to use for exhibition purposes. It would be pointless for an individual artist to apply directly for such space.

Colonies

Probably best known of the arts colonies that accept visual artists are the MacDowell Colony and Yaddo. These colonies offer a quiet, concentrated period of work in country-estate surroundings, with residence privileges (room and board and studio) for periods of one to three months. Work is passed on by admissions committees, which usually require some professional accomplishment. MacDowell offers about 175 residencies per year; Yaddo, about 100 grants per year.

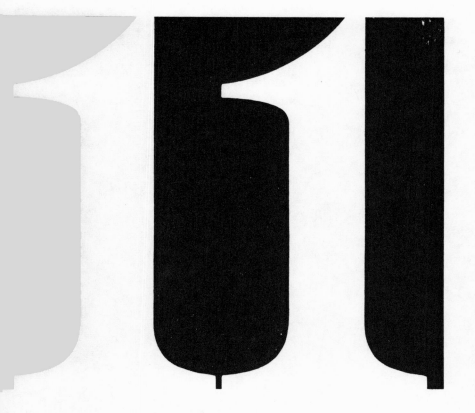

ARTIST
ORGANIZATIONS

According to some semiofficial estimates, there are at least 2,000 artist organizations in the U.S. There are no definitive lists, and no one can really determine how many informally organized groups—the ones that frequently spring up and sometimes vanish—may exist.

Where Can You Go to Talk Art?

There are about 1,000 art schools in the country. Periodically such institutions arrange public discussions and display work by faculty and students, outlets that provide some measure of exposure for artists and the opportunity to meet and exchange ideas. We in this country lack one of the most charming and conducive systems of communication, so common in Europe. We do not have the café or coffeehouse that is the designated meeting place where artists can drop by on a particular day of the week, knowing they will find other artists of more or less their persuasions and interests with whom they can engage in stimulating conversation and discussion.

Many artists new to New York have asked me, "How can I get to know some other artists here? Where can we talk art? What artists' organizations are there?" I can only deplore the absence of this old European rendezvous arrangement and wonder why we have never developed it. Perhaps it is because we have the barbarous (to Europeans) habit of rushing home to a six o'clock dinner, thus leaving ourselves no free time in the early evening for *l'heure de l'apéritif*. Perhaps it it due to our insistence on being efficient, on inflexibly plotting by calendar each hour of the day. Perhaps Americans are more geared to spending all spare time with spouses. Whatever the reason, our artists are

missing out on a rewarding experience, one which has engendered many group activities and many stimulating individual developments abroad. Some years ago I worked with a number of Europe-oriented New York artists to establish an *heure de l'apéritif* rendezvous near the Museum of Modern Art. First we found that though they were theoretically interested, artists were running to catch the next bus home. Then the restaurant, whose back room we had been able to commandeer once a week, folded up! Perhaps some American artists can make a more successful arrangement in a city less harried than New York.

More and more artist forums and panel discussions are constantly developing around the country—generally in rent-free spaces such as co-ops or other galleries, in public library meeting halls, or college classrooms or auditoriums. A good example is "Artists Talk on Art," which meets on Friday evenings during the art season in New York's SoHo (not to be confused with London's Soho, the New York SoHo is an acronym for South of Houston Street), with coffee, conversation, and scheduled panel discussions, for a $1 admission charge. Another is a coffeehouse meeting place organized by the Center for Visual Artists in Oakland, California, where artists and community people can get together informally. These group activities are often attended by artists who have lots of lively questions to ask and rebuttals to make. After the session is declared at an end, it can be difficult to get the audience to go home and allow the meeting place to be closed. The gatherings frequently stimulate subsequent discussion, conversation, and airing of beefs. Some meetings are geared precisely in this direction: one provocatively announced, "Though the panel participants are of diversified backgrounds and convictions, the focus will be on positive thoughts and approaches, and is in direct opposition to those 'Talks on Art' which propagandize a single point of view, resulting in a further splintering of the art community."

Some discussion and exchange of ideas take place at exhibition previews in museums and galleries, although here the tendency is more toward socializing. For really "chewing the rag," artists often assemble in one another's studios.

Existing artist organizations have many functions. Some provide an opportunity to mingle with other artists. A number have been formed in order to promote additional displays and

activities for greater audience, publicity, and sales. Some organize summer shows and demonstrations; some promote exhibitions in public or commercial buildings, which are increasingly receptive to such activities. Many groups are not hard to join if your interests are similar. Annual dues are not high, generally ranging from $10 to $25 a year. In many cases artists who are already members vote on the new applicants, usually after viewing their work and their records (frequently no formidable ordeal).

Artists' Equity Association, Inc.

Artists' Equity Association, Inc. (AEA), functions somewhat like a nationwide artists' union, with constant efforts toward improvement of the artist's lot, promotion of outlet and acceptance potentials, and dissemination of factual and practical information, ranging from pertinent tax and legal tips, to sources of grants and fellowships and upcoming open competitive shows. It is a membership organization not difficult to join, which offers group rates for health insurance, holds periodic forums and panel discussions, publishes newsletters, organizes for action on art-related legislation, and often serves as a catalyst for exposing complaints and controversies.

Founded in 1947, AEA has since undergone various metamorphoses. A national organization with more than 20 chapters throughout the country, it welcomes affiliate artist groups, which function autonomously, as subscribers to its Legislative Update, a comprehensive and comprehensible summary of pending art bills. It helps its affiliates with their grass-roots lobbying efforts and with local conferences on legislation, as well as representing them in its Washington lobbying activities if so desired; supplies them with its newsletters; and offers them participation in its insurance plans and legal services at group rates. Affiliates have no vote in AEA, and AEA has no interference rights in an affiliate's operations. The membership fee is $25 per year. Write the national headquarters for the address of your nearest chapter or for information on how your artist group can become an affiliate.

Local and Regional Organizations

There are many very active groups around the U.S. that operate on similar bases but on a more local level: in New York, the

Foundation for the Community of Artists; in California, the Center for Visual Artists, and the Artists for Economic Action; in Massachusetts, the Boston Visual Artists' Union, and the Artists Foundation, Inc.; in Illinois, the Chicago Artists' Coalition; in Texas, the Artists' Coalition of Texas.

All these organizations have been activist, influential, and helpful to the artists of their localities and states; all publish informative newsletters. There are many more—such as two in little Rhode Island—and they are expanding constantly. If you seek local artist groups to join, you should be able to learn about them from your state arts council or from artist-friends. To be effective, they need participation, backing, and ideological support on matters that affect your livelihood and welfare, your recognition and protection. They must be able to indicate validly that they really represent you and a good number of other artists when they undertake, for example, to testify for artists before public hearings in Washington and state capitals. Every fall, campaigning politicians hold local meetings, with questions invited from the floor. Don't forget: you are voting constituents. Today, there are always bills pending, federal and state, that affect the arts. Ask the candidates how they stand on these issues. Even better, get other artists to back you up. If you are a part of a co-op gallery, an artists' union, a local artist association, ask for a vote of the membership to determine its position on upcoming art legislative issues. Then, in questioning candidates or communicating with legislators, you can say, "We represent X number of artist-voters."

In weighing the value of artist organizations, it is perhaps important to consider the lack of any clout on the part of visual artists. In 1974 a prestigious independent committee of fifteen professionally qualified citizens produced a forthright report after seven months of privately funded study of New York City's cultural policy; their findings, they felt, related equally to the problems of artists elsewhere in the country. As reported by the chairman, Martin E. Segal, the revelations and recommendations—both devastating and enlightened—pulled no punches and continue to be highly pertinent.

One comment: "The individual artist is the driving spirit of the city's cultural life . . . creative individuals face a constant uphill struggle to survive while maintaining their artistic integrity. The same needs for funding, facilities, and services that

face other cultural groups exist for artists also; yet their problems are compounded by the fact that as individuals they are neither 'visible' nor organized, which means they are unable to exert unified pressure." It is probably only organized artist groups that can muster this pressure.

The museums are not doing it for living artists. They are much too concerned about their own promotion and financing. They have their own lobby in Washington, the American Art Alliance of institutional members, who are often in adversary positions to artists. They have a way of forgetting that they would not exist except for artists.

AEA has been proposing to government for some years that museums receiving federal aid, which virtually all do, be required to give artists more voice on museum boards and to show local creative work to their communities.

Art administrators—public and private,—government and museum—tend to put emphasis and funds into projects aiming to reach the widest possible audiences as a form of adult education, rather than into stimulation and support of those who produce art. Both are worthy aims, but if creativity is sacrificed for popularity, where will the source material come from? What will nurture the creators? And without them what will the adult education amount to? Perhaps the administrators should be reminded that following the eight WPA (Works Progress Administration) years (1935–1943) of direct though small payments to artists, more than 80% of them continued as productive artists.

Museum Unions

In 1971 the first union of museum professionals in the U.S. was established under the National Labor Relations Board: the staff of the Museum of Modern Art in New York became Museum Local #1, the Professional and Administrative Staff Association, known as PASTA. Subsequently, the staffs of many other museums have unionized.

A major objective of PASTA required staff participation at managerial and trustee meetings; and its chairman now attends all meetings at the highest managerial level and has the right to address the trustees on any policy matter under consideration by the board and to channel ideas and collective expertise into the decision-making process.

Although museum unions basically represent the staff, it is usual for many artists to work in museums as employees. Thus a certain measure of artist representation and voice in museum policy may be getting in by the back door.

When the Chicago Artists' Coalition was established in 1975, its first stated objective was for "a larger, more unified community of artists, to secure artist representation on all boards—state, city, museum—which affect artists' work and livelihood." Other artist groups have followed suit, but not enough.

Reports from England, Canada, Ireland, Holland, and Scandinavian countries, among others, indicate not only better organization but also greater acceptance of artists' demands by the art establishment. Perhaps artists should emulate the farmers—even more isolated than artists—who organized unofficially to demand a voice at a World Food Conference in Rome. No farmers having been invited, they arrived anyway to declare, "A conference doesn't produce one iota of food; it's the man behind the plow."

Art Information Centers

With all the proliferation of artist organizations, there are still too many that are ingrown, too "involved in presentation in their own right," as pollster Louis Harris found in his surveys. "They fail to bear out the image of typical community arts agencies as essentially service-oriented." The tendency is to obtain space for showing their work, mostly to one another, and to send out newsletters to members to report successes of other members.

Obviously, the Art Information Center in New York (see Introduction) cannot adequately serve the country at large. There are now many potential exhibitions and sales outlets around the country; New York is not the only mecca to which artists must make expensive and by no means always fruitful pilgrimages. Moreover, artists who do want to show in New York fare better if they first gain as much recognition as possible locally and regionally.

Organized groups of artists are the logical clearinghouses for practical, serviceable art information; they also provide display space for artists' works, and an avenue for those interested in talking with other artists. Some "tools" for operation, such as setting up certain files, are required. But there is no need to

duplicate what is readily available elsewhere, such as up-to-date reference material that can be found in the library, if the group keeps on hand a referral record of where to look for certain kinds of information. Cooperation with other organizations makes more sense than duplication or competition.

Some basic files that could be helpful to artists and persons interested in art in your region include:

Alphabetical files of area artists. List present and past exhibitors of their work; direct people who wish to see or buy their work.

Files of duplicate slides of work by local artists. These help dealers in finding new talent as well as the public in locating such work, thus becoming another outlet for artists as an alternative to galleries. Such files in New York have proved useful sources also for the art press, museums curators, and organizers of special exhibitions. These files can be arranged alphabetically, with color coding indicating medium: for example, red for painting, yellow for sculpture. Gummed labels, available in different colors at your stationery store, can be affixed to the outside of the folder for this purpose. Your members and other interested artists will supply slides and resumés. Of course, a projector is a distinct asset, but if unavailable, a couple of hand viewers will serve.

Files of brochures and catalogs of shows at area galleries. These indicate the kind of work each gallery handles. Get on gallery mailing lists. With feedback from group members, you can learn and record the terms and practices of local dealers, which is very useful information for artists contemplating exhibiting. Thus you can warn artists about any gallery that is nonprofessional, which no government organization, such as your state council, can ever do.

Sources of grants, fellowships, scholarships. In many cases you can refer inquiries relating to this type of aid to the standard reference publications on grants (see Chapter 19). If your public library does not have them, it should either buy them or obtain them on interlibrary loan. You might benefit by obtaining and filing any regional information, available from your state council, on local grants, internships, apprenticeships, and artist-in-residence programs.

Upcoming open exhibitions, competitive shows, their fees, and their jurors. Look up the jurors in *Who's Who in American Art* so you can indicate their caliber to your interested members. Keep a calendar of deadlines for entry submissions.

Spaces and facilities for studios, workshops, equipment, working from the model. Ask members for input.

Courses available to develop special skills. Check with regional schools and universities.

Organizational Information On How To Set Up A Cooperative Gallery (see Chapter 13).

Volunteers Available For Work In Museums and Art Organizations. Supply these services only as an impartial clearinghouse function, *not* as an employment agency. There is no need for your group to recommend volunteer workers: just give the facts and let the volunteer and the organization decide between themselves.

Nationwide Organizations. Record nearest branch offices, functions and uses of such groups as American Council for the Arts, American Federation of Arts, BCA, Volunteer Lawyers for the Arts, AEA. If these do not appear in your local telephone directory, write to the national headquarters of the groups for the location of the nearest office (see Chapter 21 for addresses). Members who call with queries will benefit if you have such data handy and can suggest sources of this type, where applicable, to those who may not be aware of the potentials.

Federal, State, County, Or City Buildings In the Planning Stage, And Their Architects. These records assist artists who wish to apply for commissions, particularly under the 1%-for-art rule in public buildings. Check *Dodge Reports,* (your library has copies), and local building departments. It's necessary to get in "on the ground floor" to obtain such commissions; the art for a building is apt to be determined—often by the architect—in the original contract before ground is broken, sometimes before word has reached the press.

Up-to-date Mailing Lists. Prepare lists of local art critics, galleries, art organizations, and museum curators of contemporary art, for mailing releases, brochures, and newsletters. These can be compiled from listings of art critics and museum personnel in

the *American Art Directory,* from gallery ads and listings, and from your state council on the arts and other art organizations.

Shipping and insurance information. Check local services of United Parcel Service and the Post Office, and the package express services of the Greyhound and Trailways bus companies and the airlines. Ask insurance agents about the terms for an "art floater" policy.

Pending or proposed legislation affecting the artist. Specify import, congressional proponents, deadlines for activity. This information is available from the American Council for the Arts, *The Washington International Arts Letter,* and the reports and newsletters of AEA (national headquarters).

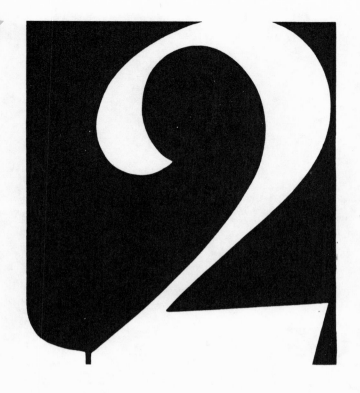

EXHIBITING
WITHOUT GALLERY
AFFILIATION

If you have not yet had any showings—and even if you have had some—you may need to build up your art background and experience before any recognized dealer will take you on. It helps a dealer when he can say to a vacillating customer that your work has been selected by some well-known jury, juror, or institution. If he has to admit you have never shown anywhere, his sales job is infinitely more difficult.

Juried Exhibitions and Competitive Shows

One way to make your art background more impressive is through open competitive shows. A really good dealer in a major art center will submit your work for you; but if you do not have this kind of conscientious or knowledgeable dealer behind you, it is your job to enter the work yourself.

Fairly comprehensive, but not complete, lists of competitive exhibitions are to be found in *American Art Directory*, at the back, and in *Fine Arts Market Place*. These reference volumes are available in any good art library. To inform yourself about the dates of these shows, consult the monthly art magazines, read the AEA newsletters and *Art Workers' News*, and pay attention to announcements posted on bulletin boards of art schools, university and college art departments, and artist organizations.

American Artist, for example gives monthly listings under the heading "Bulletin Board." This is not a selective listing; all shows for which listing fees are paid are published. Here, in fine print, you can find the forthcoming exhibitions to be held in various parts of the country, with details about how to enter and deadlines for application. *American Artist* is a nationally dis-

tributed magazine and should be easy to find in libraries. Consult it the first of each month, right after it appears. This procedure is advisable because some listings may require you to apply for entry blanks by the eighth or tenth of the month.

A small entry fee for handling is charged by most organizers of such shows. This practice is under heavy fire by some artist organizations, particularly because rejected artists generally receive no refunds; and, they argue with good reason, there would be no exhibition without the artists.

In some cases—as when only 100 artists are accepted, from, say, 2,500 applicants, all of whom paid $10 apiece—it means that those rejected paid for the show with no benefit to themselves. Nevertheless, the practice is still fairly widespread. Frequently, you are first asked to submit 35-mm color slides for viewing; those which prove of interest may be marked and returned to you with a request that you send the originals for final decision by the jury.

Local and Regional Organizations
There are many local and regional organizations throughout the country. Some are connected with a museum, as, for example, are the artists of the Cumberland Valley area who put on an annual exhibition in June at the Washington County Museum of Fine Arts in Hagerstown, Maryland. Some art associations and leagues, in areas where no museum exists, help to fill the gap by holding regular exhibitions, competitions with awards, clothesline shows, lectures, classes, and sketch nights. Community art associations frequently utilize local libraries as their show places. Regional groups also exist in most parts of the country. For example, the Pacific Northwest Arts and Crafts Association in Bellevue, Washington, exhibits regional work—all for sale—in juried and open shows and in outdoor fairs in July, with awards and with purchases that are subsequently circulated to schools and municipal centers in the region. Not infrequently, university and art school galleries also serve as centers for regional exhibitions.

Annuals and Biennials
There are numerous annuals and biennials around the United States that are well worth trying to enter. Some—like those sponsored by New York's National Academy and the Audubon

148

Artists', are located in art metropolises. Others—like those at the Butler Institute of American Art in Youngstown, Ohio, and the Print-Drawing shows at Davidson College in North Carolina—may seem far from major centers of art purchasers, dealers, and critics. Don't turn up your nose at them because of their geographic location. They have good juries; they publish well-illustrated catalogs, which get around to dealers, museums, and critics; and they have purchase prizes. Inclusion in such shows will certainly help build up your reputation.

Jurors

Not all competitive shows are worth entering, however. You can learn something about their caliber from the entry blanks, obtainable free on request, which spell out terms and purposes, and usually list names of jurors. If they don't list the jurors, write to ask who they are. If you don't know who the jurors are, look them up in *Who's Who in America* or *Who's Who in American Art*. Usually, a jury listing will include each juror's credentials. A good juror is most unlikely to lend his name or support to a phony show.

A well-known juror can make all the difference between a show worth entering and just a nice local art activity with no broader value. Some local and regional art groups are sufficiently enterprising and farsighted to obtain top-notch jurors for their annuals, which, though limited to artists from the area, often are not limited to their own members only. Even busy and prominent art experts like to gain insight into art activities taking place in various parts of the country. The advantage to the participating artists is obvious, since they can say their work was selected by a well-known juror. Moreover, local press, radio, and television give more complete coverage to the shows because of the visiting expert.

To enhance the importance of their shows in this way, members of local or regional art associations must be willing to put up the funds for a round-trip ticket and a modest honorarium—perhaps $100. ("Honorarium" is the polite term for a sum insufficient to be called a fee for the services rendered.) The visiting juror is usually entertained for two or three days in a private home; he may appear on television and radio; he may give a talk at the local museum or to the association's members while he is in town. Once an association has obtained

149

a noted juror, it paves the way and makes it easier for that organization to persuade other potential jurors to serve in ensuing years.

In the case of the smaller show, art organizations may find it more feasible to obtain the services of a nearby college or university art department chairman or a local museum curator or director; the jurying process may take only two or three hours, it may not call for transportation over considerable distances; and a $50 honorarium may be adequate. Noted local artists are, of course, frequently invited to be jurors.

A lot of artists are eminently capable of objectivity and can thus appreciate many veins of work and recognize creativity wherever they find it. On the other hand, many artists are limited to their own vision, and this may be the life-style that is completely essential to their work. It is no measure of excellence in their own work if they are unable to extend themselves effectively to other functions. Thus it is understandable that many artists, seeing the name of an artist-juror whose work they know to be antithetical to their own, simply do not bother to submit. Often they are right; they haven't got a chance. By the same token, it is understandable that museums are diffident about utilizing artists on their boards as determiners of policy contemporary art, its exhibition, and acquisition.

But where artists are possessed of the requisite perspective—probably a minority—the would-be competitor is wrong to refuse to submit, regardless of the work style followed by the artist-juror; and the museum is wrong to eschew his advisory services. In each local situation, determination regarding an artist-juror's objectivity can be facilitated by observation of his teaching, jurying, and writing style; his students' work and comments; prizes he has awarded or selections he has made on prior occasions. One pitfall to watch out for is the artist-teacher-juror who awards everything to his own students—about which there have been numerous complaints. Perhaps jurors would exercise more impartial judgment, instead of false allegiance, if they were brought in from another region so they would be less likely to know the competitors.

Some of the competitive shows conducted by institutions and organizations are aimed at only one style of art. This style may not be in at all your vein, and hence it would be futile for you to attempt to participate. You can usually judge its suitability by

the entry form's description of the exhibition aims and the type of juror engaged. On the other hand, don't be misled by a name such as "National Academy" into believing its shows will include only old-fashioned academicians. Actually, the Academy's shows include a wide variety of styles and directions.

Fraudulent Shows

Watch out for the kind of competitive show whose aim, if you read between the lines, is purely to enhance the public-relations image of the sponsoring organization. Some hotels, for example, have advertised "competitive" shows to be exhibited in their lobbies. They often "fudge" about who is to make the selections, using vague cover-up phrases like "juried by noted art experts"—experts who never materialize. They offer some prizes—and charge the artists enough per entry to pay for them. Such exploitative competitions are likely to accept all submitted works, without selection, as long as payment is received. Its promulgators hope for hotel publicity by getting on the art bandwagon, aiming to maneuver the show so that you, the artist, will pay for it without benefit to yourself. Shows like these are not covered by prominent critics or museum curators. Instead of adding to your art background, they just drain your pocketbook.

A notorious example of fraudulent art fairs was the big "Da Vinci" art festival, which was a widely advertised and publicized fly-by-night operation. Space was rented at New York's Coliseum; large prize monies were promised as well as exhibition space; thousands of works of art and thousands of dollars in entry fees poured in. The operators went broke before the festival opened. Had it not been for quick and effective action by the then State Attorney General Louis Lefkowitz, the artists' works would have been sold to pay the operators' creditors. But there was no way to reimburse artists for their considerable losses in packing, shipping, and insurance costs, and fees.

During the bicentennial year another such sham was perpetrated. In this case a widely distributed slick red-white-and-blue flyer urging American artists to show in Paris to celebrate the U.S. birthday. For this "privilege," artists paid $200 per work. A publicity gimmick for French travel and transportation agencies, the show was conducted by their public-relations officials; there were no jurors, no recognized sponsors. Some 1,500

works, representing $300,000 paid by the participating American artists, went to Paris via the French transportation agencies who dreamed up the hoax and thus cost themselves virtually nothing, while persuading many of the artists to travel on their lines to see their works. Geographically, the exhibition space in Paris was totally unrelated to the art world; the few reviews were bad; many works returned damaged; some never returned. Some of the artists brought suit. But the lengthy headaches and inevitable costs of an international suit are much less effective than an initial boycott.

Don't be taken in by any proffered showing that is going to cost exorbitant sums and has no reputable art names or organizations as sponsors or jurors.

Department Store Galleries

Department stores are becoming increasingly involved in contemporary art, many having established separate areas for galleries within their precincts. Though by no means a new departure, this activity is definitely becoming more widespread. An occasional department-store gallery, such as Gump's in San Francisco, is generally accepted in the same category as other professional galleries in town.

So far, however, the majority of these galleries have not made the grade professionally. A kind of snob rejection still prevails. But time, as well as careful selection and operation, could break down opposition. There is, indeed, a substantial argument in favor of these outlets, which offer something of a captive audience and which do not intimidate the young or new purchaser who is apt to think—quite incorrectly—that if he even walks into an art gallery he won't escape without shelling out a sizable sum. He (or more often, she, in this case) feels more at ease in a department store, where he knows his way around and understands how, if need be, to apply the requisite sales resistance.

A number of department stores have started galleries that emphasize "safe" work by big names—often in the less expensive graphic mediums. In some instances the examples are dubious; they may be lithographic reproductions of original lithographs, misleadingly advertised as lithographs by the artist. Too few purchasers know how to determine whether they are buying from a genuine "limited edition", and too many are

taken in by misleading labels and ads. This dubious practice, only occasionally found in department stores, is, unfortunately, not hard to find elsewhere.

One hopes that departmentstore galleries will demonstrate more courage about taking work by newer, less-known artists. Their approach and quality, of course, depend upon the caliber of the gallery director and on the degree of independent judgment he is allowed by his employers. As attitudes become more enlightened, department stores may become promising outlets, providing contemporary artists with a growing market.

Bookstores

Some bookstores also set aside areas for art galleries. Sometimes they specialize only in original book illustrations. In other instances they express a genuine interest in contemporary, nonillustration works of art. Within its domain on Fifth Avenue, the old established Brentano's in New York operates the Galerie Moderne, where group and one-man shows—often by younger artists—are a regular feature. In other cities where there are fewer art galleries, bookstores may generate more art activity—not necessarily because they are nobly filling a gap but perhaps because they are "latching on" to another sales potential. If a good bookstore in your city has not before shown art, try to persuade the owner that it is the coming thing to do so.

Be prepared for the "safe" attitude in some of the big bookstores which do display art—but only by well-knowns. An artist who came to see me the other day said she had gone to Rizzoli's, a *de luxe* Italian bookstore in New York which shows and advertises big-name art. She was told, she said: "You will only become the two-thousand-and-first on our list of applicants." It is not hard to tell, just by looking around, which firms show only established artists; it may be a bit harder to persuade them to alter their policy.

Banks

With all their dull architecture built from the wealth derived from our pockets, banks have taken over huge street-level areas with great display fronts of plate glass and thermopane. Yet they have nothing to display, which makes walking along the avenues a pretty boring affair. A few banks vaguely aware of their lack of eye appeal, have been willing to use their great

picture windows for art—even, occasionally, for a pretty female artist actually painting on the spot. A new and fancy branch of a savings bank opened in my neighborhood with more street-front display windows than any ten New York galleries put together. There sat a young lady painting, gawked at by all kinds of people on the sidewalk, from the soup-kitchen line of the nearby charity house to the brokers of the nearby stock-exchange house. After the opening weeks, however, no more art was to be seen.

Obviously, it is going to take enterprise and boosting on the part of artists if they wish to jolt these firms out of their familiar and comfortable ruts, but it has been and can be done. Individual artists and groups, such as AEA and BCA, have more often engendered such activities in banks than have the banks' own personnel. Even though this kind of display has not yet commanded much professional recognition, the enormous viewing advantages of these showplaces make them potentially prime art-display spots. This is what happened at Lever House on Park Avenue, whose directors long ago realized they could not make appealing shows out of acres of their soap, and so gave over their exhibition space to art. Exhibitions at Lever House are recognized professionally and do get reviewed. Besides, they can be seen day and night, for they are lighted after the building closes and are fully visible from the street through the glass walls. The Lever House managers simplify their role as arbiters by accepting work by established groups only; these groups encompass many artists and styles. There is no reason why bank outlets, if intelligently and imaginatively administered, cannot achieve the same status.

Libraries

All over the country, libraries are devoting more and more space to shows of contemporary art. Again, much has been achieved by artists themselves. A happy example is the public library in a little New England town that I visit on weekends. In recent years the library's volunteer board of directors was persuaded by one of the directors, herself an artist, to permit her to organize regular shows of contemporary art on the library walls. The library has been buzzing ever since with art and artists—some local, some imported—with openings and, in good weather, outdoor sculpture on the lawn. Good local pub-

licity and sales have resulted, as well as a new awareness of art on the part of many local residents, some of whom have been inspired to make their first art purchases. Libraries have tax-supported space and a regular audience; generally they simply need some help and know-how to start such an operation. The chances are that most libraries will welcome a practical suggestion, a plan of operation, with installation and publicity arranged by the artists.

In big cities certain branch libraries specialize in art because of their locations; some of them have specially designated art galleries. There are, for example, galleries in two branches of the New York Public Library: in the Donnell Library; because it is located across the street from the Museum of Modern Art; and in the Schomburg, which for many years was the only major showing place in Harlem for black artists. Some city libraries put on only group shows; others arrange one-man exhibitions. These libraries usually have regular opening previews and often sponsor related talks, discussions, lectures, demonstrations, and films. Works are for sale. Not much major publicity attends these shows in large cities, but they do successfully reach neighborhood audiences. Participating in library exhibitions gives you experience—and exposure of your work under any reputable auspices is not to be sneezed at.

If possible, make arrangements so that the customer can buy a work right off the wall, on the spur of the moment. Keep some spare works in a storage room as replacements.

Unlike some office and government buildings, neither libraries nor banks offer any great security hazard; they are only open when someone is there to watch.

Government Buildings

Many city, state, and federal spaces are generally available, free or at minimal rent, for legitimate art uses. But most artists don't know about them, for they certainly are not publicized, procedures are not standardized, and there is no central reference point.

In New York City an Organization of Independent Artists decided to make a point of looking into such display potentials as city-owned terminals, hospitals, schools, housing projects, landmarks, parks, and even ferries, as well as federal buildings. As a result, these artists have managed to cut through red tape,

have exhibited around the city for a number of years, and have obtained some government funds to defray costs of mounting and publicizing their shows in public spaces. Even the U.S. Custom House in New York's World Trade Center has been activated for the display of fine art. The same availability of public spaces prevails elsewhere in the U.S.

Transportation Terminals
The transportation business is now eligible for federal funds to be used for installing art in its public spaces, whether old or new. Are transportation specialists who are unaccustomed to giving any consideration to art, doing anything about applying for these funds? They probably require needling by artists and their groups to get them to promote and implement these authorized and financed uses of art. You can't leave it up to the traffic manager.

The Department of Transportation issues a free report, "Design, Art and Architecture in Transportation," outlining this legislative authorization.

Churches
One tends to think that liberal religious sects—such as Universalist, Unitarian, or community churches—are those most open to encouraging contemporary art. Indeed, they often are favorably inclined and hospitable to artists; but they don't have a corner on the market. Some of the reputedly staid denominations—like the Presbyterians and Episcopalians—have become interested and are mounting shows in their parish houses, auditoriums, or Sunday-school rooms. Some of them seek out contemporary work that has a Biblical context. It is occasionally apparent that if the title alone has some religious reference, the church will happily include it, regardless of any evident visual relationship to a religious theme. Perhaps a reverent title suffices to justify the show to a Board. Others are unconcerned about content and title.

Churches and synagogues, both here and abroad, have manifested their interest in modern art for many years. They have often led the way, especially in architecture, where church design (perhaps most notably the Catholic and Jewish) has really pioneered, embracing the arts of stained glass, tapestry, mural

painting, sculpture, and altar accessories to embellish their new buildings. Not only have they exhibited, but they have purchased and commissioned works of art as well.

In small communities churches are often interested in showing contemporary art, particularly if they don't have to worry about paying for guards and insurance out of small budgets. Actually, the church is probably safer from theft and fire than an artist's home or studio. Again, in my small New England weekend town, I have been asked on several occasions by a local minister about the possibility of showing modern art in his new parish house. He must really be interested, for we never meet in church but only over a beer in the one local lunch room. Although he has shown many good art reproductions, he has been scared about assuming the responsibility of displaying originals. I suspect that he and many other clergymen in similar positions would happily display work by local artists if these artists offered their encouragement and help in selecting, installing, and protecting the shows.

Furniture Stores

Some forward-looking furniture stores, which are open to the public as well as the trade, make a practice of inviting artists to display work in their showrooms when they feel the art is compatible with their merchandise. Their managers are usually entirely willing to sell the art—often without commission—charging the artist only for such expenses as framing and customer delivery. The works of art and the furniture displays complement one another, and the enlightened manager likes to see his wares thus enhanced. Often these stores change the art about once a month, perhaps showing one painter and one sculptor each month. If you see a handsome display of furniture, with or without concomitant art, it can do no harm to show the store manager reproductions or examples of your work for potential inclusion. Also, the manager with no art in his store may just not know where to get it.

Charity Shows and Auctions

Artists and dealers alike have frowned upon requests for total donations of art for charity, so often and so effectively that most charitable organizations have changed their approach.

Now, when the charities seek works of art for their big fancy sales and auctions, they are more likely to request 25% for the charity and to agree to a minimum price or bid on work. In general, only the auction for charity makes any sense for the living artist to enter. The big regular auction houses usually sell work by living artists only when it is included in a whole collection or estate, and such auctions are not the concern of the artist, unless he can get a resale royalty. There are occasional exceptions, when an auction house like Christie's may organize a whole contemporary show, but such shows are basically composed of works by big-name living artists only.

Suburban Galleries

Some city artists have also found it profitable to go out of town to suburban galleries. They load up a station wagon with work and cruise around showing it. They find that many of these galleries are pleased to have work brought to them on consignment; these galleries charge no expenses and generally expect a commission on sales of only 40%. It is well to keep in mind that people who buy in the outlying areas are not likely to spend as much as they would in the city where they go to make major purchases. So, in selecting works for suburban galleries, remember that smaller works and graphics are more suitable than a major opus. Remember also that any sales in suburban areas listed on your résumé look good to an urban dealer, for they indicate that you have a nearby following.

Studio "Open House"

Artists who have no gallery commitments sometimes hold "open house" at their studios, usually on weekends or an occasional evening. In New York several artists in a neighborhood occasionally get together and advertise that they will all have open house on the same day so that the visitor can easily go from one to another on a single trip. Some artists have sold by this device; others have not. Occasionally, they have received good publicity, as in the case of the "10 Downtown," centered around the New York area where so many artists work. This unusual organization, begun in 1969, rotates the studio viewings among a different set of ten artists each year; each artist selects another for the following year's showings. Thus the

"mantle" is handed on, and a fresh set of shows appears for three weekends each spring, advertised jointly with a map to guide visitors to the ten neighboring locations.

In San Francisco local artists coordinated open studio exhibitions in an area zoned for light industry, where a number found it expedient to rent fairly spacious studios.

The pupils of artist-teachers are also potential purchasers. They usually want to visit their teachers' studios, and this often results in sales.

Barter

Many artists exchange works with one another. I know one artist who had visitors at his studio open house preferred friend's work which he had obtained in a swap. Instead of being insulted, he sold the friend's work. The friend, who had the same privilege of selling the work he had obtained in the swap, was pleased to learn he had another collector. Some artists who are better salesmen than their friends have hung in their studios some work by friends along with their own and have sold for them on a commission basis.

Thus artists, without gallery affiliation but with ingenuity, have been able to devise numerous ways of exhibiting and selling. And the old barter system of exchanging art for needed services or materials has long worked for many artists. Doctors and dentists for years have been noted for their willingness to be paid in art—and not just because they have offices and waiting rooms to decorate (a form of exposure for the artist), for so do lawyers, who are not so noted for taking barter payment. Doctors and dentists are sufficiently interested in painting and sculpture to have established numerous art organizations around the country that periodically show their own hobby work. And there is an occasional expert in both fields—such as Herbert Ferber, one of our most noted sculptors who, under another name, is a highly professional dentist.

The medical-artistic affinity may perhaps be explained only by psychiatrists. But the barter trend is spreading into many other fields, as one artist learned when having a carpet laid in his apartment. The man who installed it said, "You painted these pictures? Well, I'd rather have a picture than the money." The artist was indeed surprised, but he claims that a lot of

159

artists practically live on barter. Electricians, plumbers, wall painters, and accountants have been known to take art in lieu of pay.

Open-Air Shows

There are, of course, many summer art centers and competitive juried shows. These are more likely to take place outside major cities, in summer art colonies, resort areas, or wherever artists organize them to keep lifeblood flowing in the dog days, which are often difficult for art survival and continuation. Summer exhibitions are unlikely to be one-man shows; are generally geared to appeal to the tastes of collectors in various directions and styles; and are usually not in the high-priced brackets.

All over the country there are "clothesline," village-green, or sidewalk exhibitions during good weather. Many of these shows may not amount to anything professionally—they are basically for amateurs—but they may produce sales. Some, on the other hand, are competently juried by professionals and also display invited works by recognized artists. A well-organized outdoor show with jurors, like the former Outdoor Art Exhibit, Boston's annual "June Art in the Park," puts to shame New York's Washington Square show which is available to anyone who rents sidewalk and fence space—an odd practice since the sidewalks and fences do not belong to those who collect the rent for them. There has been talk for years of making the Washington Square show more like Boston's—perhaps this discussion will one day bear fruit.

It probably won't hurt your reputation to show even in the unjuried outdoor exhibitions. Professional artists who when newly arrived in New York unwittingly took their work to Washington Square have been known to go on to reputable dealers who did not hold this against them, realizing their naiveté. But there is quite a bit of work and time involved in such shows: you usually have to be personally responsible for everything, including babysitting your part of the show. The question you must answer for yourself is, Is it worth it? Is it going to add up to something on the record of your art background? On the other hand, it may be worthwhile for local recognition in your area and for revenue from sales.

Fine art and craft art (see Chapter 16) are frequently shown together in the many outdoor fairs across the nation. A survey

160

made by the Chicago Artists' Coalition reported that 60% of their income of artists and craftsmen in the Midwest came from these fairs and that most of them showed in old-established juried exhibitions. These artists and craftsmen liked to travel and make new contacts, to get to know their customers, to exchange ideas with other artists, and to obtain some publicity. They did not like fairs charging a commission rather than a flat fee, for in such situations the best sellers carried the others, and profit margins decreased. Some complained about managers who interspersed crafts and fine arts, making it more difficult for judges to see all displays in their field, and for customers to do comparison shopping—for judges and customers do get foot-weary.

Any admixture of showing, both in outdoor shows and in dealer-galleries, brings up a problem in pricing, resulting in effects on sales potential.

A watercolor artist recently visited the Art Information Center thinking to seek regular gallery outlets as alternatives to traveling around to open-air shows. For some years he and his wife, spelling each other in baby-sitting his shows, had made the rounds of the open-air exhibitions, from New England to Florida, depending on weather. In this fashion he had regularly sold most of his output.

When he realized that should he have gallery representation, 50% would have to go to the dealers, he began to wonder. Would his market bear the increased prices (doubled, in order to give the dealers their 50% commission and to give him his usual price)? Would he sell many fewer and wind up with much less income?

Moreover, I reminded him that if he had New York gallery affiliations, for instance, the dealers would object to his selling in Washington Square at half price. For even when galleries take work on trial consignment and ask no exclusivity, they understandably do demand that other sales outlets be in line with their price structure, especially in nearby locations. Thus his carefully built-up open-air outlets might be severely curtailed, if not cut off entirely.

The watercolorist went away, determined at least to look into my suggested gallery possibilities but at the same time thinking out loud about weighing these against potential losses, as well as against costs of travel, portable racks, motels. I wonder what he

will decide. Perhaps wanderlust will win out over other considerations.

Museums and Lending Libraries

If the museums in your area show contemporary art—and many do—their curator of painting and sculpture, or their curator of graphics, will usually see work, or slides of work, by living artists. It can do no harm to call the curator's office and inquire about the procedure, for systems vary considerably in different museums. The Whitney Museum of American Art in New York, for example, suggests that you leave or send slides along with a return, stamped envelope. Slides should be of recent work, in your current style, each labeled with dimensions of original, medium, and your name. From these, the Whitney picks some works for its biennials and, sometimes, for special theme or medium shows. Don't expect the museums to make comments, judgments, or criticisms of your work. They usually make their own notes, but say nothing to the artist. You have nothing to lose except postage, and you are at least entered in their records.

Even those regional museums that are notoriously old-fashioned about exhibiting modern work are more open-minded about showing their own local artists. They manifest an almost forced attitude of community responsibility, and they are more apt to receive newspaper publicity if their "local boy makes good." Museums just love publicity; it pays off well with their trustees and other donors. Consequently, if you are a local artist, you might as well cash in on this hometown situation.

Some museums have art-lending libraries—often as a special privilege and as a come-on for membership in the museum. People can rent works of art that are for sale, usually applying the rental price to the sales price if they decide to buy the piece after living with it. The rental period is usually limited to about two months.

At New York's Museum of Modern Art works available for rental include only works on paper and a few small sculptures. Collages, photographs, paintings on paper, drawings, and prints are screened for approval by a committee advised by curators. Selections come from dealer-galleries and from independent studios, in roughly equal numbers. Periodic shows are organized by the Art Lending Service from work by artists who

162

are younger or lesser known than those displayed in the Museum's regular galleries. The program is conducted by the Museum's Junior Council of donors. All museums have to pander to their donors in one way or another; the operation by the council of its own special project makes for greater involvement and identification with the museum's functions, and, they hope, more purchases of modern art, and more donations of both art and money to the museum.

Unless the two-month rental results in a sale, the artist receives nothing, the proceeds from rentals being absorbed by insurance and administrative costs. There are pressures afoot from some artist organizations to pay artists 50% of rental fees and not to allow the fees to be a form of installment purchase. Another aspect resented by some artists is the possibility that if their work is not bought by the renter, a pejorative stamp may be put on it—a kind of "used and rejected" label. There may also be a problem if a new work goes in and out of rental over a period of, say, a year; after this the work is likely to be eschewed by the artist's dealer as too old—in pandering to the cult of demand for newest, most recent.

Art-rental services are operated not only by museums but also by some dealer-galleries here and there. Some artists have found them useful for exposure and sales; it may be worth your while to look into this potential outlet.

CO-OPERATIVES

T

he co-operative gallery is becoming more and more popular as an alternative to the gallery system.

Beginnings

Co-ops sprouted in New York City after World War II, often with artist-members, assisted by relatives, doing most of the installation work and manning the gallery on a rotating basis. A number have been sufficiently successful to move into better quarters and hire manager-directors instead of artists "baby-sitting" the galleries themselves. Problems of operating a gallery in New York, with its fierce competition, high rents, and artists scattered geographically, are greater than just about anywhere else on the globe. So the fact that some co-ops have made the grade there should indeed be encouraging for their development elsewhere.

Laying the Groundwork

In forming a nucleus of artists to set up a co-op, it is helpful to obtain work in various styles and mediums, to appeal to various art tastes and pocketbooks. This approach applies particularly to co-ops outside New York City, where there are now so many co-ops that some have felt it advisable to adhere to the New York commercial dealer's usual inclination to display work in one particular direction.

It is also advantageous to keep in mind that you will need people who know about handling money and accounts, who can write press releases, who will do physical labor. These might be artist-members or reliable outside well-wishers whose assistance

can be counted on when needed. At the start you may have only a half-dozen solid and dedicated members to lay groundwork and establish procedures.

Once you have a nucleus of artists, start worrying about money at least six months before opening the gallery. If possible, get a backer—perhaps from industry: paint suppliers or framers, or possibly a firm, like a department store, that may like prestige publicity.

Elect officers. Most important is the treasurer, who needs to realize that whatever monthly dues or initiation fees you establish should cover far more than just normal operating costs. For, as one co-op president puts it, "There are many hidden woes ready to crop up in the life of a gallery, such as worn floors, broken pipes, insufficient wiring, inadequate storage, etc., etc." The nucleus is going to want to expand its membership before opening the gallery. But before anyone joins, it should be made clear that he or she is expected to give time, labor, and money to the gallery—on time, for dues in arrears will not pay the rent, and offers of help next week will not get this week's show on the walls. It is important to have enough money on hand so that you are not pushed into accepting members just for the additional cash.

Besides a president and vice-president, you will need a secretary who keeps minutes of your meetings and who might also double as head of a publicity committee, if you can get someone who has facility in writing. You must also have someone in charge of installations and someone responsible for getting the printing done on time and accurately and inexpensively.

Enlist the interest of the community: emphasize your educational functions for the area; get public opinion behind the venture. Perhaps a local politician will make a public statement of approval; perhaps stores and businesses will agree to mention your shows in their ads as prestige publicity for themselves. The more local acceptance and recognition you achieve, the more likely you are to gain attention and make sales. You are also more likely to obtain donations and backing—not only in funds but perhaps in space and services supplied.

If a department store has sufficient suitable space, it might turn it over to you, either free or at a low rent, with a view to drawing in additional populace. If you offer credit lines, some equipment or skilled services may be donated or considerably

reduced in cost. It is easy to put on a brochure or checklist, "Printed as a public service by . . ." or in a note on the gallery wall, "Lighting kindly donated by. . . ." You can promise donors that you will give them grateful acknowledgment in a gallery ad in the local paper.

To find potential suppliers of these aids, ask the advice of some business or other community leaders, whose names you can then use as introduction and reference when approaching those they suggest.

Space Considerations

Locate adequate space for the gallery that will pass whatever local building inspection is required. You need two display rooms or sections: one for one-man shows and one to house a small sampling of each member's work always to be on hand and easily available for customers. You also need storage space and bins. For storage and for back-room samplings, many galleries find useful the sliding panels of heavy crisscross wire, on both sides of which you can hang paintings and slide them out at will. This is a space-saver, not necessary if you have plenty of room. Sculpture is not so easy to store, but it can often be housed on shelves built to accommodate various heights.

Utilities

By all means check the wiring and lighting potentials. You need a lot of lighting, so the "load" potential of the wiring is important. I went to one opening preview where overloading blew out everything; assembled guests had to grope grumpily down black stairs—certainly not disposing them toward making purchases. Although artist-members can do a great deal of the renovation work, this is an area where skilled labor may well be needed, or required by inspectors.

Lighting needs to be flexible to suit different exhibitions. Simple "spots" that rotate and have magnifying lenses are commonly available and frequently used by galleries. If liberally strung along the ceiling, particularly in slotted runners, they lend themselves to various adjustments so that each different show may have its proper illumination. Avoid any lighting that has a tint or color, for this will distort painting colors.

In addition to essential heating and plumbing, certain "housekeeping" details can be useful. A sink, a hot plate, a

refrigerator, add much to the comfort of anyone spending the day tending the gallery and are useful in serving refreshments at openings and to purchasers as a gracious amenity.

Seeking New Members

Once you have determined your gallery quarters, you may well start looking for some additional artist-members, the nucleus group deciding by vote on the merits of each prospective member's qualifications and work. You should probably never have more than about 25 total, and you do not have to collect them at once, for it is always possible to add members later. The number is predicated on the fairly usual procedure of giving each artist a one-man show every two years. It has been the experience of many galleries that exhibitions need to run close to three weeks in order to catch on. Thus, if each show runs 18 or 19 days (to allow time between shows to set up the next one), and if the art season is considered to be from mid-September to mid-June, there are only 26 exhibition periods in two years. One of these you will probably want to dedicate each year to a pre-Christmas group show of lower-priced works to be purchased as gifts.

The number of members may, however, be varied according to the size of the gallery space. If you do not have enough back-room space to house, say, three works by each member, perhaps you will want fewer members. If space permits two one-man shows at a time plus the needed additional storage, you may be able to take in more artists.

Establishing Fees and Commissions

When you have decided how many artists you want to accommodate, you will need to determine how much each member is to pay in monthly dues and/or initiation fees. These charges are based on your projected costs plus that all-essential extra cushion. You will also have to establish what commission the gallery will charge on sales. In New York a number of co-ops charge $700 to $800 in annual fees and take a commission of 20% to 25%, requiring the artist to pay for publicity for his own one-man show (of printing and mailing brochures, ads, preview costs). In some instances co-ops (unlike private dealers) take no commissions on work sold by the artist. Co-op commissions are always geared lower than those of private dealers.

Rates suggested by these New York experiences may serve to

some extent as guidelines. But you will need to orient your scale to local conditions. In New York the private dealer's normal commission is 40% to 50%; elsewhere it may still be 33% to 40%. Rents are probably higher in New York, and the figures cited are from co-ops that hire manager-directors.

With the newly elected members, you will have additional help for the committees; they will probably volunteer for committees on the basis of their interests and abilities and whom they know in town who could be useful. And there will be more hands to pitch into fixing up the space.

Sprucing Up

The paint on the walls needs to be a noncompetitive background, in, for example, white or sand or pale terra cotta. Peg-board or composition board of a rough-textured type that will not show nail holes is often used to make each new installation easier. Equipment must of course include telephone, desk, file cabinet, typewriter, a few chairs, and perhaps a bench, ashtrays, and vase to house flowers sent to openings. Like the hot plate and refrigerator, much of this equipment can probably be rounded up from friends' castoffs, second-hand or thrift shop sales, or corporate donations which are duly credited. You can probably get away with no liability insurance, but be sure to reduce hazards like rough floors that trip people, projecting shelves that might hit heads, or dark stairs. For openings at which wine, punch, or liquor is served, the "best" galleries are using simple clear plastic glasses, which are inexpensive. Unless you have a big desk from which to serve and on which to set out the glasses and some crackers and cheese, you will need a table or a 4' × 8' sheet of plywood set on legs.

Pricing

Many artists are puzzled about how to price their work. If you have sold from your studio, the price you charged may have been on the low side, especially if the purchaser is a friend. But studio sales entail no gallery commission or overhead costs. When you sell more professionally from a gallery, the privileged friends should easily understand why prices may now be higher. But don't price yourselves out of the market. It is better to start at a lower rate and then, after sales and successes, increase prices, rather than to have to decrease them because of poor sales.

Big collectors who pay big prices tend to go to major art centers for their purchases, but they and others will often buy locally in the lower price brackets. Many galleries in smaller towns have found it wise to show work at prices not over $500 to $600. If possible, check with other galleries in similar localities and do some comparative shopping.

Some galleries believe in the direct approach of putting the price of each item right on its wall label. Others type up a price list (usually covered with cellophane for protection and marked "For Gallery use only," so it will not be carried away), which anyone can consult at the desk. In any case, prices should be visible and easily available, because many people shrink from asking prices.

Insurance

You may wish to carry insurance just on the gallery itself and your investment in it, leaving the insurance of the art up to individual artists. Dealer galleries, which do insure art, usually cover only up to a maximum of about 40% of what the artist would receive from sales, and that only for work while it is actually on the premises. Hence artists who want their work covered while in studio, in transit, or on loan to friends need to carry additional inland marine policies. In a co-op, where costs are shared anyway, art insurance can just as well be left up to each individual. Indeed, there are certain conditions under which it is impossible to obtain any insurance, as in the case of a gallery above a restaurant: insurers fear fire from commercial kitchens and will take no risks. In major art centers like New York and Chicago, art insurance has become very difficult to obtain because of the increase in art thefts.

The possibilities of theft can be diminished by wiring down small, easily snatched sculptures or other works and hanging pictures on cup hooks that can be bent closed. Of course, proper locks on windows and doors are needed, as well as constant, watchful guarding when the gallery is open.

Publicity

Printing and publicity should be considered prior to the opening of the gallery. Some kind of catalog is needed for each show. This may be anything from a mimeographed checklist to a fancy catalog with color reproductions. Try to establish a rapport with one printer so that he will develop a knowledge of

your needs and style of presentation. If he knows that he will be receiving a job from you every three weeks, he may well reduce his rates, so it is a good idea to work out these details with him on a long-term basis before you start printing anything.

The one-man exhibitor often pays for all publicity for his show. Besides the cost of the brochure or checklist, there are expenditures for ads, press releases (which can be photocopied, mimeographed, or multilithed), postage for all mailings, photos for the press (glossy finish, either 5″ × 7″ or 8″ × 10″), and the opening party. In such cases, the decisions about kind and expense of catalogs and parties are usually left up to the individual artist who is paying, as long as results are not undignified for the gallery's image.

Publicity is not a simple matter of leaving everything up to the individual artist; many artists are babes in the woods about such matters. Your secretary or press secretary presumably has more experience in writing releases and catalog material—or will soon gain it. It is often true that *anyone* can write better about an artist's work and background than he can himself. But he can frequently talk about his work if someone interviews him and asks pertinent questions, then organizes the relevant material so gleaned.

Set up a guest book and ask visitors to write their names and addresses. Thus you build a mailing list of interested people. Also ask each member for names of friends who are potential buyers. Send brochures and press releases to the people on this list, as well as to the local press, and invite them to the opening. The invitation to the opening need not be a separate card; it can be incorporated in a brochure or release.

The local press will almost certainly be willing to list editorially (without cost) your shows and hours, if you get copy to them in time to meet their deadlines. If they have no staff members who cover art, give them release material written so they can use it verbatim, and offer to supply an occasional general interest article, either a review or feature story, about the gallery. When selecting photographs to give to the press— whether shots of the gallery, of artists, of works of art— remember that newsprint reproduction is by no means the clearest kind. Select subjects that will have good definition and contrast; don't waste negatives on diffuse subjects or work that is all in one tone.

Remember that everyone reads the "letters to the editor"

section in publications, so solicit letters from co-op members and their friends on various aspects of the gallery's functions, to build up more awareness and public reaction.

To emphasize the educational facets of your operation, you might invite art teachers to make appointments to bring in their students, or Y leaders to bring in groups of their members encouraging these visitors to ask questions of the exhibiting artist and engage in discussions. Perhaps they could also visit the studio of an artist-member. The press secretary can then write up these events for the newspapers, with quotations from the kids and the artist and factual reports to point up how you are reaching into the community. This is news and publicity.

Posters make good publicity. Perhaps silk-screen them yourselves. Place them in strategic shop windows and on the bulletin boards of libraries, clubs, and other meeting places. It is not difficult to persuade people to display a good-looking poster for an interesting and educational purpose.

It is important to let it be known exactly what hours the gallery will be open—and these should be on a regular rather than a sporadic, whimsical basis. It is equally important to be sure that the gallery will really be tended during these hours. I know of one case where a co-op manager arbitrarily decided to leave an hour early. It was just then that three people arrived from out of town, hence they had made some effort to see the show and were thus predisposed to buy. Naturally, they and the exhibiting artist were disappointed and angry, and the gallery's reputation suffered. Better to announce shorter hours, but adhere to them. A few co-ops are open on weekends only.

Certain activities arranged in conjunction with the community may increase publicity and also funds. Perhaps open the season with a benefit show of work by your artists, thus enlisting the cooperation and awareness of those involved with the organization being benefited. Financial arrangements for such shows are often on the basis of one third to the charity and two thirds to the artist, with the charity paying costs, which can include something for electricity and overhead. The charity benefit is a way to reach new purchasers and audiences, as well as being a good news peg for publicity. Sometimes a charitable organization or church wants to hold a "white-elephant" sale or auction in the evening or some other time when the gallery is normally closed. For this they should be willing to pay rent as

well as all costs. (I even know of one instance where a gallery was rented for an evening wedding reception, providing an unusual and much appreciated environment.)

In such cases it is important to have an artist-member on hand to protect your property and works of art against carelessness and ineptness. Too many people are prone to putting fingers on paint surfaces. Never let anyone bring an umbrella far into the gallery; if umbrellas are stacked in a corner at the entrance, they cannot poke holes in canvases.

Some co-ops occasionally put on "guest" shows in off-season—late June, early September—introducing work from another city, that co-op members have carefully selected to maintain their standards. The gallery can charge a 33⅓% to 40% commission on sales, plus costs of light, heat, and publicity. It may thus collect some funds, as well as expanding interest in its operation farther afield. If the gallery is normally closed in summer, and a summer group of artists, craftsmen, and/or illustrators wants to use its facilities, again they will pay rent and costs, and again you need to be sure your property is protected. If the work may be beneath your standards, you can insist that mention be made in their notices and ads that you are not sponsoring the show, merely renting space. It need not be that baldly stated, but they can publish that they "have the good fortune to utilize the facilities" of the art gallery "during its vacation period," which will make your role clear.

In New York, where there are many co-ops, it has been found advantageous to have an "umbrella" organization to which many belong. Artist-Run Galleries, a co-op of co-ops, can get certain materials needed by all its member groups—such as paper for brochures—at wholesale rates. The organization can also coordinate publicity approaches for a number of member galleries to make them more effective. The umbrella group is probably most effective in situations where there are a dozen or more co-ops in the same general area.

There may be a lot of work and thought required in operating a co-op gallery. But it is great to be your own boss, make your own decisions, have the benefit of a pool of minds working together, and benefit yourselves from your own proceeds.

14

CAREER
OPPORTUNITIES

Demands for breadth of background, and development of various interests, are more vital requirements in today's job market than overemphasis on specialization at the expense of broad-based education and training. Even advertising firms seek employees who have not only the requisite statistics and business courses but also imagination and creativity.

Career-Opportunity Opportunists

More grants are available for curriculum-training guidance for arts and humanities occupations: from the Bureau of Occupational and Adult Education, from the U.S. Office of Education, and through the Vocational Education Amendments, among others. More jobs have been created for directors of placement and career counselors in educational institutions at all grade levels. More workshops and symposiums are being held on management and the arts, not only in colleges and universities but in communities.

Too many of these mounting manifestations of interest in the arts are vague, generalized, uninformed, and pointless efforts to get on this particular bandwagon. Career centers and students alike send out mimeographed forms far and wide demanding "free information and publications on jobs, careers, and updated materials at regular intervals." Then these centers apply for a grant on the basis of having issued so many inquiries. They are simply trying to pass the buck, without even sending a postage stamp, and with no basic research, thought, or effort on their part. Children who have not even been taught

to write, send form postcards handed out by their teachers: "I am thinking of going into the art field. Please tell me the different possibilities in the arts, including salaries to be expected, fringe benefits, and schooling necessary."

There are occasionally some meaningful and valuable efforts. Career Opportunity Guidance, an organization in Largo, Florida, has published a pamphlet that reaches school systems across the country. It outlines qualifications for fine artists, commercial artists, and art teachers, stressing "a strong, broad educational background," including social studies, science, and foreign languages; as well as psychology, "since artists paint people, express ideas, and depict human emotions"; travel, "to broaden experience and knowledge"; a "well-rounded cultural background," which together with mastery of the technical aspects of art can help artists to get "bread-and-butter" jobs, for "most artists find it necessary to supplement" what income they get from their works of art. For teachers, the *Career Brief* suggests seeking out the demands in various geographical locations, for there is an oversupply in some areas.

There are now numerous university graduate schools and programs for arts management. You can locate them in the *American Art Directory's* section on art schools and their courses, the *Fine Arts Market Place,* and other standard reference volumes, as well as in the numerous pamphlets, books, and reports published by the American Council for the Arts.

Perhaps not as widely known is the monthly *Affirmative Action Register, for Effective Equal Opportunity Recruitment,* which aims to "provide an opportunity for female, minority, and handicapped candidates to learn of professional and management positions throughout the nation." Its listings are not at all limited to the arts but include many job openings in colleges and museums, whose libraries receive free copies.

A nonprofit corporation, Opportunity Resources for the Arts, covers "a broad range of administrative, technical, and professional activities, in performing, visual, and arts organizations." Not for placement of creative artists, historians, or teachers, it is for employment of those experienced in arts management only: executive directors, administrators, accountants, publicity personnel, fund raisers, curators, and registrars. There is a small annual registration fee.

Aviso, the monthly newsletter of the American Association of Museums, distributed only to individual members (anyone can become a member by paying the dues), contains regular placement listings for museum jobs throughout the U.S.

Other Sources of Job Information

Following are some tools to work with and some examples of regional programs whose counterparts you might seek out in other areas, or initiate in your own. There are no definitive references: new potentials keep popping up, and some older ones disappear. Individual initiative and probing are basic requisites.

Be specific and to the point in your inquiries. I find nothing more irritating than the all-too-frequent query to multifaceted organizations, "What do you do?" or "Tell me what your services are." *You* need to tell *them* what *you* do, what type of service *you* seek, and where *your* interests and skills lie; they must be told what is pertinent.

The Careers Division of the Department of Health, Education, and Welfare regularly publishes pamphlets and surveys on a variety of training programs and careers in regional expansion arts, such as *Grass Roots and Pavements: Art in America's Neighborhoods.* Ask for an up-to-date list of these organizations.

State councils on the arts frequently publish calendars or newsletters listing various job opportunities, or they can supply such information on request.

Art museums generally have personnel departments where anyone can apply. Some will pass on résumés of applicants they can't absorb to art galleries seeking assistants, so your application may serve a double purpose. Most gallery help is obtained via the grapevine or from such museum files, for generally there simply are not employment agencies in the field of fine arts.

AEA and its more than twenty chapters around the country have information about placements from time to time, often published in their local newsletters. The same is true of the Foundation for the Community of Artists, which, under the aegis of the Cultural Council Foundation, has also adminstered some jobs in the arts field, funded under the Comprehensive Employment Training Act (CETA).

For Regional Arts Programs

Arts Yellow Pages, published by the American Council for the Arts, is a directory of community, regional, and state service organizations.

Annual reports of state and regional arts and cultural councils contain good clues to their operations; in some states central bureaus have been formed.

Park and planning commissions, cultural divisions.

Artist organizations and their newsletters.

Community cultural development associations; for example: the Artists' Foundation, Inc., in Boston, aids New England artists; and the Brooklyn Museum, Brooklyn, New York, displays works by local artists, in its Community Gallery, including those by various ethnic groups.

Union of Independent Colleges of Art: career resource center for graduates of its nine member institutions, offering placement services in many related fields. Its publication *Career Resources List* contains a small but useful bibliography.

For Art Teaching:

College Art Association and its Journal lists art-teaching jobs in its "Position Listings Placement Services," mailed to members five times a year; its annual convention serves as a placement resource.

NEA and its Educational Welfare programs: resource centers for teachers; public demonstrations, lectures, and workshops, often organized under universities, museums, state and community cultural centers.

Bureau of Occupational and Adult Education, Office of Education.

For Art Administration and Management:

Sangamon State University, Arts Management Program.

State University of New York, at Binghamton, School of Management in the Arts.

A Survey of Arts Administration Training in the U.S. and Canada; prepared by the Center for Arts Administration, University of Wisconsin at Madison, and available from American Council for the Arts; describes some specific university graduate programs in arts administration, and arts and museums studies in

182

general; and special workshops, internships, and seminars in museum and arts council administration.

State councils on the arts: for internships.

Gallery Management, by Rebecca Zeler-Myer: for administration of dealer-galleries.

For Museum Training:
Smithsonian Institution: publishes and distributes *Museum Studies Programs Directory.* Also training program for museum professionals: free, intensive workshops in specific studio and laboratory projects. Paying fellowships and internships in museum work offered by the National Collection of Fine Arts under the Smithsonian's Office of Academic Studies.

Fogg Museum of Art, Harvard University, trains art historians and museum professionals.

Fairleigh Dickinson University: museum training course.

Ohio State University, College of the Arts: museum training.

Colleges and universities in many parts of the U.S. recommend students for paid internships in museums; e.g., College of New Rochelle.

Museums in many parts of the U.S.: Outreach, Community Development, Museum Collaborative Programs, for training and employment.

For Conservation and Restoration:
Cooperstown Graduate Programs, State University at Oneonta, c/o New York State Historical Association: one-year M.A. program and two-week summer sessions in special areas.

New York University, Institute of Fine Arts: four-year conservation program.

Fogg Museum of Art, Harvard University, Center for Conservation and Technical Studies.

Oberlin College, Intermuseum Conservation Association Laboratory: for graduate students in conservation needing a residency prior to professional practice.

For Artist Commissions:
General Services Administration, Director of Arts Program: for art in governmental buildings throughout the U.S., send slides and resumé.

Artists in Public Places—New England, Institute of Contemporary Art Boston: sponsors ten New England artists for work in public spaces for five summer weeks.

City Walls, commissions for outdoor murals and sculpture in cooperation with New York City government and local communities; disseminates procedural information for other such proposals in U.S.

For Art-Therapy Specialization:

In recent years this field has become so popular that, like law which has attracted more practitioners than the profession can handle with good pay, it threatens to become oversaturated. However, with more doors constantly opening to the new possibilities—for children, senior citizens, the handicapped, prisoners, and hospital patients—the saturation point may be a while coming.

American Art Therapy Association, Inc. is the chief national headquarters: offers active, associate, and student memberships; issues *American Journal of Art Therapy, Newsletter, Code of Ethics, Membership Directory*. Lists available: Training Programs and Schools with Art Therapy Courses; Guidelines for Art Therapy Educators; Regional Groups; Annual Conference Information. Send 28¢ and a stamped self-addressed envelope for each two items.

Pratt Institute, Graduate Therapy Office: art programs, brochure on Art Therapy Expo, reprints of pertinent articles; send postage.

Programs at universities, art schools, teaching hospitals. e.g., Hahnemann Medical College and Hospital, Art Therapy Program, Division of Mental Health; University of Louisville, Art Therapy; University of Kansas, Department of Creative Therapies; Montclair State College, School of Fine and Performing Arts.

National Institute of Mental Health: for information on other such programs forming.

NEA Special Constituency Program: services include help for handicapped artists.

HEW Rehabilitation Centers, whose services include technical assistance in the arts; publishes *Art Therapy Bibliography, 1970–1973* (periodically updated).

Employment potentials include: hospitals; private and gov-

ernment mental health facilities; special-education schools for the emotionally disturbed, retarded, deaf, blind, disabled; community centers involved with drug addicts, alcoholics, prison inmates; nursing homes; geriatric centers; halfway houses. Art therapists are also employed to teach sensory awareness and self-discovery for adults and children in continuing-education departments, special workshops, residence "retreats," collective creativity centers. In some states art therapy is a civil service classification, with established annual salaries.

Publications: *Arts and the Handicapped: An Issue of Access,* and *The Place of the Arts in New Towns,* among publications of Educational Facilities Laboratories; *Taking Part,* by Lawrence Halprin and Jim Burns M.I.T. Press; *Art Not by Eye,* teaching guide for visually impaired adults, from the American Foundation for the Blind.

"FINE" PRINTS AND "LIMITED" EDITIONS

The very word "print" is so ambiguous that there appears to be no way to define it precisely in the field of art, since it applies equally to a reproduction. "Limited" edition is perhaps more explicit but is still open to too many interpretations. There are no universally accepted standards or definitions.

Background

A group of 41 print experts, known as the Print Council of America, attempted to formulate a standard code when they published *What Is an Original Print?* in 1961. There were many, however, who argued with the adjective "original," for a print is a multiple; the only true original is the plate or woodblock from which it was pulled. But it is what is printed that collectors cherish and hang.

The council's code required that the artist alone must create "the master image in or upon the stone, plate, woodblock, or other material for the purpose of creating the print." Yet teamwork between the artist and a master printer was a common procedure for many old masters, and many artists today also would prefer to spend their time creating rather than learning mechanical processes. Moreover, with the many recent technological innovations now utilized inventively by artists, and with the incorporation of photographs, Xeroxes, and other reproductive images, this definition became obsolete; the council withdrew it in 1975 and closed its doors. Subsequently the term "fine print" has been widely used as a substitute for "original print," although this is not a well-defined term either.

Limited Editions

In defining "limited edition," some experts insist that each print should carry not only an indication of the total edition and the serial number of the print but also the signature of the artist both in the plate and again by hand. Yet many highly desirable prints by older masters are not so circumscribed.

These stringencies and requirements may cause complications for artists (a) who don't wish to determine the size of an edition until they see how the print sells, and see no reason not to issue prints on demand as long as images are sharp and results maintain their reputation; (b) who work in more than one color and thus usually don't know the exact order in which each color was printed; hence the sequence may change and the serial number of the print becomes meaningless; (c) who feel that a signature within the work conflicts with the composition (which is why the copyright ruling was changed to allow the signature on the back or anywhere visible).

When does "limited" go beyond the limits? "Obviously, a limited edition is whatever is opposite to an unlimited edition; this means that anything short of infinity could be a limited edition," says Sylvan Cole, director of the largest print gallery in the U.S., the Associated American Artists. Thus the term can be as meaningless as the advertiser's sales pitch "at only a fraction of the regular price," when 99 44/100% is a fraction.

However, it is common practice today for prints to be numbered, largely because the collector demands it, seeking rarity and investment value. Cole goes on to say: "In practice, most fine prints are limited to editions of about 100. Some editions go as far as 300, and a very few exceed this number. Editions in excess of 100 usually sell for relatively little money, or are produced by artists whose work is in such demand that they can go to larger numbers."

These limits are based not just on demand but also on how many times the plate can be pulled without deterioration of the image. Even original copper plates by Rembrandt, of which the North Carolina State Museum in Raleigh owns 96, have little value—except as a curiosity—beyond that of the copper, so worn are the images. Some materials hold up better than others. Plates can be steel-faced and then printed virtually ad infinitum, but much of the nuance and delicacy is lost, and the price zooms downward. You can buy a print from a steel-faced original plate by Goya for about $15.

Unlimited Editions

Unlimited "editions" are printed by some publishing houses, but usually they are reproductive images and not editions at all; they print as many as the market will absorb. Lithographically reproduced lithographs, by Toulouse-Lautrec for example, have been well executed photomechanically and sold as the artist's lithographs, thus begging the question. Some such reproductions may be signed by the artist, usually in pencil, but the only additional value, then, over the price of a reproduction is just an autograph. Artists have signed, often without realizing how easy they were making it for the unscrupulous dealer to pass them off as limited print editions. Many reproductions of this sort have come here from France: recognized reproductions are dutiable, whereas print editions are duty free, as is spelled out in paragraphs 1807 and 10.48 of the U.S. Tariff Act. There have been numerous suggestions that reproductions should be required to be clearly labeled as such, but to date they often are not. The old Print Council suggested that the artist should never sign any reproduction unless this fact was clearly stated.

A number of states—New York, Illinois, California, among others—have laws regarding sales of prints under false pretenses, with misdemeanor penalties. These laws doubtless reduce some of the potentials for duping the buyer. But they do not really put a stop to the cagey dealings of the unscrupulous who find a loophole or a "weasel."

Trial proofs from unfinished states are not part of a print edition, it is generally agreed. But artist's proofs are; thus they become part of certain deceptive practices: not being numbered but believed to be limited, they may be turned out in the same quantities as the "limited editions" or in greater quantities. Other gimmicks include issuing a number of serialized editions on different colored papers, or with Arabic numbers on some and Roman numerals on others, each set starting with No. 1 despite the fact that it is all one much larger edition.

Publishing Prints

If you want to have your prints published, there are many firms around the U.S. that handle expert printing and sales distribution on a solid and legitimate basis. Perhaps check with reliable, established print galleries. Print publishers welcome the submission for consideration of an artist's proof or sketch plus a

group of other prints to indicate ability. The artist should always be able to inspect at any time the publisher's books—the artist has the same rights in this respect, as the IRS—or to request an official business report in order to ascertain how many copies were actually printed, how many sold, and at what price.

Considering the state of semantic confusion in this equivocal art field, it would help if print distributors and galleries made a point of aiding the public in understanding the difference between a reproduction—signed or not—and a true limited-edition print, and the method by which it was created; and then left the purchaser free to decide for himself on the merits of the work and its worth to him.

Meanwhile, the true artist probably only desires artistic freedom and some protection against rip-offs.

CRAFTS AS ART

With the considerable upswing in the crafts-as-art movement, many more gallery and museum outlets have opened up in recent years for display and sale of such work. The artist-craftsman is no longer relegated solely to gift shops and showrooms simply because of the form or medium of his work.

Craft Recognition

A bronze pot may well be a work of sculpture; a stained-glass panel or a wall hanging may be as fully a work of fine art as a painting. New galleries have sprung up around the country specifically to show such work; and older galleries have extended their vision to include woven and batik paintings, sculpture-jewelry, tapestries, and other forms of craft art.

The NEA regularly issues grants to stimulate and foster creative crafts throughout the U.S., although they are far too limited for the needs and the numbers of applicants: in 1978, 1,421 artist-craftsmen submitted 10,000 slides, but there were only 41 Craftsmen's Fellowships. These went to applicants in 23 states, each of whom was thus allowed to pursue his career development for a year as he wished.

The NEA supports the study of communications in the crafts field, an example of which is the *Artist-Craftsmen Information Bulletin.* Formerly free, now by subscription, the sheets supply useful and timely information on grants (see Chapter 19), competitions, conferences and their achievements, crafts-apprenticeship programs, and relevant pending legislation. Government-supported bulletins of this nature have a tendency to come and go; but even if this one disappears, you can doubt-

less obtain similar information from the Crafts Coordinator, of the NEA.

Craft Organizations

Best known of the art-craft organizations is the long-established American Crafts Council, the parent organization of the Museum of Contemporary Crafts in New York. The Council's monthly publication *Craft Horizons*, provides up-to-date information in the field. Also useful is the *Crafts Report* monthly newsletter, and the listings of open and competitive shows in the "Bulletin Board" section, published monthly in *American Artist*; included are many arts and crafts fairs across the country (see Chapter 12). There is a constantly expanding bibliography on this subject. Perhaps the following may prove informative: *ARt & Crafts Market*, published and updated annually by *Writer's Digest Books; Career Opportunities in Crafts*, by Elyse Sommer, Crown Publishers; and *Crafts and the Law*, published by The Artists' Foundation.

17

TAXES AND SELF-EMPLOYED ARTISTS

Commenting on confusing tax measures and decisions in the artist's domain, the American Council for the Arts wrote, "Tax procedures with regard to such matters are in almost complete disarray." Despite this gloomy assessment of the situation, there are some measures the artist can take under consideration, some facts he can assimilate, which may make life easier and perhaps less costly as far as taxes are concerned.

Keep Records

First of all, to qualify as a self-employed artist, you must show evidence of continuous effort to make a profit from art as a profession, to prove you are not just a Sunday painter dabbling in art as a pastime. For this you must be businesslike: keep careful records and accounts of all costs related to your profession as a self-employed artist. If you are also employed elsewhere, such as in teaching, these income and outgo records need to maintained separately. You will need all such reports whether you work out your own tax forms or hire a certified public accountant to do them for you.

There are various pamphlets and tip-sheets to consult, which go into greater and often updated detail, published by Volunteer Lawyers for the Arts, AEA, the Foundation for the Community of Artists, *American Artist Business Letter*, *Art in America's Art Letter*, and others. But some basic accounts to keep are those related to sales receipts; payments received for such art activities as lecturing and jurying; costs of materials and equipment; studio; travel or shipping to deliver and collect your

work; travel and housing expenses for art conventions and professional meetings attended or for research in your field; cost of travel to exhibitions for educational purposes or to expand your professional knowledge. The IRS will usually accept 50% of the cost of such travel without question; beyond this percentage they may figure that you only spent part of the trip on self-improvement, that you must have enjoyed yourself part of the time (probably true). Sometimes the whole cost can be proved to be a legitimate deduction.

Accounts need to substantiate income and outgo. The IRS complains that all too often the self-employed claim expenditures of $4,000 on a reported income of $3,000, an indigestible discrepancy to them,—yet it can happen. Keep in mind that if you have a particularly good year, then Income Averaging over five years may benefit you in making up for the bad years; get the IRS Form 1040 Schedule G.

Tax Deduction Problems
Professional people, including artists, are not allowed to include the cost of any work space as a business deduction unless it is totally separate from living space and is used solely for work. This is particularly tough for the artist in high-rent urban areas where many cannot afford two separate rentals but are not allowed to have even a cot and a hot plate in the studio or loft if they want a deduction. Bills have been proposed to correct this hardship, and we hope the inequity will soon be removed.

Another serious injustice is found in the 1969 Internal Revenue Code, which removes the right of creative people to donate their works to tax-free organizations with a tax-deductibility equivalent to that of collectors. Artists, writers, and composers may deduct only "the cost of materials," i.e., paint, canvas, ink, paper. Yet the wealthy collector can deduct the full market value of his gift.

This legislation is being protested not only by artists but also by nonprofit institutions all over the U.S., for they are suffering great declines in acquisitions. There is much less public representation of living artists and a consequent ebb in public education regarding contemporary art. Numerous bills have been proposed in Congress to ameliorate the situation, but most of

them suggest only a 30%-of-market-value deduction instead of full equity with the collectors' deduction privilege.

Keogh and Individual Retirement Account (IRA)

For whatever part of your income derives from self-employment, such as sales of your art, you can take advantage of the Keogh Retirement Plan (Keogh was the congressman who sponsored the legislation in 1962). Anyone who works for himself in an unincorporated business or partnership is eligible, as are those in professions. The Keogh Plan allows you to deposit in a savings bank up to 15% of your total self-employed earnings, or $750 (whichever is larger), for a period of either three or five years, at your determination. You will receive bank interest, and you can deduct from your federal, state and city income taxes each year, the entire amount deposited in the previous year. You will not be taxed on the interest gained until you begin collecting—not earlier than age 59½ or later than 70½—when you may be in a lower tax bracket, and you can then spread the Keogh payments over a number of years. This plan provides a substitute for the retirement benefits enjoyed by those who work for employers and is at the same time a legitimate tax deduction.

You can take the Keogh Plan deduction even if you do not itemize other deductions.

Individual Retirement Accounts (IRA): Any employee not covered by corporate or government pension or annuity plans can deposit up to $1,750 per year in an IRA with the same deductibility and ultimate repayment provisions as the Keogh Plan. This plan can be particularly useful to anyone working for employers on an irregular or hourly basis, or part time or seasonally (in a "fill-in" job to supplement art sales, for example, or a student summer job), and wishing to build up a supplement to his Social Security pension.

Inheritance and Gift Taxes

Inheritance taxes are charged on every estate in the U.S. with assets (including art) of $134,000 or more (if death was in 1978), or $175,000 or more as of 1981, after deduction of estate debts and expenses. A legal method for reducing this burden on your heirs is to make gifts during your lifetime. You can give

money or property, such as works of art, in values up to $3,000 per year per person—with no limit on how many persons— without payment of any tax either by you or them. If gifts to one person are more than $3,000 in any year, the additional amount will be taken off the total estate deductibility at death.

At death, the works in an artist's studio are at the present time taxed at full market value. However, a bill orginated by Representative Fred Richmond of New York and backed by many cosponsors will perhaps have changed this punitive legis- lation by the time this book is in print. The bill would require works to be valued at death on the basis of the cost of materials only, for inheritance tax purposes, with income tax levied on the sales price only when a work is actually sold after the artist's death. This legislation would remove the "voluntary and tragic destruction of works by the artists themselves to avoid placing an unnecessarily heavy tax burden on their families," says Richmond; and it would also remove the double tax on estates, i.e., the full market value assessment for estate tax plus ordinary tax when sold.

It is impossible to spell out any uniform stipulations about estate taxes in the various states, for they vary and in some cases do not have as liberal allowances as those of the federal gov- ernment. But many states do have such taxes, which must be taken into consideration, in addition to the federal.

Social Security

The Social Security tax for the self-employed is higher than for those with employers who pay half: 8.1% in 1979–1980, as compared with 6.13% for the employer-employee, gradually increasing to 10.75% in 1990 and later. Whether income is from wages or self-employment or both, the more credit you build for all earnings up to the maximum covered by Social Security, the bigger the monthly check to you or your depen- dents upon your retirement. In 1978 the maximum on which Social Security tax was paid was $17,700, but this amount in- creases annually—check with your Social Security office. Stock dividends, interest on bonds or from loans, and pay for jury duty don't count for Social Security credit.

The IRS tax forms required for earnings over $400 are 1040 Schedule C (Profit or [Loss] from Business or Profession), and

1040, Schedule SE (Computation of Social Security Self-Employment Tax). If you expect to owe self-employment taxes of $100 or more next year, you are also supposed to pay an estimated tax by April 15 in advance and file Form 1040-ES (for estimated tax payments). You may have to pay Social Security taxes even if you owe no income tax, if you have any income subject to self-employment tax, and even after you start receiving a Social Security pension. (It sounds a bit like robbing Peter to pay Paul.)

If you work on fill-in part-time jobs on a fee-for-service basis, where the employer is not liable for half the Social Security tax, you can obtain Form 1099-*MISC* from the employer if you want to build up your Social Security earning credits. This can apply to any commission from a firm—for a mural, a book jacket or illustrations, a lobby sculpture. The firm files a Form 1099-*MISC* with the IRS, stating the amount paid you, and sends you a carbon copy; you simply include this amount on your IRS reports of income and get credit for these earnings.

When you need information about Social Security systems, IRS knows nothing; phone your nearest Social Security office as listed in the phone book. Social Security always refers to "contributions," never "taxes"—as if we had the same choice as we do with charitable contributions. They also refer only to "benefits," not "pensions"—as if promulgating the idea of a bountiful, beneficent government rather than recognizing our due after years of required payments for these insurance premiums. Don't be surprised at their terminology; just translate.

If you work after retirement age (62 or 65 according to your choice), you are subjected to a "retirement test" up to the age of 72 (age 70, starting in 1982), after which you will receive full pension regardless of earnings. Thus if your annual earnings in the specified post-retirement period total more than $5,000 in 1980, or $6,000 in 1982, you will be docked by $1 out of $2 on the amount earned above this cut-off point. But you must continue to pay both income tax and the additional Social Security tax as an elderly earner even if denied payments from funds to which you have contributed for years. The wealthy whose income derives not from work but from coupon clipping are not docked. It seems a pity that the government aims to push older creative people out of productive work, especially since mandatory retirement at age 65 has been outlawed.

Medicare

Medicare hospital and medical insurances are not affected by your earnings. To receive Medicare coverage, you must apply, with birth certificate, to your local Social Security office, during the first three months of the year in which you will become 65. The Medicare I.D. card serves as an "open sesame" for obtaining reduced admissions to museums, concerts, movies, and local transportation.

18

THEFTS

I n recent years art thievery has been increasing alarmingly on a broad international scale and with growing involvement of organized crime rings.

Theft Archives

When an art theft occurs, there are two privately funded organizations that should receive a report of that theft immediately, regardless of the value of the work stolen. There is no charge for filing such reports.

The Art Dealers' Association of America probably has the largest archive in the U.S. of stolen works of fine art: paintings, drawings, prints, and sculptures. The Association needs a written description including the artist's name, title and date of the work, medium, and dimensions. A photograph is especially useful. The Association publishes periodic notices with reproductions of stolen work and sends them to leading dealers and museums here and abroad, as well as to law-enforcement agencies, to try to locate the works and to halt any resales. Police and insurance companies constantly consult the Association's files which are open to anyone with a specific question. They also publish notices of recovered art.

The International Foundation for Art Research catalogs records in an Art Theft Archive to check against reports by Interpol (International Criminal Police Organization, with headquarters in France), the FBI, state and local police, insurance companies, the Art Dealers' Association, and foreign governments. It has developed a computer program to describe stolen work by identifying objective features, like visual forms and shapes, understandable to police and customs officials who may

not be versed in art terms. In England this type of system has proved valuable in the recovery of stolen art. This archive includes not only the visual fine arts but also antiques, furniture, the decorative arts, if they are unique (for example, hallmark silver would be entered but not standard pattern silverware).

Art Registry

The International Art Registry, Ltd., aims to halt theft and effect recoveries utilizing a "fingerprint" technology for "positive identification" in advance, prior to any theft. A small section of a work of art is photographed in color and then projected onto a screen beneath a grid pattern; in this way the unique characteristics of the work are defined in just as particularized a record as a fingerprint. This coded description, registered in a computer bank, can immediately be circulated internationally.

The system was invented in 1970 by two London constables named Chapman and Gerrard whose purpose was to deter thefts and forgeries. They knew nothing about art, not even what they liked; but they knew fingerprinting and sleuthing. The coding system of these two young British bobbies won them high praise all the way from Scotland Yard to the National Gallery in London.

Because of the high costs, registering whole collections of art has proved more feasible for museums and dealers in expensive art than for individual artists. However, the Registry has reduced its fees for artists to exclude any profit, charging only a flat fee for actual costs in an effort to interest individual artists also in protecting their work.

GRANTS

When seeking grants, fellowships, or scholarships, almost everyone thinks first of turning to the federal and state governments. These are logical sources; but with such huge demands upon them there are never enough grants to go around. It is wise to seek out additional sources of funding.

Government Grants

If you do apply for government grants, then be sure you apply to the proper departments with a correct approach. In the *Artist-Craftsmen Information Bulletin,* supported by the NEA, Editor Alice Kling wrote a practical and sensible piece called *Grantsmanship.* Since this sheet is so difficult to locate, a digest of her precepts follows. Although she wrote with artist-craftsmen largely in mind, it is easy to apply the same maxims to other art fields.

> The mark of good grantsmanship is the ability to match a project, not only with the logical funding source, but also with less obvious potential donors. Craftsmen who work in sculptural modes may also be eligible for Artist Fellowships. Projects may be fundable because they are also folk art, because they are involved with festivals or exhibitions, or because they will be exhibited in museums. In some cases, money may be available for publications, for touring of an exhibition, or other related activities. The way you define your project may greatly increase its eligibility for funding from a variety of sources.
>
> As a first step, we suggest you write for the general *Guide to Programs* which describes all available grant categories. Then investigate any program that appears to have a reasonable connection to your project and ask for its *Guidelines.* Study them carefully. If you

have questions, write again. Describe your project and ask whether it appears to meet the guidelines of the specific program you have in mind. An affirmative response will not ensure you of getting the grant, but it will let you know that you are in touch with the right people. In each case, write to the indicated office, National Endowment for the Arts, Washington, D.C. 20506.

Some of the funding sources at the Endowment:

Expansion Arts funds reach three primary areas: Instruction and Training; Arts Exposure (which brings the arts to senior citizen centers, prisons, hospitals, etc.); and Special Summer Projects (such as youth projects and festivals). Expansion Arts assists neighborhood and community-based programs where citizens are directly involved in artistic, administrative, and developmental policy and where arts organizations can provide professional leadership.

Folk Arts Program gives grants for traditional art forms with emphasis on those from groups which share the same ethnic heritage, language, occupation, religion, or geographic area. The program seeks to encourage community-based arts that have endured through several generations rather than support an individual artist working from personal vision.

Museum Program assists art and other types of museums to carry out interpretation, exhibition, preservation, and acquisition in various ways. Museums have to initiate the proposals. Grants might be given for research on a collection or to develop an exhibition; to provide internships or apprenticeships that would aid the museum; to catalog a collection or publish a handbook; to revamp displays of a collection; to introduce new or experimental ideas via a museum's education department.

See the *Guidelines* for details and deadlines which occur throughout the year.

Another source of government funds is CETA, which has little to do with sponsoring creativity but may supply sideline functions and bread-and-butter support. See *A Guide to Seeking Funds from CETA: A Booklet to Assist Individuals and Organizations to Learn How to Apply for CETA Money,* available from the U.S. Government Printing Office.

Foundation Grants

There are numerous good publications dealing with grants from the private sector; seek them out in the library. Many of the big foundations have slashed their grants to about half, partly because of inflation, partly because of new taxation. But there are more sources than there used to be, notably among

corporations (see Chapter 9). Most of the reference publications include grants to the performing arts as well as the visual arts, so it is necessary to weed out and pinpoint those most applicable to your needs and situation.

The *American Art Directory* contains a section on scholarships and fellowships.

The Foundation Center in New York City publishes *The Foundation Directory,* with information on nearly 3,000 U.S. foundations: as well as *Foundation Grants to Individuals.* Free pamphlets are available: *What Makes a Good Proposal?; What Will a Foundation Look for When You Submit a Grant Proposal?; Publications,* a list of all the center's available publications; and a list of the center's public reference collections in 44 states.

The *Washington International Arts Letter* publishes *Grants and Aid to Individuals in the Arts,* by Daniel Millsaps, with some 1,800 listings applicable to both professional and educational needs; and *National Directory of Arts Support by Private Foundations, Volume 3,* which gives fields in which the foundations operate, their officers, and addresses; and *National Directory of Arts Support by Business Corporations.* The Letter is published ten times a year and periodically reports addenda to these volumes.

Money Business: Grants and Awards for Creative Artists is published by the Artists' Foundation, Inc.

Grantsmanship: Money and How to Get It is published and periodically updated by the A. N. Marquis Company.

SAMPLE FORMS

Contract Form

Many galleries draw up some kind of a contract, which artist and dealer sign before holding a one-man show. These contracts vary considerably: sometimes they are not a form at all but merely an exchange of letters; occasionally agreements are purely verbal. The following, filled out in duplicate, is a typical formal contract.

1. The (name) Gallery, (address), referred to hereafter as the "Gallery," agrees to act as sales representative for (artist's name), referred to hereafter as the "Artist," for a period of year(s) from date.

2. The Gallery shall receive % [40% in some places; up to 50% in large art centers] of all sales made on its premises.

3. The Gallery shall receive % of all portrait, sculpture, or mural commissions that it gets for the Artist, and % of any others awarded during the contract period [because the gallery's promotion has built the artist's reputation; and because the artist may not sell directly in competition with his dealer].

4. The Gallery shall not receive any commissions on royalties, sale of reproduction rights, or commercial assignments unless arranged by the Gallery, in which case the commission will be %. It shall be understood that all sales are made exclusive of reproduction rights, and written acknowledgment of that fact shall be obtained from purchaser by the Gallery. [Work copyrighted after January 1, 1978, is automatically pro-

tected for all reproduction rights.] Reproduction rights may be specifically purchased with the Artist's written consent in each case.

5. The Gallery shall not receive commissions on prizes or awards granted to the Artist by art institutions, foundations, or a government agency.

6. During the period of the contract, the Artist shall not contract for any other representation, except in the following fields if they do not conflict with the Gallery's outlets:

 a. representation outside the city in which the Gallery is located

 b. foreign countries

 c. multiples

The Gallery may arrange for representation of the Artist by another agency, but will pay such agency by splitting its own commission.

7. The Gallery will act as continuous sales representative for the Artist, keeping always available a few examples of work. The Gallery will exhibit the work of the Artist in a one-man show of weeks' duration [usually just under three weeks]. At least one work will be exhibited in all gallery group shows.

8. The costs of a one-man show will be borne by the Gallery, except for publicity costs, the actual bills for which are to be paid by the Artist. Publicity costs will be deemed to include only the costs of: printing and mailing of brochure; advertisements; photographs for the press; preview costs (if any). The Artist agrees to pay publicity costs in advance.

9. The Gallery will pay costs of packing and shipping work sent to clients and exhibitions. It will insure work against loss or damage while the work is on its premises only; insurance will be at %[average: 30% to 40%] of price the artist would receive if the work were sold.

10. A written agreement will be signed by Artist and Gallery on prices for all work left on consignment. Only with the written consent of the Artist may the Gallery accept a lower price.

Should the Gallery obtain a higher price, it is guaranteed that the Artist will receive his same percentage of the total proceeds.

11. Payment to the Artist for any sales made by the Gallery shall be made within fifteen days from the date payment is received. If payment is to be made in installments, the Artist's prior consent shall be required, and payment to the Artist shall be made within fifteen days after final payment is received.

12. All works are received by the Gallery on consignment and in trust. The net proceeds of all sums received by the Gallery on account of works sold shall, after deduction of commission and expenses agreed upon, belong to the Artist.

13. The Gallery will give the Artist a written receipt for all work received; the Artist will sign a receipt for all work returned.

14. The Gallery shall keep records of transactions regarding each Artist's work, records which the Artist may inspect at any time during business hours.

15. This agreement may be canceled by either party up to three months prior to the opening of a one-man show by giving five days' written notice. No cancellation may become effective, however, if the printing or advertising for a show has already been placed.

 Date ...
 Gallery Official
 Artist ..

Bill of Sale Form

(to be filled out in duplicate)

Place ..
Date ...

Name [Dealer or Artist]
Address ..
Sold to ..
Address ..
Description of work: Price:

Terms of payment:
Reproduction rights reserved

Purchaser (signed)

Authorized Dealer or Artist (signed)

Receipt Form

(to be filled out in duplicate)

Received from:
Name of Artist ...
Address ...
Phone ...

Title	Medium	Size	Sales Price	% Commission
1.				
2.				
3.				

To be held until (date)

While the works listed above are on the Gallery's premises, they will be insured against loss or damage for the benefit of the Artist at % of the sales price less commission. None may be removed during the exhibition except as agreed in writing. Reproduction rights reserved by the Artist.

Date ..
Authorized Dealer

LIST OF ADDRESSES

(The following are addresses for references in text. To refer back to text, see Index)

Affirmative Action Register for Effective Equal Opportunity Recruitment (monthly),
10 So. Brentwood Blvd.,
St. Louis, MO 63105

Allied Artists of America,
1083 Fifth Ave.,
New York, NY 10028

American Art Directory,
Jaques Cattell Press,
Box 25001, Tempe, AZ 85282

American Art Therapy Association, Inc.,
Box 11604,
Pittsburgh, PA 15228

American Artist,
Watson-Guptill Publications,
1515 Broadway,
New York, NY 10036

American Artist Business Letter,
Watson-Guptill Publications (op. cit.)

American Association of Museums,
1055 Thomas Jefferson St., NW,
Washington, DC 20007

American Council for the Arts,
570 Seventh Ave.,
New York, NY 10018

American Crafts Council,
44 W. 53rd St.,
New York, NY 10019

American Federation of Arts,
41 E. 65th St.,
New York, NY 10021

American Foundation for the Blind,
15 W. 16th St.,
New York, NY 10011

American Watercolor Society,
1083 Fifth Ave.,
New York, NY 10028

Annotated Bibliography,
of the arts for the handicapped,
available free from ARTS,
Box 2040, Grand Central Station,
New York, NY 10017

Anyart, newsletter,
5 Steeple St.,
Providence, RI 02903

Armenian AGBU Gallery,
628 Second Ave.,
New York, NY 10016

Art & Crafts Market 1978,
published and periodically revised
by Writer's Digest Books,
9933 Alliance Rd.,
Cincinnati, OH 45242

Art Dealers' Association of America,
575 Madison Ave.,
New York, NY 10022

The Art Gallery: Exhibition Guide (monthly),
Ivoryton, CT 06442

Art Hazards Resource Center,
5 Beekman St.,
New York, NY 10038

Art in America Art Letter (monthly),
850 Third Ave.,
New York, NY 10022

Art Information Center, Inc.,
189 Lexington Ave.,
New York, NY 10016

Art Now: Gallery Guide,
144 No. 14th St.,
Kenilworth, NJ 07033

Art Therapy in the United States,
by Ulman, Kramer, and Kwiatkowska;
Art Therapy Publications,
Craftsbury Common, VT 05827

Art Work, Division of Foundation
for the Community of Artists (q.v.);
for CETA jobs for New York City artists

Art Workers' News,
published by Foundation for the
Community of Artists (q.v.)

Art/World, (monthly),
published by Arts Review, Inc.,
1295 Madison Ave., NY 10028

Artist-Craftsmen Information Bulletin,
806 15th St. NW, Suite 427,
Washington, DC 20005;
by subscription

Artist-Run Galleries,
c/o Pleiades Gallery,
152 Wooster St.,
New York, NY 10012

Artists' Coalition of Texas,
P.O. Box 12693,
Dallas, TX 75225

Artists' Equity Association, Inc. (national),
3726 Albemarle St. NW,
Washington, DC 20016

Artists' Equity of New York,
225 W. 34th St., Suite 1302,
New York, NY 10001

Artists for Economic Action,
10930 Le Conte Ave.,
Los Angeles, CA 90024

The Artists' Foundation, Inc.,
100 Boylston St.,
Boston, MA 02116

Artists' Rights Association,
165 Park Row, Apt. 19D,
New York, NY 10038
(unlisted Tel.: 212-732-3873)

Artists Talk on Art,
15 E. 10th St., Apt. 2F,
New York, NY 10003

Arts Yellow Pages,
American Council for the Arts (q.v.)

Attorney General's Consumer Protection Division,
New York State, 2 World Trade Center,
New York, NY 10047

Audubon Artists,
1083 Fifth Ave.,
New York, NY 10028
(unlisted Tel.: 212-369-4880)

Austrian Institute,
11 E. 52nd St.,
New York, NY 10022

Better Business Bureau of New York,
257 Park Ave. So.,
New York, NY 10010

Black Emergency Cultural Coalition,
463 West St.,
New York, NY 10014

Boston Artists' Foundation:
See Artists' Foundation, Inc.

Boston "June Art in the Park,"
Mayor's Office of Cultural Affairs,
182 Tremont St.,
Boston, MA 02116

Boston Visual Artists' Union,
77 No. Washington St.,
Boston, MA 02114

Brentano's Inc. Galerie Moderne,
586 Fifth Ave.,
New York, NY 10036

Brooklyn Museum,
188 Eastern Parkway,
Brooklyn, NY 11238

Bureau of Occupational and Adult Education,
Office of Education,
Washington, DC 20202

Business Commiteee for the Arts, Inc.,
1501 Broadway,
New York, NY 10036
Publications available:

Business & the Arts,
An Answer to Tomorrow,
by Arnold Gingrich, 1969

Business in the Arts '70,
by Gideon Chagy, 1970

The State of the Arts
and Corporate Support,
by Gideon Chagy, 1971

The New Patrons of the Arts,
by Gideon Chagy,
Abrams Publ. 1972

Butler Institute of American Art,
524 Wick Ave.,
Youngstown, OH 44502

Canadian Consulate, gallery,
1251 Sixth Ave.,
New York, NY 10019

Career Opportunities in Crafts,
by Elyse Sommer, Crown Publishers, Inc.,
1977, 1 Park Ave.,
New York, NY 10016

Career Opportunity Guidance,
Largo, FL 33540
Publications: *Career Briefs*

Carnegie Peace Building,
(Endowment International Center),
345 E. 46th St.,
New York, NY 10017

Center for Inter-American Relations,
680 Park Ave.,
New York, NY 10021

Center for Visual Artists,
1333 Broadway,
Oakland, CA 94612

CETA: *A Guide to Seeking Funds from CETA:*
A Booklet to Assist Individuals and Organizations
to Learn How to Apply for CETA Money,
United States Government Printing Office,
Superintendent of Documents,
Washington, DC 20402;
Stock No. 029-016-00049-6; $1.30

Change, Inc.,
P.O. Box 705, Cooper Station,
New York, NY 10003, and
669 No. La Cienega,
Los Angeles, CA 90069;
grants to artists for emergency needs

Chicago Artists' Coalition,
500 No. Michigan, 20th floor,
Chicago, IL 60626

Citiartnews,
189 Mathewson St., Rm. 5,
Providence, RI 02903

Citizens' Stamp Advisory Committee,
c/o Postmaster General,
Washington, DC 20260;
commissions for stamp designs

City Walls,
25 Central Park W., Suite 25R,
New York, NY 10023

The Clocktower,
108 Leonard St.,
New York, NY 10013, and P.S. 1
46-01 21st St.,
Long Island City, NY 11101

College Art Association of America,
16 E. 52nd St.,
New York, NY 10022

College of New Rochelle,
New Rochelle, NY 10801

Cooperstown Graduate Programs:
See New York State Historical Association

Copyright Office,
Register, Library of Congress,
Washington, DC 20559

Crafts and the Law,
published by The Artists' Foundation (q.v.)

Crafts Coordinator,
National Endowment for the Arts,
Washington, DC 20506

Crafts Report (monthly),
700 Orange St.,
Wilmington, DE 19801

Cultural Council Foundation,
1500 Broadway,
New York, NY 10036

Davidson College Art Gallery,
Box 2495,
Davidson, NC 28036

Department of Transportation of the U.S.,
Washington, DC 20590

Directory for the Arts, 1978,
published by Center for Arts Information,
152 W. 42nd St., New York, NY 10036;
for New York State only

Dodge Reports,
McGraw Hill Information Systems,
1221 Sixth Ave.,
New York, NY 10020

Donald Art Co., Inc.,
90 So. Ridge St.,
Portchester, NY 10574

Educational Facilities Laboratories,
830 Third Ave.,
New York, NY 10022

Ethical Culture Society,
2 W. 64th St.,
New York, NY 10023

Fairleigh Dickinson University,
Madison, NJ 07940

Fine Arts Market Place,
revised and reissued periodically
by R.R. Bowker Co.,
1180 Sixth Ave.,
New York, NY 10036

Fogg Museum of Art,
Harvard University,
Quincy St. & Broadway,
Cambridge, MA 02138

Foundation Center,
888 Seventh Ave.,
New York, NY 10019

Foundation Directory,
published by Foundation Center (q.v.)

Foundation for the Community of Artists,
280 Broadway, Suite 412,
New York, NY 10007

Foundation Grants to Individuals,
published by Foundation Center (q.v.)

Gallery Management,
by Rebecca Zeler-Myer,
published by Syracuse University Press, 1978,
1011 E. Water St.,
Syracuse, NY 13210

General Services Administration,
Office of Fine Arts,
Washington, DC 20405

Goethe House,
1014 Fifth Ave.,
New York, NY 10028

Grants and Aid to Individuals in the Arts,
by Daniel Millsaps,
published and periodically updated
by Washington International Arts Letter (q.v.)

Grantsmanship: Money and How to Get It,
published by Marquis Who's Who, Inc. (q.v.)

Graphic Artists' Guild,
30 E. 20th St.,
New York, NY 10003

Hahnemann Medical College and Hospital,
Art Therapy Program,
Division of Mental Health,
314 No. Broad St.,
Philadelphia, PA 19101

The Healing Role of the Arts,
available free from Rockefeller Foundation,
1133 Sixth Ave., New York, NY 10036;
programs for the handicapped

Health, Education, and Welfare Department,
Careers Division,
Washington, DC 20202

Hertzl (Theodor) Institute,
515 Park Ave.,
New York, NY 10022

House of Living Judaism,
838 Fifth Ave.,
New York, NY 10021

Institute for Art and Urban Resources, Inc.,
The Clocktower (q.v.)

Institute of Contemporary Art,
955 Boylston St.,
Boston, MA 02115

Institute of International Education,
United Nations Plaza & 47th St.,
New York, NY 10017

Institute of Museum Services,
Health, Education, and Welfare Dept. (q.v.)

Intermuseum Conservation Association Laboratory,
Oberlin College (q.v.)

International Art Registry, Ltd.,
111 John St.,
New York, NY 10038

International Center of Photography,
1130 Fifth Ave.,
New York, NY 10028

International Directory of Arts,
Verlag Müller GMBH & Co. KG,
16 Grosse Eschenheimer Strasse,
D-6000 Frankfurt/Main 1, West Germany

International Foundation for Art Research,
24 E. 81st St.,
New York, NY 10028

Israeli Art Gallery
485 Madison Ave., 11th Fl.
New York, NY 10022
Israeli painting and sculpture on consignment

Japan Society,
333 E. 47th St.,
New York, NY 10017

Kappa Pi International Honorary Art Fraternity,
P.O. Box 7843, Midfield, Birmingham, AL 35228;
for its many Chapters, see *American Art Directory*

Knickerbocker Artists,
14 Sutton Place So.,
New York, NY 10022

Kosciuszko Foundation,
15 E. 65 St.,
New York, NY 10021

Lever House, gallery,
390 Park Ave.,
New York, NY 10022

Library and Museum of the Performing Arts,
111 Amsterdam Ave.,
New York, NY 10023

M.I.T. (Massachusetts Institute of Technology) Press,
28 Carleton St.,
Cambridge, MA 02142

MacDowell Colony,
Peterborough, NH 03458

Marquis Who's Who, Inc.,
200 E. Ohio St.,
Chicago, IL 60611

Medicare,
See local Social Security Office

Millay Colony for the Arts,
Steepletop,
Austerlitz, NY 12017

*Money Business: Grants
and Awards for Creative Artists,*
published by Artists' Foundation (q.v.);
also available from American Council for the Arts (q.v.)

Montclair State College,
School of Fine and Performing Arts,
Upper Montclair, NJ 07043

El Museo del Barrio,
175 E. 104th St.,
New York, NY 10027

Museum of Modern Art, New York City
11 W. 53rd St.,
New York, NY 10019

National Academy of Design,
1083 Fifth Ave.,
New York, NY 10028

National Arts Club,
15 Gramercy Park So.,
New York, NY 10003

National Association of Women Artists,
41 Union Sq.,
New York, NY 10003

National Collection of Fine Arts,
See Smithsonian Institution

*National Directory of Arts Support
by Business Corporations,* 1979,
published by Washington
International Arts Letter (q.v.)

*National Directory of Arts Support
by Private Foundations,* Vol. 3, 1978,
published by Washington
International Arts Letter (q.v.)

National Endowment for the Arts (NEA),
Washington, DC 20506

National Institute of Mental Health,
Washington, DC 20014

National Sculpture Society,
777 Third Ave.,
New York, NY 10017

National Society of Mural Painters,
41 E. 65th St.,
New York, NY 10021

National Society of Painters
in Casein and Acrylic,
1083 Fifth Ave.,
New York, NY 10028

National Trust,
Jackson Pl., Washington, DC 20006;
for new uses for old buildings

New England Art Advisory Services,
204 Westminster Mall,
Providence, RI 02903;
to promote sales of New England artists' works

New York Graphic Society, Ltd.,
140 Greenwich Ave.,
Greenwich, CT 16830

New York Public Library. Galleries:

Main Library,
42nd St. & Fifth Ave.,
New York, NY 10036

Donnell Branch, 20 W. 53rd St.,
New York, NY 10019

Library and Museum of the Performing Arts,
111 Amsterdam Ave.,
New York, NY 10023

Schomburg Center,
103 W. 135th St.,
New York, NY 10031

New York State Historical Association,
Cooperstown, NY 13326

New York Times,
229 W. 43rd St.,
New York, NY 10036

New York University,
Institute of Fine Arts,
1 E. 78th St.,
New York, NY 10021

North Carolina State Museum,
107 E. Morgan St.,
Raleigh, NC 27611

Oberlin College,
Oberlin, OH 44074

Ohio State University,
College of the Arts,
128 No. Oval Dr.,
Columbus, OH 43210

Opportunity Resources for the Arts,
165 W. 46th St.,
New York, NY 10036

Organization of Independent Artists of New York,
201 Varick St.,
New York, NY 10013

Pacific Northwest Arts and Crafts Association,
10310 NE 4th St.,
Bellevue, WA 98004

Pastel Society of America,
15 Gramercy Park So.,
New York, NY 10003

Portraits, Inc.,
41 E. 57th St.,
New York, NY 10022

Pratt Institute,
Graduate Therapy Office,
125 Higgins Hall,
Brooklyn, NY 11205

Professional & Administrative Staff Association (PASTA),
employee union at New York's Museum of Modern Art (q.v.)

Rainbow Art Foundation,
60 E. 86th St.,
New York, NY 10028

Register of Copyrights,
Library of Congress,
Washington, DC 20559

Rizzoli Bookstore Gallery,
712 Fifth Ave.,
New York, NY 10019

Rothko, Mark, Foundation,
226 W. 47th St.,
New York, NY 10036;
Grants to mature artists for emergencies, $500 to $5000

Sangamon State University,
Arts Management Program,
Springfield, IL 62708

Sculptors' Guild,
10 E. 53rd St.,
New York, NY 10022

Smithsonian Institution,
Washington, DC 20560

Society for Occupational
and Environmental Health,
1341 G St., NW,
Washington, DC 20005

Stained Glass Association of America,
1125 Wilmington Ave.,
St. Louis, MO 63111;
Membership $30

State Councils on the Arts:
In every state and territory,
listed with officers and addresses
in *American Art Directory* (q.v.)

State University of New York
at Binghamton, Binghamton, NY 13901

Studio Museum of Harlem
2033 Fifth Ave.,
New York, NY 10035

Union of Independent Colleges of Art,
4340 Oak St.,
Kansas City, MO 64111

Union of Rhode Island Artists,
189 Mathewson St., Rm. 5,
Providence, RI 02903

United Arts Funds:
Administered by American Council
for the Arts (q.v.)

United States Customs House,
6 World Trade Center,
New York, NY 10047

United States Government Printing Office,
Washington, DC 20402

University of Kansas,
Department of Creative Therapies,
Lawrence, KA 66044

University of Louisville,
Art Therapy Department,
Belknap Campus,
Louisville, KY 40208

Visual Artists' and Galleries' Association (VAGA),
1 World Trade Center, Suite 1535,
New York, NY 10048

Volunteer Lawyers for the Arts,
36 W. 44th St., Suite 1110,
New York, NY 10036

Washington County Museum of Fine Arts,
P.O. Box 423,
Hagerstown, MD 21740

Washington International Arts Letter,
P.O. Box 9005,
Washington, DC 20003

Washington Square Outdoor Exhibit, Inc.,
33 Fifth Ave.,
New York, NY 10003

What Makes a Good Proposal,
published by Foundation Center (q.v.)

What Will a Foundation Look for
When You Submit a Grant Proposal?
published by Foundation Center (q.v.)

Whitney Museum of American Art,
Madison Ave. & 75th St.,
New York, NY 10021

Who's Who in America,
published by Marquis Who's Who, Inc. (q.v.)

Who's Who in American Art,
published by Jaques Cattell Press,
Box 25001, Tempe, AZ 85282

Yaddo,
Union Ave.,
Saratoga Springs, NY 12866

INDEX

INDEX